Cross-Cultural Design

Henry Steiner and Ken Haas

Cross-Cultural Design

Communicating in the Global Marketplace

THAMES AND HUDSON

To my mother Lillie (born) Hofbauer

H S

To Shirley Hoffman, Trudy Haas, and the late Edgar Haas

K H

First published in Great Britain in 1995 by
Thames and Hudson Ltd, London

First published in the United States of America in 1995 by
Thames and Hudson Inc., 500 Fifth Avenue, New York, New York, 10110

British Library Cataloguing in Publication Data

A catalogue record for this book is available from the British Library

Library of Congress Catalog Card Number: 94-62071

ISBN 0-500-97423-3

Printed in Hong Kong

Contents

Foreword

People often assume, mistakenly, that the arts are truly universal, that "music is the universal language," and that "great art" will naturally be appreciated by all, no matter which culture is exposed to it. They forget that the arts, and design, are also part of a person's set of cultural understandings of the world and reality; a reality structure so profound that it blinds us to certain dimensions of the universe even as it fixates us solidly on others.

The Mahayana Buddhist tradition perceives the impermanence of all matter, including humans. Portrayed against the backdrop of the cosmos, people are truly puny subjects of the gods, and so the Chinese arts concentrate not on individuals but on nature. While Western artists developed portrait painting to a fine art, Chinese painting turned towards landscapes wherein humans are merely small figures engulfed by the rolling hills and streams of the natural world. Western artists like to demonstrate their individuality and creativity by following bold new visions of their craft; Chinese artists like to display their virtuosity and sensitivity by masterfully recapturing the images of the masters of their craft. All artists unthinkingly embody the patterns of their culture, even those who hold themselves in rebellion against their own traditions.

How then can artists and graphic designers communicate cross-culturally? If our culture sets the parameters of our vision, then how can we hope to communicate to others whose visions are colored by quite different cultural lenses? The task is demanding but not impossible, as indicated by the rich selection of successful cross-cultural designs in this book. Although absolute translation is rarely possible, cross-cultural interpretation of a design or work of art is attainable. Those communicating across cultural borders, however, must be prepared for the possible reinterpretation of their work along somewhat different lines. As long as *mis*interpretation is avoided, we should be satisfied when our work speaks back to us with a foreign accent. That is, in fact, how we know that we have been successful; it says to us that we have communicated meaningfully to others on their own terms.

Dr. Greg Guldin, *Professor of Anthropology, Pacific Lutheran University*

Preface

I've been carrying out photographic assignments for Henry Steiner for over sixteen years. We've become close friends and, given the battle that creating an annual report can be, comrades-in-arms. Despite this long association, it was only a few years ago that the full scope of Henry's *cross-cultural* contribution became apparent to me; that his was not just the case of a world-class talent who had settled in Asia for the challenge of pioneering then virgin territory.

I believe a significant reason Henry remained in Hong Kong was an intuitive attraction to being at *the* crossroad of East and West. His work seems determined to weave and transmute the strands of two contrasting traditions into a statement that is neither and both. Like his heroes Mahler, who blended the sublime with the vulgar, and Joyce, who set the eternal against the everyday, Henry has deftly managed to mate the virtues of incompatible species without producing a monster. His uncanny ability to juxtapose the magisterial tradition of Roman typography against the sensuous curves, bold strokes, and delicate teardrops of Chinese script is but one example.

That Henry dexterously manipulates elements of East and West is evident even to the untrained eye. Yet the single-mindedness and complexity of his experiment took years for me to comprehend. As Henry and I discussed his work we realized that there was no book on cross-cultural design, although cross-cultural studies existed for other disciplines. We planned a volume in which we would survey Henry's work to define the issues and serve as a template for a range of cross-cultural problems. We would then open the floor to the efforts of other distinguished colleagues around the world, celebrating the diversity that characterizes our profession. The response was magnificent, coming from almost every continent. We are enormously grateful to our contributors for their whole-hearted support and enthusiasm.

The guidance of our patient and vigilant editor, Amanda Miller, was invaluable, as was Beth Crowell's expert work on layout. We would also like to express our appreciation to Jennifer Betson, who kept much of the project organized and has been kind enough to remain on speaking terms with us still. Betty Kwok brought grace and resourcefulness to our efforts, as she has so often in the past.

K H

Introduction

Business is global.
People are different.
Communication means survival.

We are now well into an explosive transition which, like the industrial revolution in the nineteenth century, will alter almost every facet of human existence. This cybernetic revolution, marked by the age when computers came into being, has spawned an era of communication on an international scale. Visual, technological, and even political information is being shared in an unprecedented manner. The Berlin Wall is down, the USSR no longer exists, the new millennium looms. And Orwell was wrong.

For one thing, technology has *not* become an instrument of enslavement in the hands of an all-powerful Big Brother. On the contrary, microchips, computers, modems, faxes, and the technological marvels soon to come have broken the back of the State's monopoly on information, much as the printing press did in earlier times. Individuals have access to tools of expression in ways once dreamed of only by a few. During the Tiananmen Square ordeal, for example, newspaper reports from around the world were photocopied so that they could be transmitted by regular phone lines to the individual fax machines of pro-democracy leaders, keeping them abreast of international reaction.

Regardless of the European Community and planned common economic markets in Asia and the Americas, the world has *not* coalesced into a few huge geopolitical masses, each conforming to a rigid totalitarian code. Free markets and open communication are the order of the day, and with them an extraordinary return to ethnic pride on a national and regional level. Despite the superficial homogenization of a Big Mac and a Coke, people continue to assert, even at the cost of war, their own cultural identities.

With the fierce trend to "protect" cultures comes the misguided notion that civilizations best maintain their integrity when isolated and spared contamination. A broad view of history suggests just the opposite: societies prosper when they intermingle, when ideas and knowledge are transferred in the exciting dance of cultural cross-pollination. Europe dominated much of the world by the end of

the nineteenth century, largely through its advanced technology. But how would the European empires have been built without Chinese paper, compasses and gunpowder, Egyptian trigonometry, or Arabic numerals (borrowed in turn from the Hindus)? Japanese civilization is admired by many, but how would it have developed without the language, legal system, and religious philosophy so freely appropriated from China?

Cross-Cultural Design illustrates the particular challenges and rewards graphic designers have experienced while working on assignments aimed at cultures other than their own. It explores the inspiration offered by the unfamiliar traditions of a foreign society as well as the potential hazards of ignored or misunderstood taboos. The book focuses on the exciting synthesis that can result from the melding of the designer's native perceptions with the conventions of the target audience whose perceptions of life's basic issues – time, religion, family relations, the role of sex and gender, technology, politics, economics – may differ dramatically.

The exchange of ideas is one thing, the development of style and design quite another. Integrating different aspects of separate cultures into a common theme is as formidable as it sounds. The ability to supply a visual statement that provides a direct, clear communication of the message is basic for good designers and imperative when working cross-culturally. They must strive to transmit one set of messages within the medium of a foreign tradition without losing the meaning and attitude of the original concept. Designers venturing into the global marketplace need to be as sensitive to cultural conventions as they are uninhibited in finding new ways to exploit them.

This book presents the achievements of some of the world's great designers accompanied by commentaries based on their own words. They tell about how they have overcome geographical, cultural, and political boundaries in the service of communication. They share a common sensitivity and their efforts exemplify the ways in which exotic elements can be absorbed and transformed to produce a distinctive style, an object of beauty, a compelling argument.

HS & KH

A Cross-Cultural Portrait: Henry Steiner

Chameleons and Spam Sushi

An Introduction to Cross-Cultural Design by Henry Steiner

I am explaining the concept of this book to a colleague: "It covers projects done by designers working in or communicating to a foreign culture." He suggests for inclusion a charming book he produced after a trip through China; it is full of beautiful, perceptive photographs and comments. It would not be suitable, I tell him with some regret, because the images he shows are presented as examples – *quotations* – and this book is about *transformation*.

. . .

Among guests at dinner one night, there are a philosopher and an anthropologist who also teaches literature. I ask them if they know of any theoretical works dealing with cross-cultural design. They are intrigued by the subject but cannot cite any literature of relevance. I say that my theory and practice have been inspired by the comments and creations of Magritte, Mahler, and Joyce, who dealt with *contrast* and *transformation*.

. . .

Paul Rand started teaching at Yale when I was still there and I have followed two of his *dicta* throughout my career. The first was the primacy of concept; if you can't write down the idea behind your visual submission on one side of a small index card, then you have no design.

The other principle is that *contrast* is what gives life to a design. It can be visual (big/small, rough/smooth, light/dark) or psychological (old/new, familiar/unusual), but a design without contrast will falter.

. . .

There are three stages in the cross-cultural design process.

1. Quotation. Here one uses, without comment, foreign images for their quaintly exotic flavor, as decoration. This stage is precariously close to plagiarism, employing icons without necessarily understanding them.

2. Mimicry. Working in the style or manner of an artist or school, here one attempts to understand to some degree how and why the model was done. The thrust is more towards re-creation than reproduction. An operative adjective is *influence*.

3. Transformation. In this stage, influence has been assimilated and the once foreign becomes personal and natural.

Examples of the superficial quotation are as common as picture postcards, airport souvenirs, or "ethnic" snack packaging.

Mimicry can be seen in van Gogh's copying of Japanese *ukiyo-e* woodblock prints, while his later paintings show his mastery over the initial impact and his profound understanding of the Japanese aesthetic, demonstrating transformation.

Picasso's work was influenced by Iberian, Oceanic, and African primitive sculpture in the period leading to *Les Demoiselles d'Avignon*. Combining (as did Braque) these influences with the vision of Cézanne, he created Cubism, which became his personal visual language. In *Guernica*, for instance, the original influences have been so thoroughly digested and transformed that one sees only Picasso being himself.

· · ·

Musical examples. Arthur Sullivan quotes a Japanese song in *The Mikado* but in *The Yeomen of the Guard* he writes in the manner of Wagner. Tchaikovsky quotes *La Marseillaise* in the *1812 Overture;* Stravinsky mimics a German chorale in *L'Histoire du Soldat;* Ravel and Poulenc transform *gamelan* music. And Mahler transforms and transcends his Chinese sources in *Das Lied von der Erde*.

· · ·

Gastronomic examples. What could be more American than hamburgers and wieners? So much so that the cities that gave them their names seem quite irrelevant today. I can remember when pizza was alien in New York and Japanese cuisine extraterrestrial. I am amused now to find in Hawaii – the calm eye of the Pacific Rim cross-cultural storm – pineapple pizza and spam sushi.

· · ·

The Japanese *mon* are simple, schematic crests used to identify families and, by extension, companies. They occupy basic geometric shapes such as circles and are designed in black and white so that they can be dyed into the fabric of formal kimonos. They must be seen easily and often can be "read." For example, Mitsubishi means "three diamonds" and the familiar emblem shows them in a direct and unequivocal way.

What Picasso has done is to invent a kind of creole, a language which assimilates an alien vocabulary to a familiar syntax.

ADAM GOPNIK

In imitation what matters is the unwitting infidelity to the model.

MAURICE RAVEL

After the opening of Japan to the West in the middle of the 19th century, *mon*, along with *ukiyo-e* prints and other arts and crafts, were eagerly welcomed by European and American artists who saw in the Japanese aesthetic (as in the "primitive" works brought back from Africa and Oceania) a vibrant alternative to the stagnant realism that dominated the visual arts.

Ukiyo-e was crucial to the development of Impressionism and Post-Impressionism. French painters went outdoors to paint, inspired by the bright colors of the Japanese prints. Lautrec signed his works with a kind of *mon*. Degas was influenced by the eccentric cropping of the prints. Van Gogh copied in oil several prints, most notably ones by his near-contemporary Hiroshige.

At the same time, the *mon* were adopted by German and Austrian designers and the influence of this style spread from the Wiener Werkstätte and the Bauhaus to industry, which began dropping the old-fashioned trademarks based on signatures and illustrations in favor of the sturdier geometric symbols. By the end of the Second World War the *mon* style of trademark was predominant in successful Western businesses.

In the meantime, Japanese industry after the Meiji restoration had adopted the "signature" style of trademark as part of their eagerness to be up-to-date and thoroughly Western. The fussy, imported images had replaced most of the simpler "old-fashioned" domestic *mon* by 1945. (In an effort to become "modern" Japanese painters went to France in the 1920s to study the techniques of the Impressionists and their successors. In treating the work of van Gogh, for example, as something new and different, they displayed a form of cultural amnesia, overlooking the remarkable Japanese influence on the Dutchman's style.)

After World War II the Japanese felt again a great need to learn from the triumphant West and especially from America. Among other things, they could not help comparing adversely the clean-looking Western corporate identities with their own "granddad" Meiji style trademarks.

So, in another instance of cross-cultural amnesia, they emulated the *mon*-based Western identities. I call this phenomenon the *Echo Effect*.

· · ·

Most people are as unaware of their own culture as they once were of oxygen, evolution, or gravity. Culture is our environment; it is the "natural" way to think and behave, as unquestionable as water to a fish.

The pattern is universal: *we* are human, *they* are simian; *we* are normal, *they* are bizarre; *we* are civilized, *they* are barbaric; *we* religious, *they* heathen.

There is a stunning episode in Bruce Chatwin's *The Songlines* that exemplifies this attitude. He recounts a tedious and – yes – barbaric aboriginal myth about two sisters turning into hills and wallabies. Just as we are getting annoyed with this primitive mumbo-jumbo, he staggers us by modulating into a discussion of Ovid's *Metamorphoses* and we realize with a shock how tribal and – again – barbaric are these classic stories of people turning into trees, flowers, and eagles. I have not been able to see the Greek mythology as fundamental and sublime since this epiphanic encounter with Chatwin's aborigines.

. . .

I find myself using such terms as "displacement" and "ambiguity" in describing the cross-cultural design process. Another useful expression is "irony," the ability to stand back from your own work and see it in a broader context while allowing your audience an opening to make connections. The designer's eye cannot be innocent in our age and neither may we patronize our audience. Humor is always welcome but, above all, wit (which is not the same as being funny) is essential.

. . .

Perhaps if you are a wanderer and an exile and if you are shy and mistrustful, you rely on signs more than on people. You study them and learn how their appearance and meaning can be of use to you. You know the flavor of street signs in Basel and Beijing; they speak to you in specific ways and you become attuned to the nuances and potential of these marks to express the intentions of people who are no longer there.

. . .

There are cross-cultural cities. Vienna was one; the ferment created by the influx of numerous peoples from all over the Austro-Hungarian empire contributed

5

essentially to the greatness we associate with Viennese culture from the end of the eighteenth century until after World War I. I was born in Vienna in 1934 but had to emigrate with my parents five years later. In any case, the golden age was over, but in our destination, New York, I was lucky to find another cross-cultural city at its peak. My painting teachers in college were from the "New York School" of Abstract Expressionism, a transformation of European Modernism, in particular of Dada and Surrealism. (An important figure at Yale – besides Rand, who was deeply influenced by Cassandre, Klee, and Miro – was Josef Albers, the head of the art school and a Bauhaus transplant.)

In 1961, in Hong Kong, I discovered another cross-cultural city-state undergoing the transformation from provincial outpost of an empire to international focal point. I was born too late for another great cross-cultural city, Shanghai. Only its remaining Art Déco architecture bears testimony to what was one of the most sophisticated metropolises in the first third of this century.

. . .

Hong Kong's official flower – which appears on the new coinage, which in stylized form will be on the flag of the Special Administrative Region, and which I have incorporated into a redesigned "post-colonial" set of banknotes to replace the British coat of arms – is the *Bauhinia Blakeana,* a magenta tree orchid named after a former governor.

Botanically it is a vivid, sterile hybrid; I love that.

. . .

Working in Hong Kong has provided me with a living visual vocabulary that would have been inaccessible and inappropriate in New York. Further on in this book are examples of my work categorized according to technique: iconography, typography, symbolism, split imagery, and ideography. These techniques are demonstrated in my examples and indeed in most of the works presented by other designers.

These techniques are not uncommon in graphic design although some are particularly apt to cross-cultural works. Before coming to Hong Kong, while working for *The Asia Magazine* in New York, I was doing advertisements on an East/West

theme – contrasting types of tea cups, of footwear, of office equipment, and so on – influenced by the "two-punch" comparison advertising layouts pioneered by Doyle Dane Bernbach in the mid-fifties.

Ultimately, it is the context of a design that makes it cross cultural and this is determined by the designer's *attitude*. You don't have to be an outsider, but it helps. Perhaps a French designer, for example, could consciously and objectively communicate something about basic Frenchness to his or her compatriots but that designer would first need to be alienated in some way – as are most artists.

· · ·

The Cantonese have a delightful metaphoric expression for mutual incomprehension: "a duck talking to a chicken."

· · ·

In 1980, HongkongBank took a controlling interest in New York's Marine Midland Bank. By then I had been responsible for the HongkongBank's annual reports for fourteen years and this year we decided to mark the occasion with a visual theme comparing aspects of Hong Kong with New York. I chose to use a format of "rhyming" images, comparing photos of the two cities side by side. As it happened, Ken Haas, who had been working in Hong Kong for the last two years and had photographed several projects for me, was returning to New York late in the year. He was thus ideally positioned to do both sets of photographs, assuring their visual continuity. It was an ambitious concept but it worked out beautifully. Ken started shooting before leaving Hong Kong and I went to New York to check on the intricate process of getting the subjects to match. During that visit we discussed the question of the cover. In those days, because of comparatively slow production schedules, the report was in two volumes: the accounts in black and white, and the operations review in four color (which could be printed earlier). The covers for these two were decided; one would have the bank's lion matched with the lion from the New York Public Library, the other would have a Cantonese opera performer contrasted with the Statue of Liberty. For over a decade the two books had been distributed in a "wallet" folder and we agreed that this time its cover would need to

Mahler's music is about Mahler – which
simply means that it is about conflict.
Think of it: Mahler the Creator vs. Mahler
the Performer; the Jew vs. the Christian;
the Believer vs. the Doubter; the Naïf vs.
the Sophisticate; the provincial Bohemian
vs. the Viennese homme du monde; the
Faustian Philosopher vs. the Oriental
Mystic; the Operatic Symphonist who
never wrote an opera. But mainly the
battle rages between Western Man at the
turn of the century and the life of the
spirit. Out of this opposition proceeds the
endless list of antitheses – the whole roster
of Yang and Yin – that inhabit Mahler's
music.

LEONARD BERNSTEIN

be not just an example of two items from the cities but symbolic of the theme in a fundamental manner.

New York was easy, it is the "Big Apple." So we puzzled over how to rhyme that image with a symbol of Hong Kong. Perhaps a lychee off a tin can label?

The dilemma was still unresolved when Ken came back to organize the remaining photos in Hong Kong to match with his images from New York. I still had no acceptable foil for the "Big Apple" and was agonizing over whether to use the lychee or a vegetable or *something*; all the options seemed unsatisfactory.

Then Ken asked, "Isn't Hong Kong the 'Pearl of the Orient'?" The resulting cover design was as close to perfection as I've been. I had been looking for *fruits*, you see. What I should have been thinking was *circles*.

I tell this story because of the way it demonstrates the importance of standing back, of having that "ironic" attitude.

. . .

Japan's *Idea* magazine asked me in 1980 to design the cover for an issue that carried an article on my work. The editors politely declined the first sketch, which was based on a female nude. (The Japanese can be prudish, in public.) They requested a more personal design.

About a year before this I had attended an international design conference in Japan. A few of us foreign delegates met in Tokyo and we took the Shinkansen bullet train to Osaka, the site of the conference. We took up about a third of one car while another third was occupied by a group of American wrestlers performing in different Japanese cities. The other travelers were Japanese civilians.

The wrestlers were playful, colorful, noticeable. They wore Hawaiian shirts, told jokes, teased the staff, played country and western music on their cassette players. They each had a distinctive hair style or clearly distinguishing features; one sported a black and silver spandex mask that covered his whole head.

And then there were the designers: businesslike, quiet conversationalists, dressed in sober suits.

I was struck by the contrast and its implications. We, the designers, were in fact public performers through our work. Our work needed to be favorably noticed or we

were failures. The work had to be vivid, colorful, witty, memorable. Yet in person we were dull.

I remembered that train ride and the masked wrestler in coming up with the eventual cover design. I had myself formally photographed in a dark blue suit against a neutral background. The only interesting element in the design was my face, which had been made up in the thick red, white, and black stripes of Cantonese opera.

I meant it to be a statement generally about the designer as a performer and specifically about my own role in Asia.

. . .

When designing across cultures, it is important to keep in mind that it is not a question of right or wrong, better or worse. Chameleons reflect local color but retain their form. Ideally, designers are representative of their own culture yet adaptive to new surroundings. The goal is to achieve a harmonious juxtaposition; more of an interaction than a synthesis. The individual character of the elements should be retained, each maintaining its own identity while also commenting on and enriching the other, like the balance of Yin and Yang.

Combination, mixture, blending – these are useless concepts as they will result in a kind of mud. Street stalls in Hong Kong serve an understandably unique beverage called "Yin-yang," a combination of tea and coffee. It tastes as you would imagine: the worst characteristics of both are enhanced. In the *Tai Chi* (the Yin Yang symbol) the elements don't merge; they stand for positive/negative, male/female, light/dark, and they are complementary, yet discrete.

. . .

The virtues of cross-culturalism? Cross-pollination, the creation of new nuances, extended sensibilities. Invigoration of one's own tradition by taking a holiday in another. Humility in the presence of other cultures, understanding and respect for alternative ways of approaching life. And the invaluable sense of distance in seeing – albeit briefly – the exotic as commonplace and oneself and one's beliefs as being, after all, alien.

There is no special reason . . . why one chapter [of Ulysses] should be told straight, another through a stream-of-consciousness gurgle, a third through the prism of a parody . . . but it may be argued that this constant shift of the viewpoint conveys a more varied knowledge, fresh vivid glimpses from this or that side. If you have ever tried to stand and bend your head so as to look back between your knees, with your face turned upside down, you will see the world in a totally different light. Try it on the beach: it is very funny to see people walking when you look at them upside down. They seem to be, with each step, disengaging their feet from the glue of gravitation, without losing their dignity. Well, this trick of changing the vista, of changing the prism and the viewpoint, can be compared to [James] Joyce's new literary technique, to the kind of new twist through which you see a greener grass, a fresher world."

VLADIMIR NABOKOV

9

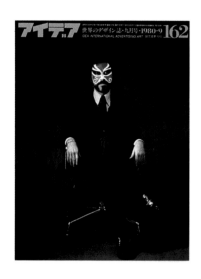

The simplest way to suggest a foreign ambience is to borrow an exotic image. To qualify as a true cross-cultural design, however, it is necessary for an image to be *transformed* in some way; to be appropriated and redefined. An image should be more than a quotation that gives a sense of local color. It must take on a new significance in the context. For example, a design that merely shows a native in traditional costume doesn't qualify as a restatement. We do not see the subject in a new way; that is, with psychological contrast. Picasso is reported to have said, "A mediocre artist borrows, a great artist steals." (And, I might add, reinvents.)

ABOVE *Cover design for* Idea *magazine, 1980. The Chinese opera makeup is a comment not only on a Westerner working in Asia, but on the designer as a type of public performer.*

RIGHT *Cover for* Hong Kong Artists of the Year Awards, *1990. The image is based on traditional images of Buddhist sacred objects. In this case the brush stands for the written and visual arts while the karaoke microphone represents the performing arts.*

OPPOSITE *Self Portrait poster, 1989. The portrait shown above was incorporated, along with other designs, into this photograph of a Chinese commercial artist (a spiritual ancestor of the designer) photographed working in Hong Kong in 1865 by John Thompson.*

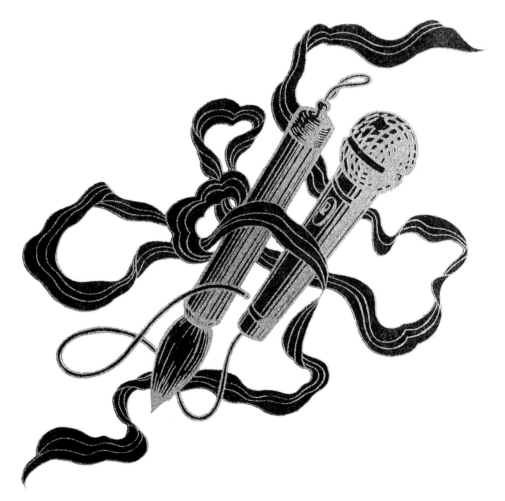

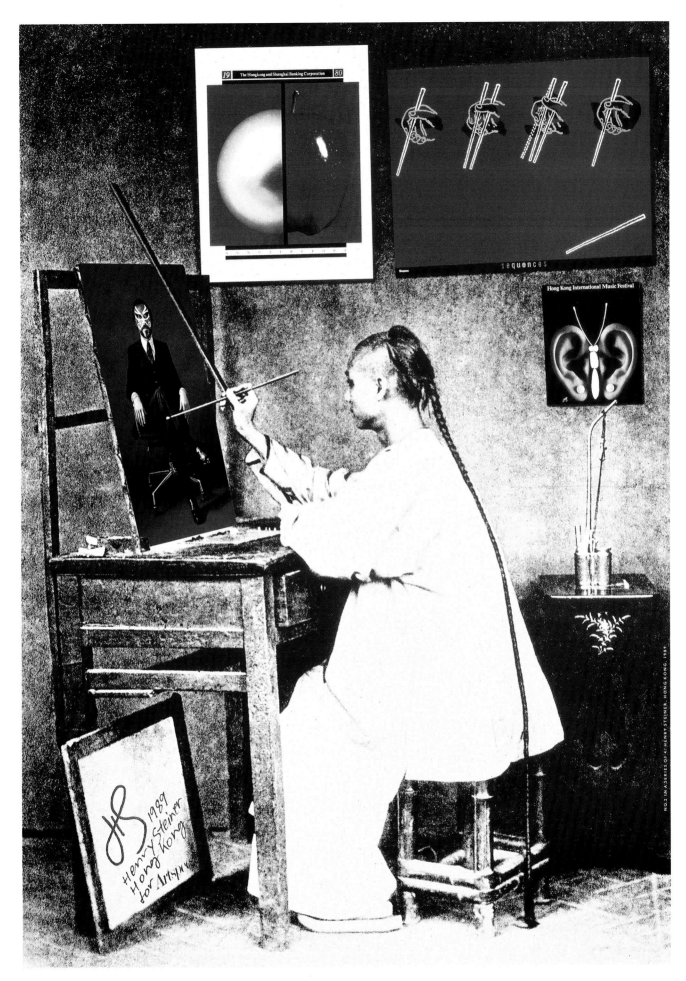

OPPOSITE TOP *The series of banknotes for the Standard Chartered Bank was first designed in 1978 and with minor revisions has been in use through the present. A new series was first issued in 1993 with the reverse modified to feature Hong Kong's official flower instead of the formerly used British armorial bearings; this move was intended to*

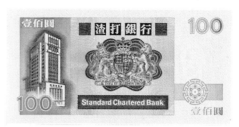

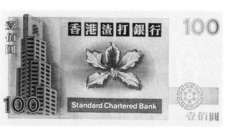

position the notes in a "post-colonial" mode. The mythical Chinese animals are arranged to form a natural hierarchy corresponding to the denominations – from aquatic to amphibious to terrestrial to celestial. A traditional legend has the carp turning into a dragon, giving the series a cyclical character. The most common identifying feature of paper money is a portrait, but due to Hong Kong's political sensitivity the animals were a diplomatic move and have proved an extremely popular design.

OPPOSITE BOTTOM *Set of postage stamps on the theme "Hong Kong Fishing Vessels," 1986. The transposition of scale of boats and fish gives these designs their interest. The fishing net pattern on the folder flap reinforces the theme.*

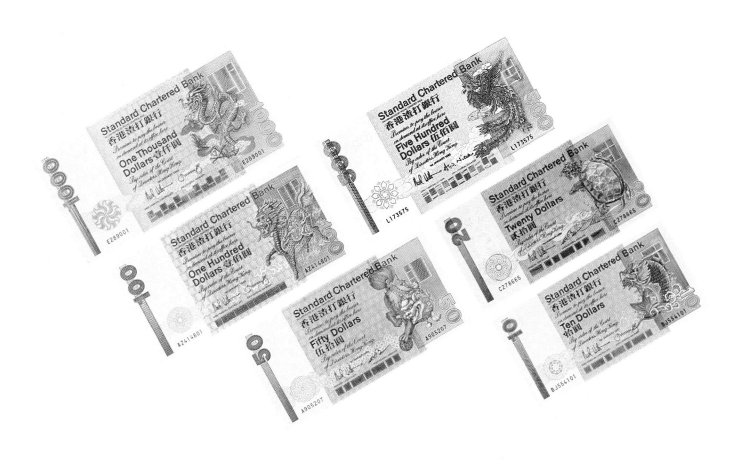

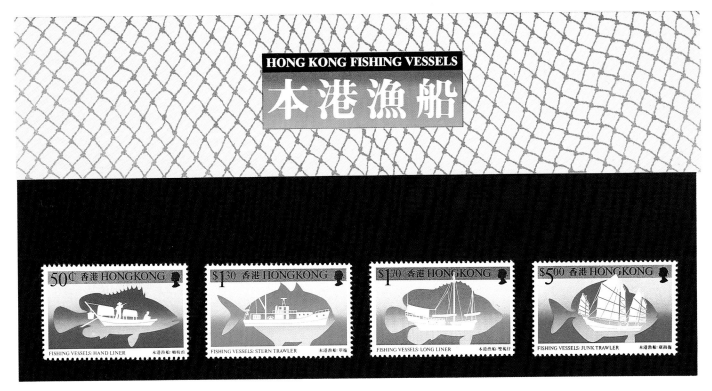

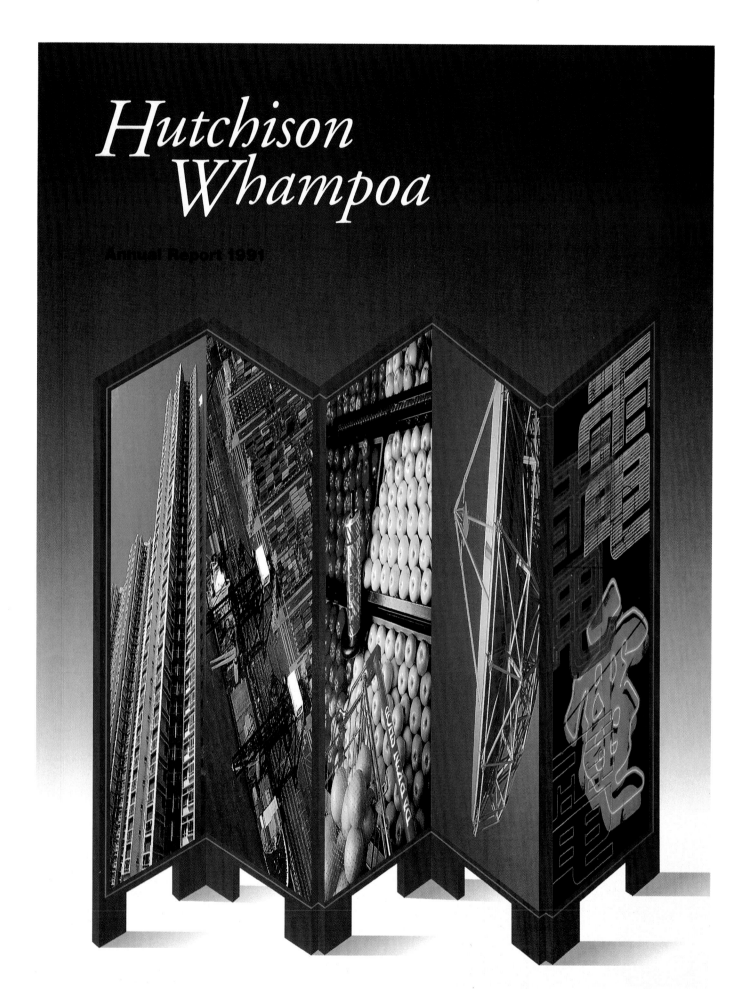

OPPOSITE *Annual report cover design, 1992. The traditional Chinese folding screen unifies the corporation's operating divisions, shown inside the five panels.*

ABOVE LEFT AND CENTER *Cover design derived from the 1920s Arrow Collar illustration. Combined with a woodblock portrait of Danjuro by Sharaku; the necktie design is the actor's* mon.

ABOVE RIGHT *Logotype and cover design for* Asiaweek, *1981. The color and imagery refer to the clash of Communist and Islamic ideology in Malaysia.*

RIGHT *The cover of the 1978 Hong Kong Telephone Company commercial directory is a still life of the sort of objects associated with a Chinese shopkeeper.*

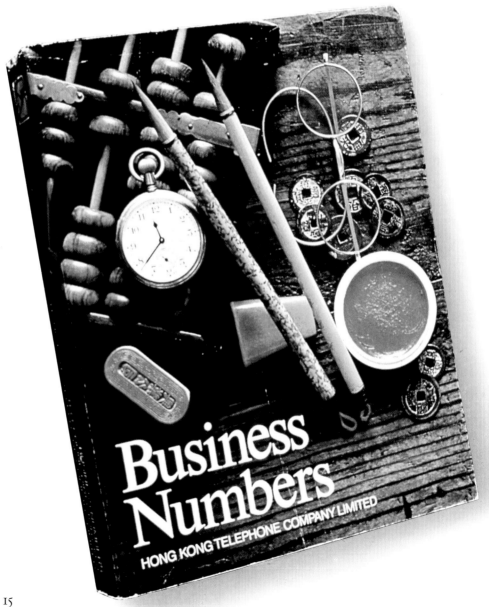

HENRY STEINER: EAST/WEST DESIGN DIALOGUES

First Asia/Pacific Design Conference Australia 1988 Mildura 31 July-2 August

Henry Steiner's participation is sponsored by Tomasetti Paper, Australia's leading paper merchant.

OPPOSITE *Poster, 1988, derived from an* ukiyo-e *composition by Utamaro (see page 39). The illustration is reproduced from a Ching dynasty book.*

RIGHT *Page from the 1987 book* Stars & Stripes; *designer Kit Hinrichs asked colleagues to reinterpret the American flag. This design, photographed directly from a computer display, shows an Asian Pac-Man in action.*

BELOW *Chopstix, 1986, poster on the theme* Sequences; *art director James Cross asked a series of designers to interpret the theme. The "readymade" artwork is taken directly from a chopstick wrapper and a fourth step has been added. The Chinese numbers 1 to 4 appear behind the hands. The palette (red, white, yellow, black, gold) is pure Chinatown.*

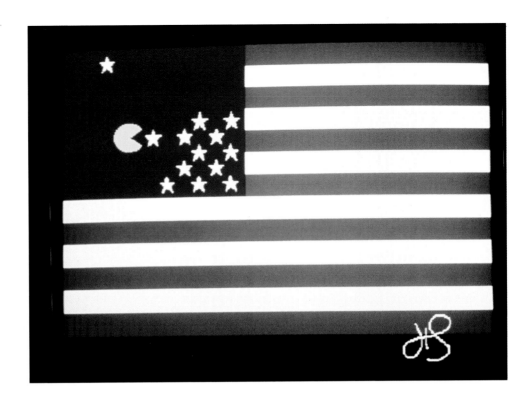

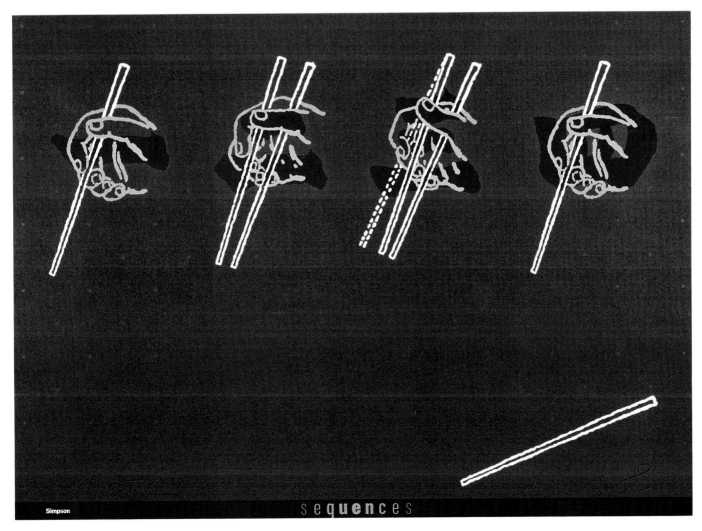

Simpson

sequences

BELOW *The enlarged detail from a woodblock print gives this book jacket the feel of a photographic close-up. The cartouche is based on principles used in titling ukiyo-e prints, especially the grading of colors (bokashi).*

RIGHT *Cover and inside of a moving announcement, 1981. Fortune cookies are not indigenous to China so this image seemed appropriate for a New Yorker in Hong Kong.*

OPPOSITE *The pixel portrait was incorporated into the Thompson photograph to create Self Portrait #2, 1992, used as a New Year's card. The paintings were in the original photograph.*

A moving announcement.

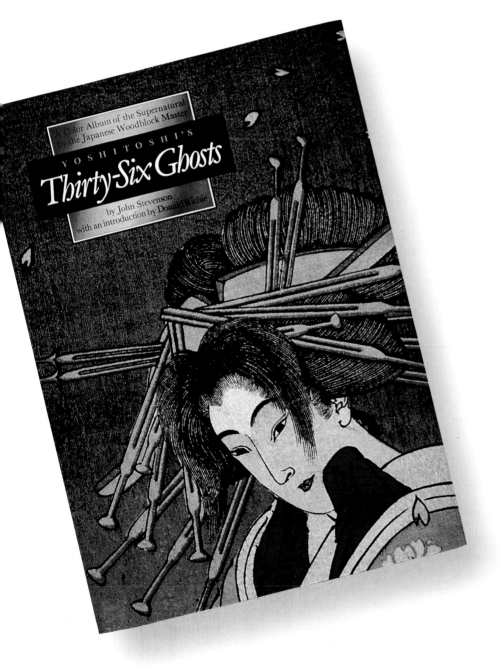

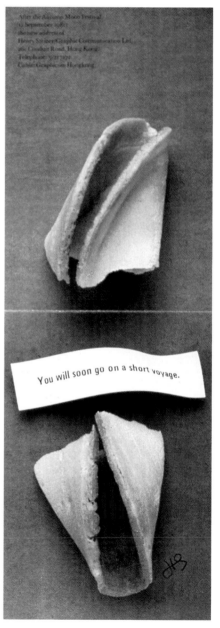

You will soon go on a short voyage.

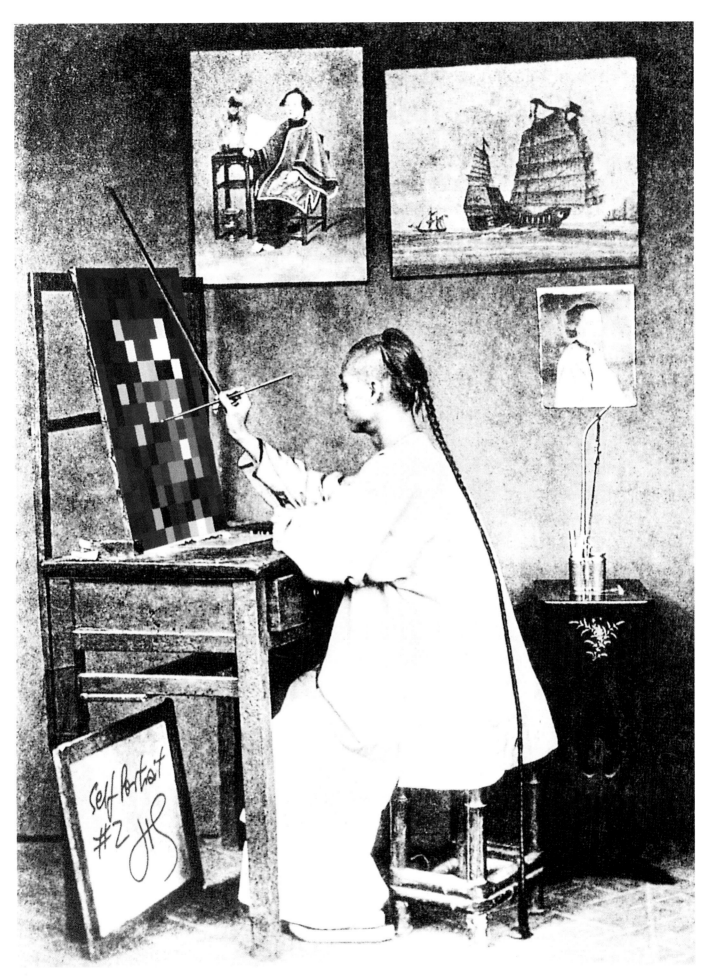

The inclusion of Chinese characters in a design conveys an immediate sense of exoticism. But the obligation to reinvent is as urgent in the use of foreign typography as it is with iconography. To make an impact requires the addition of ambiguity so that we are uncertain of the meaning not only of the alien language, but also of our own.

In a sense, all language is perceived as an image. English readers don't, for example, spell out the characters and syllables that form the word hippopotamus – they have a gestalt of the word stored in their memories that recognizes it as a whole. It is these preconceived word associations that can be subverted with foreign typography.

ABOVE *Design for the American Institute of Graphic Arts' 1974 Color exhibition allowed Europeans to "read" the names of colors in Chinese.*

RIGHT *Wordmark for a jeweller, 1972. The green letters reflect the jade color while the character itself, which looks like an E, is in Chinese ink black.*

OPPOSITE *Poster for the Japanese typesetting company, Morisawa, 1991. The white letters are debossed to suggest the stone engraving common to both systems. The Roman letters are from the book* Il Perfetto Scrittore *by Giovanni Francesco Gresci (Rome, 1570). The Chinese are from a Tang dynasty inscription by Liu Kung Chuan (841 AD) in the "Forest of Steles," Xian. The signature is colored and positioned in the manner of a Chinese seal.*

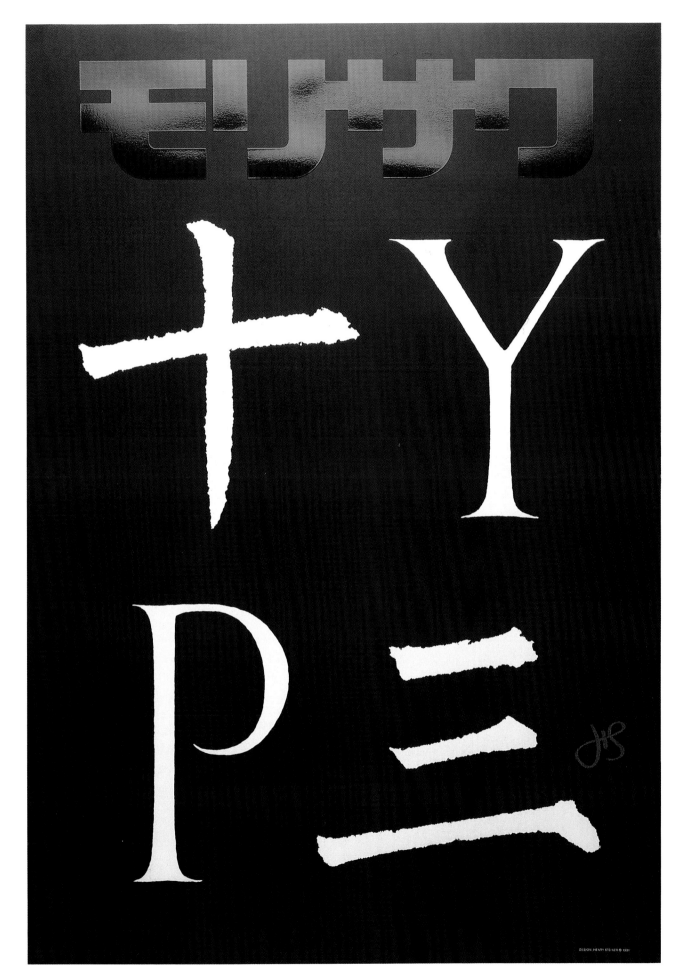

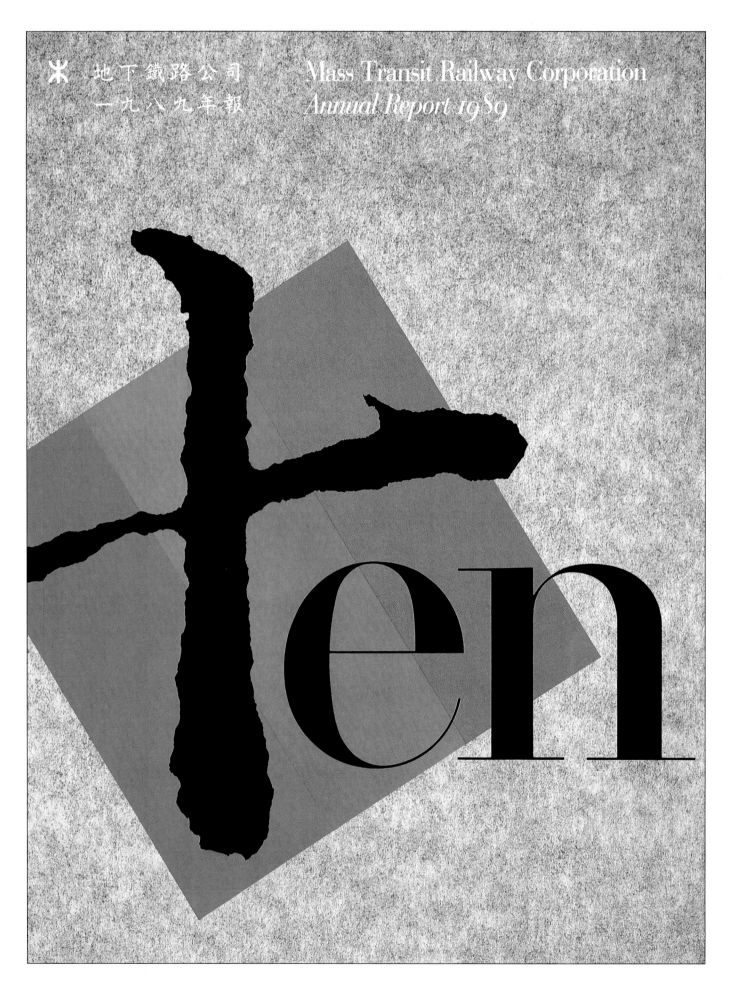

地下鐵路公司　Mass Transit Railway Corporation
一九八九年報　Annual Report 1989

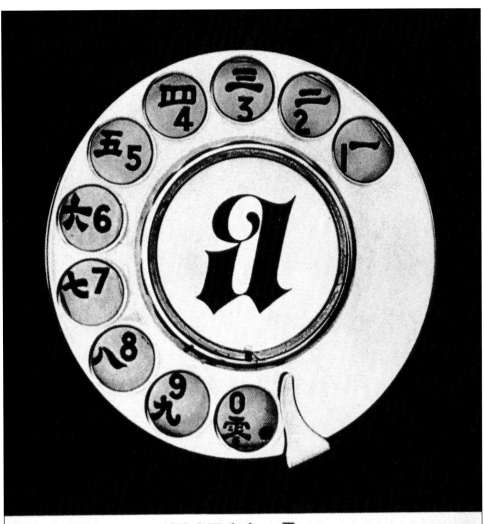

Dial 三六七一零

It's as easy as that to talk to 732,000 Asian families. Call up *The Asia Magazine's* Hong Kong headquarters (or any of its six advertising offices in Europe, Asia and North America) and place an advertisement in this new, text-and-picture magazine. Each Sunday *The Asia Magazine* goes directly into the homes of 732,000, English-reading able-to-buy Asians in 14 key markets — from Pakistan in the west to Japan in the east to Indonesia in the south. This is the biggest circulation, the broadest coverage, the deepest penetration you can buy in Asia. And at a cost-per-thousand readers one-third that of the next largest magazine. Give us a call; we have lots to talk about.

Hong Kong: 31 Queen's Road, Central, Hong Kong, Tel. 26710. **Tokyo:** 2 M Building, 1, 3-chome, Omote-machi, Akasaka, Minato-ku, Tokyo, Japan, Tel. (501) 9061-5. **New York:** 210, East 56th Street, New York 22, New York, U. S. A. Plaza 3-3921. **London:** 2 Old Bond St., London W. 1, England, HYDe Park 4188. **Frankfurt:** Am Leenhardabrunn 13, Frankfurt-am-Main, Germany Tel. 77-16-14. **The Asia Magazine** is distributed in Burma, Ceylon, Guam, Hong Kong, India, Indonesia, Japan, Korea, Malaya/Singapore, Okinawa, Pakistan, Philippines, Taiwan, Thailand, Vietnam.

星島報業有限公司 一九七二至七三年度年報

想像拾捌香港

園

香港般含道四十四號
至四十六號 將於一
九八一年十一月三十
日星期一公開拍賣

uston
44~46 Bonham Road
Hong Kong. To be
sold by Public Auction
on Monday the Thirtieth
of November 1981.

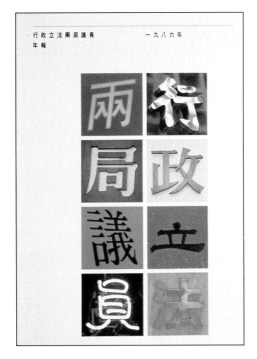

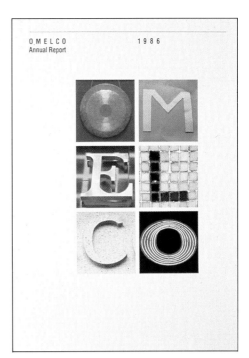

OPPOSITE CLOCKWISE *Annual report for a Hong Kong publishing company, 1973, the vertical title complements the stacked newspapers. Chopstick wrapper for a Champion Paper sales conference, 1972. Front and back covers for a 1981 property auction prospectus, the building was in Gothic Revival style and the Chinese matches the William Morris-style illuminated initial and typography.*

THIS PAGE CLOCKWISE *Chinese characters can be written vertically, allowing decorative arrangements unavailable with Latin letters. (The narrow wooden upright reads "Post no bills" and means it.) Photographs of lettering ("typography without type") on matching covers for a municipal annual report, 1986. Wordmark for the Yale Club of Hong Kong, 1988. The straight lines in Yale blue combine with authentic brush strokes from classic writing models. A New Year's card, 1991; the character for 'sheep' replaces the Y.*

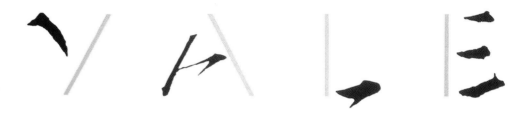

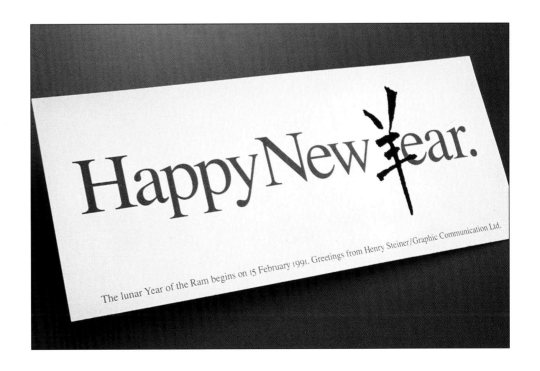

BELOW *Financial reports for Jardine Eastern Trust, 1971, with the word "east" in both Chinese and Arabic. The color changes allowed for ease of identification.*

RIGHT *Still printed in three flat colors, a later series of the same publication (1973) had the two languages layered, creating an additional color and a more interesting effect.*

OPPOSITE *Annual report for International Pacific Securities, 1975. Names of countries represented in the fund were cropped from relevant banknotes. I call this technique "Typography without Type"; a category of Readymade.*

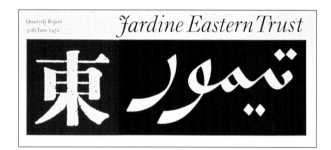

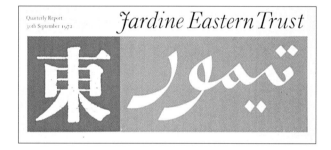

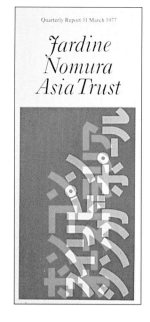

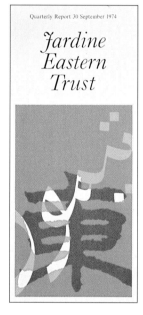

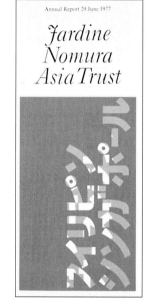

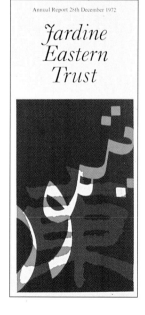

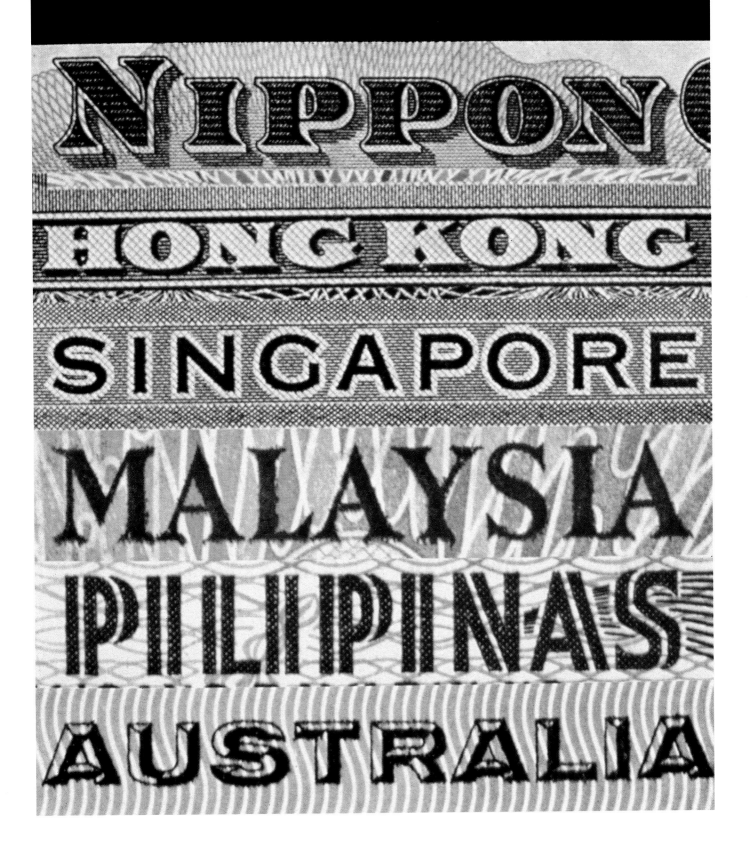

ABOVE AND RIGHT *Corporate identity for the Hong Kong Telephone Company, 1978. Besides a stylized* T, *the symbol is derived from a wooden noisemaker used in Chinese temples.*

OPPOSITE *Poster for a Hong Kong music festival, 1969. The ears take wing and the earrings stand for the "Pearl of the Orient."*

The examples shown in this category demonstrate a higher level of abstraction than those classified as *Iconography*. Here objects are transformed by being placed in an unexpected context. The term *displacement* is useful here to describe an image from one culture (Sir John Tenniel's White Rabbit, for example) representing – and commenting on – a concept in another (the Year of the Rabbit in the Chinese Zodiac).

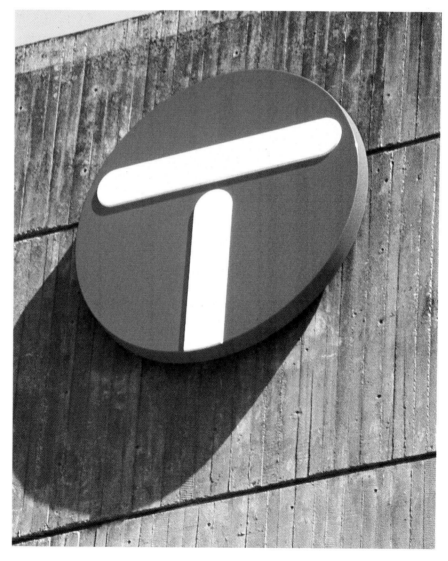

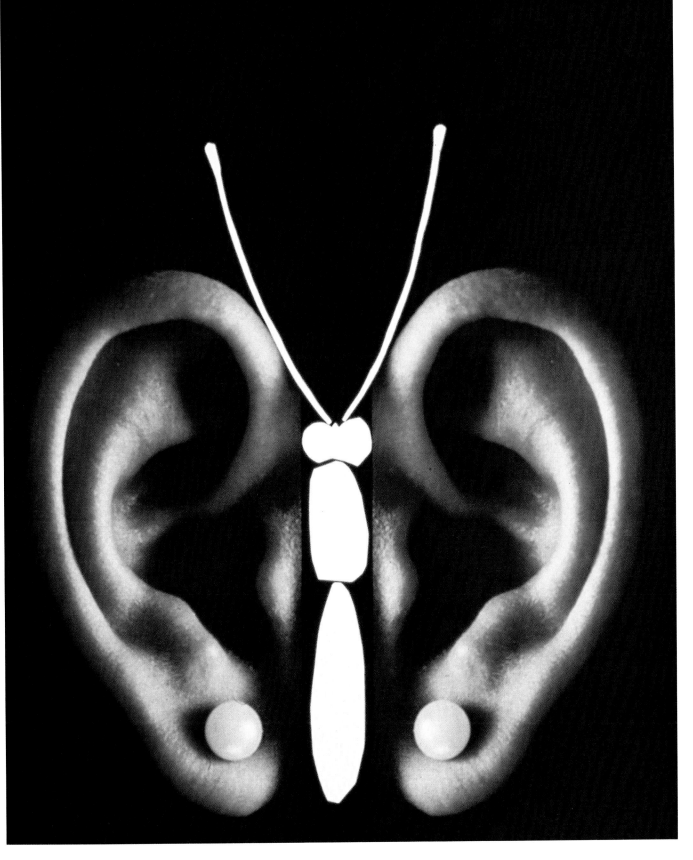

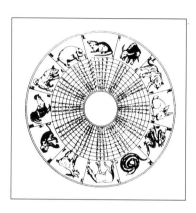

ABOVE *Traditional chart of the Chinese Zodiac reading clockwise from the Rat.*

OPPOSITE *Set of twelve stationery designs for successive years of the Chinese Zodiac, 1974-1986. For a dozen years, Graphic Communication Ltd. changed its corporate identity annually. Shown are: The Year of the Rat (Mickey Mouse's profile is in the cheese), Ox (whose horn becomes a cresent), Tiger, Rabbit, Dragon, Snake, Horse, Sheep, Monkey (the tail is a Chinese tailor's ruler), Chicken, Dog, the 'ear' of the Pig.*

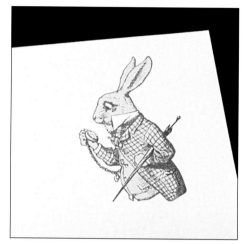

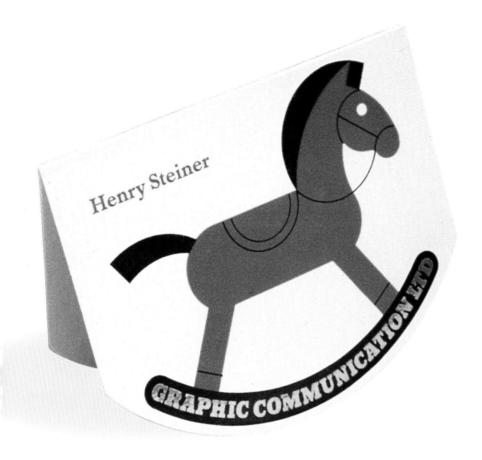

Henry Steiner

GRAPHIC COMMUNICATION LTD

fourth floor, 57 Connaught Road Central, Hong Kong
Telephone: 5-457777 cable: Graphicom Hongkong

TO COMMEMORATE
THE YEAR OF THE CANINE PERSON
25 January 1982 – 12 February 1983

5 JANUARY 1989

FarEasternEconomic REVIEW

CHINA-INDIA
Rajiv Goes Fence-Mending

PHILIPPINES
Soft-Sell from the Soviets

INDUSTRY
AIDS for Latex Producers

1989: Year of the Snake

where to put your money

-M. McKEEVER-

Local prices
Australia A$3.75
Bangladesh .. Taka 38
Brunei B$4.50
Burma .. Kyats 5.50
Canada C$4.50
China ... US$2.50
France Ffr 22
Holland G 8
Hongkong .. HK$20
India Rs 24
Indonesia . Rps 3000
Japan ¥ 660
Korea .. Won 2000
Laos US$2
Malaysia ... M$5.50
Nepal Rs 25
New Zealand NZ$4.50
Pakistan Rs 22
PNG .. Kina 2.50
Philippines .. P 30
Saudi Arabia SR 11
Singapore . S$4.50
Spain P 300
Sri Lanka .. Rs 45
Sweden .. SKr 25
Taiwan .. NT$90
Thailand . Baht 70
U.K. £2.40
U.S.A. .. US$3.50

OPPOSITE *Logo and cover design for a news weekly featuring the Year of the Snake, 1989. The illustration is based on the game 'Snakes and Ladders' and turns into a dollar sign.*

RIGHT *Book cover, 1965; Chinese painting cut into an arrow shape, suggesting escape. Booklet for a firm of chartered surveyors, 1978. An ivory hammer, used in British property auctions, is placed on a lease document from Shanghai.*

Lin Yutang

A suspense-filled novel about escape from China by the author of MOMENT IN PEKING

The Flight of the Innocents

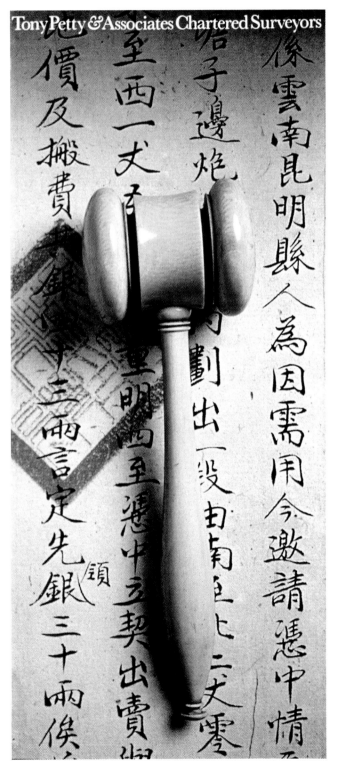

Tony Petty & Associates Chartered Surveyors

ABOVE *Illustration for a magazine cover, 1984. The prototypical American food joins a Hong Kong symbol, the Star Ferry.*

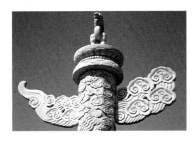

OPPOSITE TOP *Poster for recycled paper, 1992, showing a wooden plate rack protecting a cloud. The idea is derived from a painting by Magritte (top) while the imagery is inspired by a monumental column in Peking (above). The contrast and interplay of hard and soft has a profound Taoist resonance.*

OPPOSITE BOTTOM *One-off souvenir for an Italian-American colleague who left Hong Kong in 1973. The object is a complex visual pun; when it is spoken it sounds like* Chow Fan *(fried rice). A red thumbprint as an alternative to a seal impression is traditional.*

RIGHT *Booklet for a management consulting company based on the idea of indigenous Asian games, 1986. 'Rock, Scissors, Paper,' the most prevalent game of all, is shown on the cover represented by Chinese scissors, a Japanese paper, and an Indian 'lingam', or rock.*

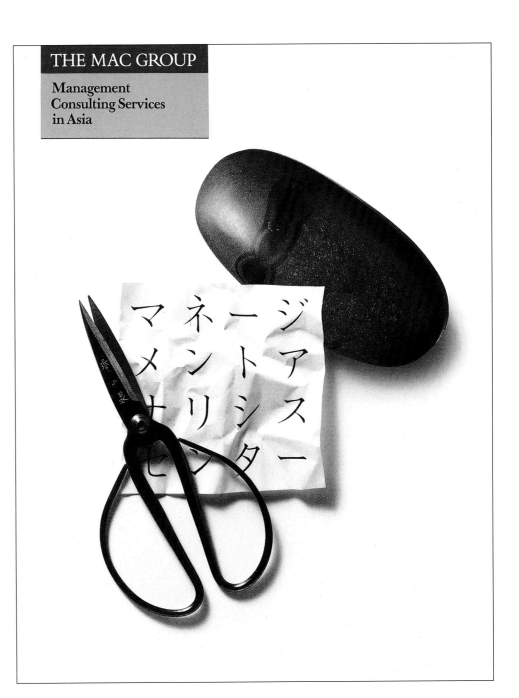

THE MAC GROUP

Management
Consulting Services
in Asia

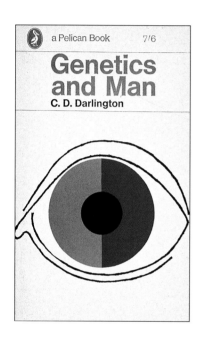

A dialectical technique, the split image is the most basic way of juxtaposing visual elements in order to achieve a synthesis. A new icon results from the combination of disparate elements. It can be perceived as a metaphor of the synergy resulting from the meeting of two cultures. Symbolically, the image echoes the interaction of the brain's hemispheres. For this procedure to be effective, the individual images combined must to some degree be incomplete while yet possessing a relationship or characteristic in common. "Rhyming" or paired images (as on page 41) can also be covered by this heading.

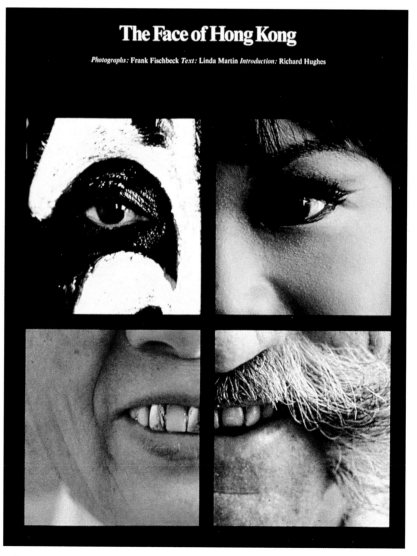

ABOVE *Although not depending on cross-cultural imagery, this 1966 cover for a book on heredity focuses on the common question: Will the baby's eyes be blue or brown?*

RIGHT *Quadruple split image allows a composite face reflecting Hong Kong's population on a book jacket, 1970.*

OPPOSITE *Cover for a 1991 Japanese design magazine inspired by the Taoist concept of Fung shui or "wind and water." The objects are a traditional Chinese geomancer's compass confronting a computer disk, with a wave and cloud background.*

IDEA

INTERNATIONAL
ADVERTISING
ART

アイデア

世界のデザイン誌・5月号
1991・5・誠文堂新光社

226

1991年5月1日発行・第39巻・第3号・通巻226号〈隔月1日発行〉ISSN0019-1299

Hong Kong at
Comis-Eurotricot

ABOVE *An ivory ball juxtaposed with a
ball of wool to create a symbol of Hong Kong's
participation in a German knitwear fair, 1972.*

RIGHT *The split image taken to an extreme
of scale on the cover of a 1989 booklet for
an Asian photo agency; the opera singer's eye
is contrasted with the eye of the typhoon,
reflecting the company's name as well as its
work.*

OPPOSITE CLOCKWISE *Perhaps the
prototypical split image in my work is this
house advertisement for a 1964 issue of*
The Asia Magazine *devoted to Eurasians;
the yellow skin and the blue eye blend in the
green type. Two house advertisements for a
1965 Chinese edition of* The Asia Magazine
*rely on the old/new device, in one case using
pictures, in the other combining the Chinese
characters for New and Old. Another 1964
example of the contrast of old/new, this case
uses Japanese imagery; its common thread is
girls regarding their reflections.*

Typhoon Pictures Ltd

*a new concept in
corporate photography*

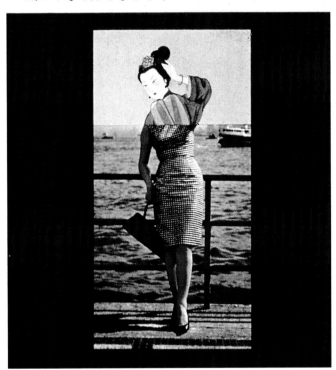

新舊的對比
香港是進步神速的社會,無論環境與人物都爭趨潮
流,亞洲週刊就是適應現代仕女需要的最新讀物.

A NEW LOOK AT THE EURASIANS
*A legacy of European rule, they once formed a people apart:
rejected by the West, unaccepted by the East. Today, this half
white minority is a vital element of Asian society, from
Calcutta to Tokyo. The Asia Magazine takes a new look at The
Eurasians in a theme-issue appearing November 22.*

時代不斷進步,事物新陳代謝,古舊的已成歷
史,面對的是新与進步,亞洲週刊就是代表新"
的讀物增加你新的智識,使你認識新的事物.

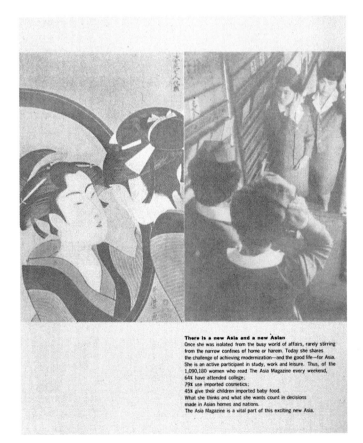

There is a new Asia and a new Asian
Once she was isolated from the busy world of affairs, rarely stirring
from the narrow confines of home or harem. Today she shares
the challenge of achieving modernization—and the good life—for Asia.
She is an active participant in study, work and leisure. Thus, of the
1,090,180 women who read The Asia Magazine every weekend,
64% have attended college;
79% use imported cosmetics;
45% give their children imported baby food.
What she thinks and what she wants count in decisions
made in Asian homes and nations.
The Asia Magazine is a vital part of this exciting new Asia.

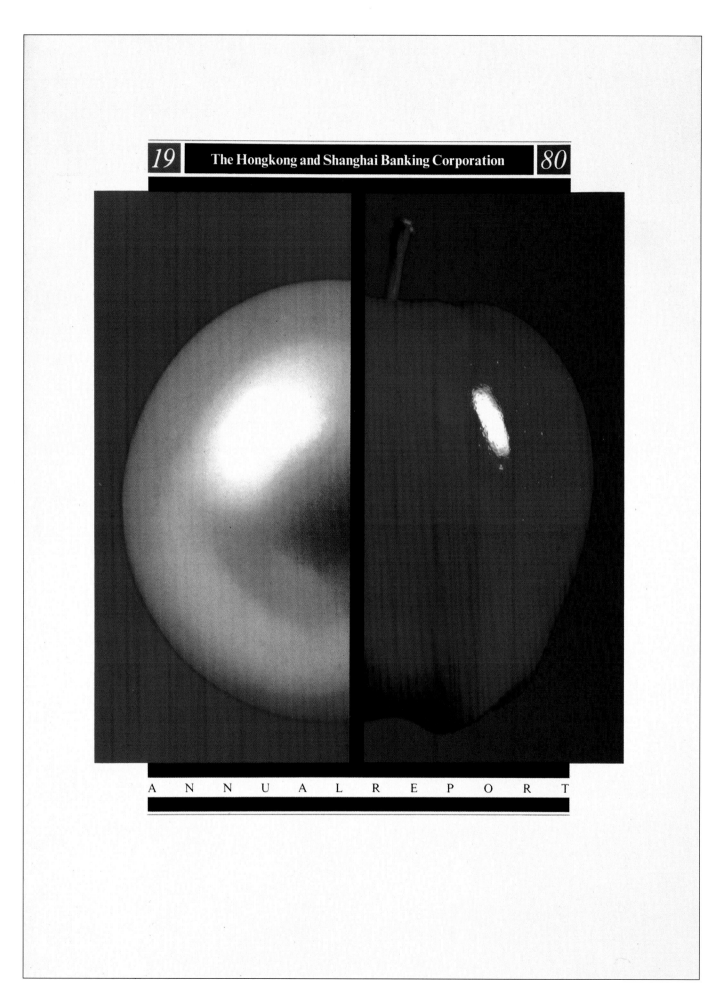

The Hongkong and Shanghai Banking Corporation

19 80

A N N U A L R E P O R T

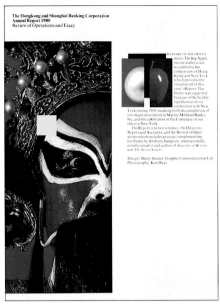

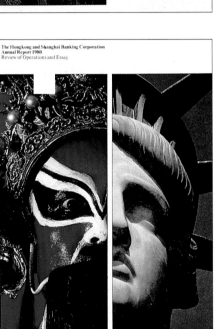

The Hongkong and Shanghai Banking Corporation
Annual Report 1980
Review of Operations and Essay

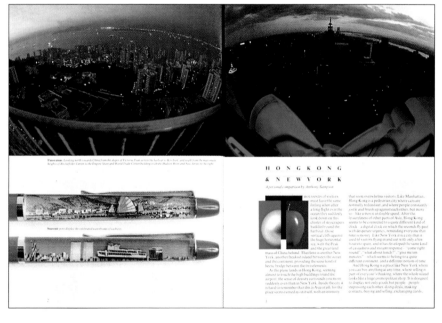

OPPOSITE *The Pearl of the Orient meets the Big Apple on the wallet cover of this 1980 annual report, concisely symbolizing the acquisition of a New York-based bank.*

THIS PAGE *The report books inside the wallet shown opposite extended the symbolism with, for example, a Chinese opera star confronting the Statue of Liberty and a series of "rhymed" photographs inside the reports where scenes from Hong Kong were matched with ones from New York.*

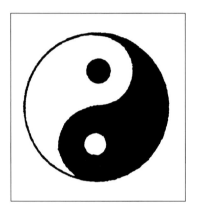

The term *ideograph* is usually applied to those Chinese characters that express ideas (for example, "big," 大), as opposed to *pictographs*, which represent objects (albeit in simplified form, like "field," 田). These concepts are perhaps the most abstract of all and condense several layers of meaning into an apparently simple image. Again, what gives these icons their bite is the felicitous and unexpected combination of two cultures.

A B O V E *Traditional Taoist "Tai Chi" symbol:* Yin *(dark, female) and* Yang *(bright, male); together these are the central universal forces.*

R I G H T A N D O P P O S I T E *Corporate identity for a Korean conglomerate, 1989. The name Ssangyong means 'twin dragons' and the logo combines the Korean double* S *with an echo of the two dragons and the yin/yang* tai chi *symbol.*

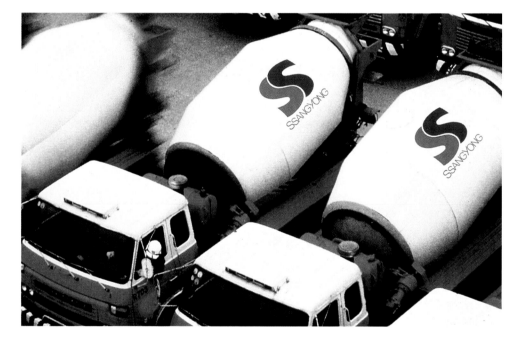

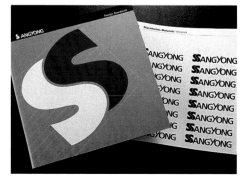

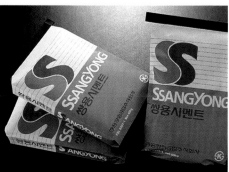

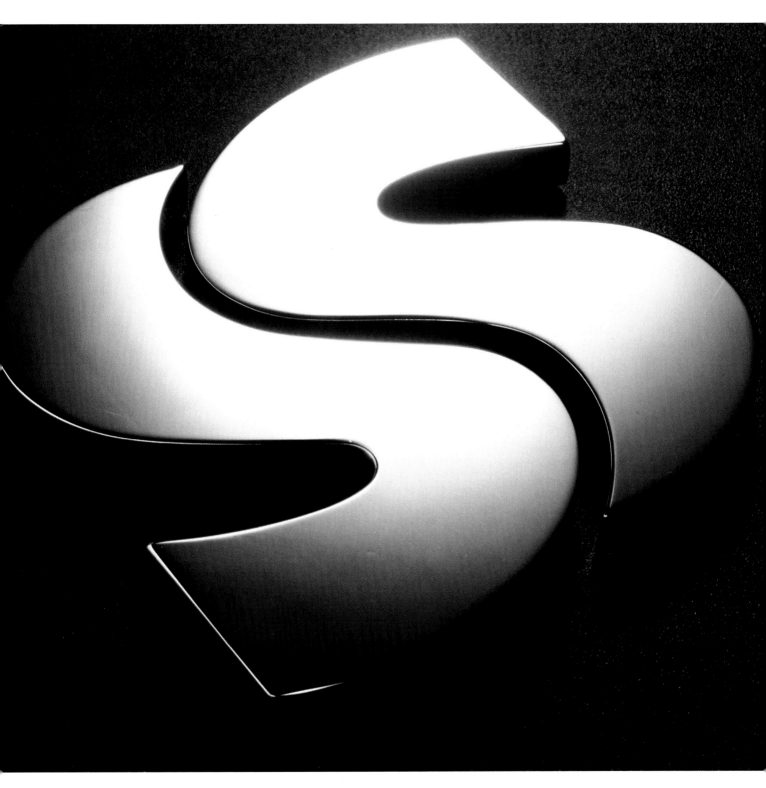

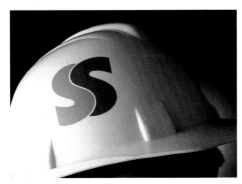

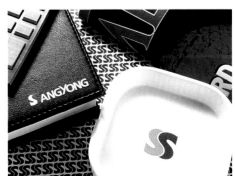

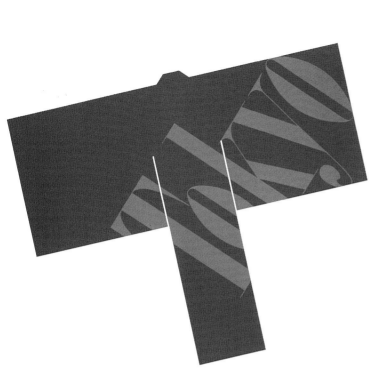

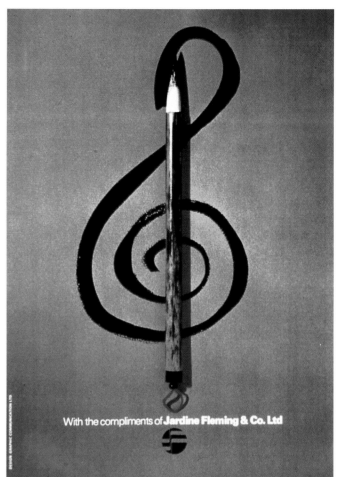

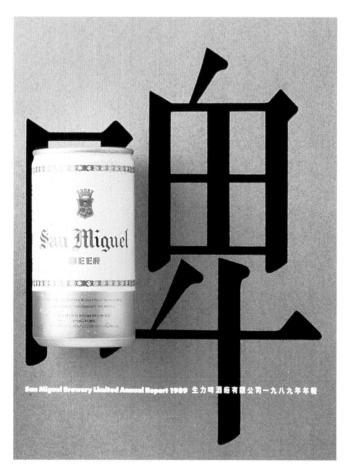

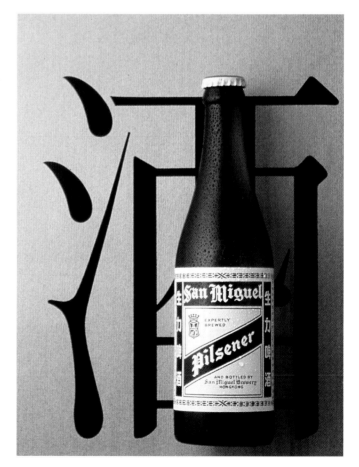

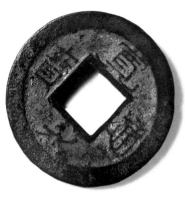

OPPOSITE CLOCKWISE *Printed keepsake for Alliance Graphique Internationale 1988 Congress in Tokyo; the kimono becomes a* T. *Advertisement in a concert program, 1969. Front and back annual report covers for a Hong Kong brewery, 1989; components of the two characters have been replaced by appropriate shapes – the can over the "mouth" radical and the bottle over the "jar" section of each.*

THIS PAGE TOP TO BOTTOM *Wordmark for a Japanese financial concern, 1989. The diamond shapes are the counters punched out of the traditional coin shape.*

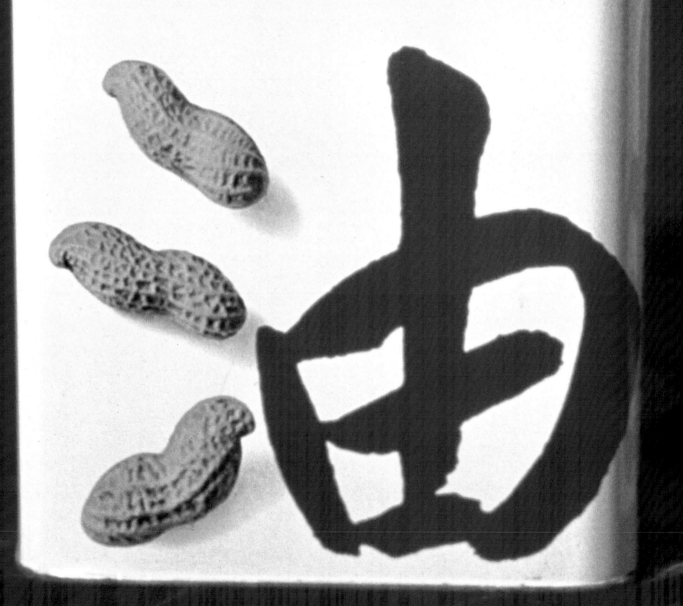
淘化大同公司花生油

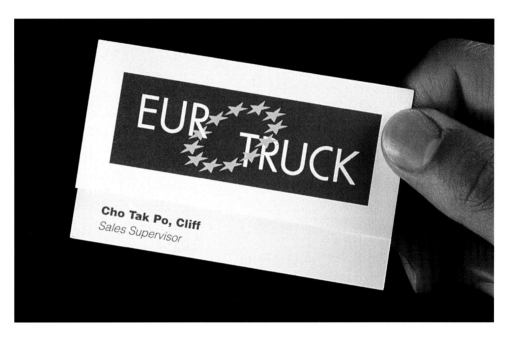

ABOVE AND OPPOSITE *Package for peanut oil, 1979. Many Chinese characters have radicals – aids to meaning or pronunciation. Here the "three drop" radical means "liquid," and when the strokes are replaced by peanuts the resulting image communicates its meaning immediately to any Chinese reader.*

RIGHT *Corporate identity, 1992, for EuroTruck, an automotive distributor. The European Community symbol can be read both as an O and as a wheel in motion.*

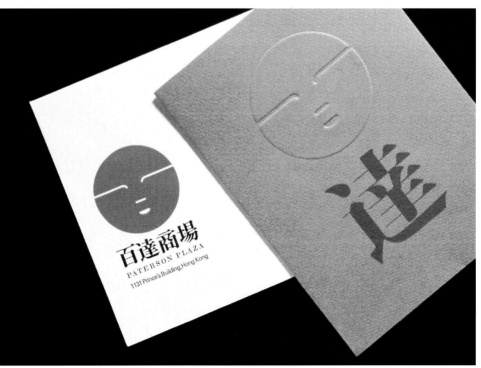

ABOVE AND RIGHT *Corporate identity for a shopping mall, 1979. The character bah means "100" and can be so thickened that it resembles a doll's face.*

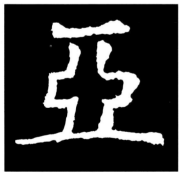

ABOVE *Chinese character* Ah *meaning "Asia."*

RIGHT *Corporate identity for the International Bank of Asia, 1982. The components of the ancient form of the character for Asia have been transposed to make an initial* I.

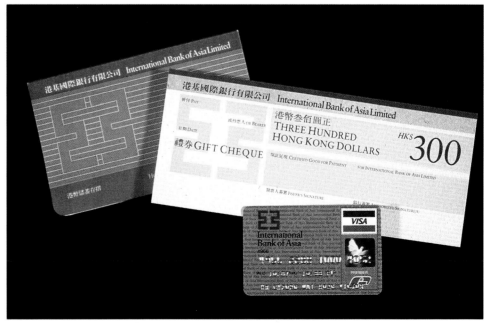

OPPOSITE *Corporate identity for a Hong Kong property company, 1968. The logo represents the* H *of Hongkong Land, and incorporates the Chinese character for longevity (see left) which is visible in the negative space of the logo and is appropriate to real estate. The design also resembles the floor plan of an office building.*

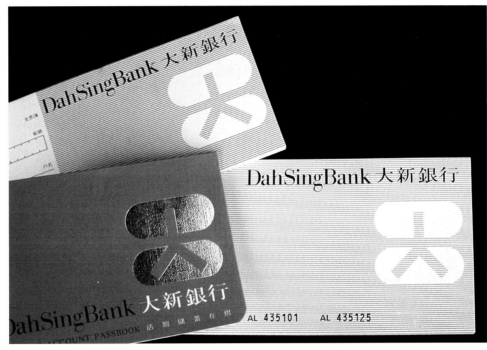

RIGHT *Corporate identity for a bank, 1980. The symbol is derived from the beads of an abacus, which contain in negative the character* dah, *meaning "big."*

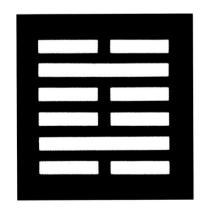

RIGHT *Corporate identity for the Hongkong Hilton, 1962. The double* H *logo resembles Chinese lattice work as well as one of the* I Ching *hexagram symbols.*

A Cross-Cultural Anthology

Anspach Grossman Portugal

United States

Country
Japan and worldwide

Design Director
Eugene J. Grossman

Sanyo

Sanyo wished to be seen as a diversified global corporation rather than as a purely Japanese company. They desired an identifier that did not rely on a separate symbol. Rather, they wanted a logotype within which a symbolic element was contained as well as a totally integrated visual system that would function worldwide. Because the company and its chairman were so focused on their mission, there were no setbacks on the project. Today, working in Japan is much easier than it was years ago because there are skilled interpreters and many Japanese speak English. From a cultural point of view, there *are* differences in the work ethic. For example, in Japan the hours are longer, the Japanese are sticklers for detail, and they deliberate excessively. The approval process is very different from that in the western world. Decisions are made from lower management levels and they work their way upward to the top, with each level endorsing a concept before it can progress. Yes, there are cultural differences, but they're not insurmountable. There is one goal that the Japanese share with us – quality. We learned to be patient, and we discovered how to negotiate in the early stages of drafting an agreement. Be prepared to give the client extraordinary service and exclusivity.

Sanyo identity
RIGHT *Logo*
OPPOSITE *Advertising signage*

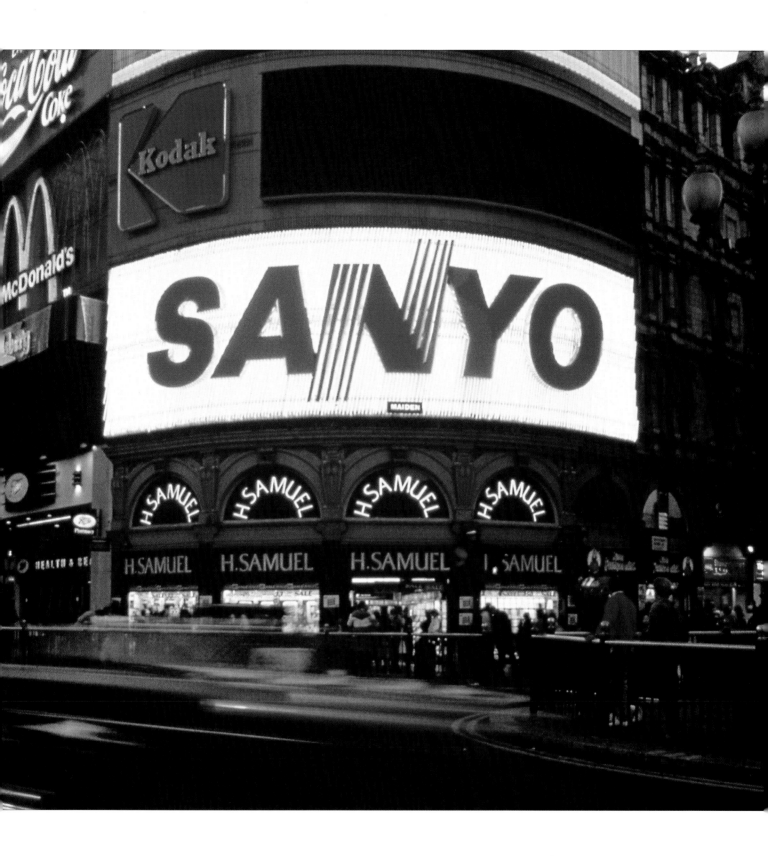

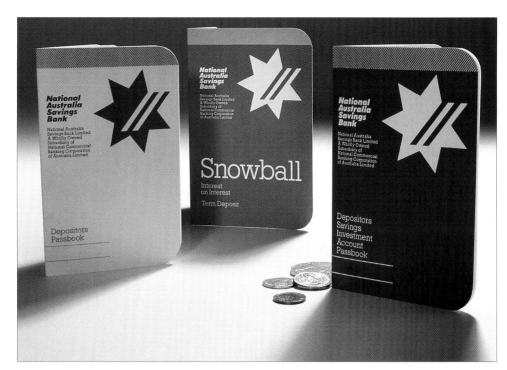

Country
Australia

Design Director
Eugene J. Grossman

National Australia Bank

Two major Australian banks merged into a single entity. A new name had to be created along with a new identifier for the bank. Additionally, a total identification system was required. At first we thought that the distance between the United States and Australia was a major concern (and this was before the fax machine). However, the program was probably one of the most efficient and smoothest we've ever done. The only major difficulty was the 27-hour flight to Melbourne. When we traveled to Australia we would usually stay for at least five days – this was quite efficient and served the client well. Of course, Australians speak English, so there's no real problem in communicating. Occasionally, however, their dialect can get confusing. Australians are very "buttoned up," and although they are quite demanding, they are exceptionally pleasant to work with. Regardless of the geographic distance between us, they expected top service. My advice to someone working between the United States and Australia is to beat the jet lag by falling into the daily time frame. Don't go to sleep when you arrive but at the appropriate local time. Also the oysters are excellent. Try them.

Country
Japan

Design Director
Eugene J. Grossman

ABOVE *Logo in English and Japanese*
RIGHT *Bank cards*

Mitsubishi Bank

The assignment was to create a more friendly and contemporary image for their retail banking customers. The project involved both graphic and environmental design work, dealing with Mitsubishi's 385 branches throughout Japan.

In Japan, for the most part, personal banking is done by women. Also, rather than queuing up for a banking transaction, people are seated until their transactions are completed. Special service banking functions, too, are transacted at a counter with seating arrangements, and all bank personnel work behind the counter. This requires a totally different design structure for a typical banking environment. Of particular importance in this project was the need for a bilingual treatment of the bank's identification elements as well as for general information. Working with Japanese characters (*Kanji, Hiragana,* and *Katakana*) is something to get used to. The typographic elements are very different than those used for Western characters.

The Japanese people are diligent and extremely hard working. They expect a lot of their consultants and make rather heavy demands upon them. They are, however, pleasant and grateful for your efforts. They enjoy recreation after working hours, and drinking and dinner can run fairly late. You have to be geared up to this routine. It's all part of their "workaholic" process. The Japanese are quite demanding of your time and attention and, to some degree, want to have your services exclusively to themselves. Be prepared to eat classic Japanese foods; they're very different from those available in Japanese restaurants in the United States.

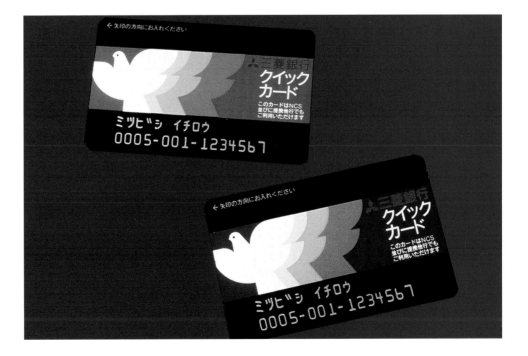

DEA Mineraloel AG identity
RIGHT *Credit card*
BELOW LEFT AND RIGHT *Applications*
BOTTOM *Signage*
OPPOSITE *Package design*

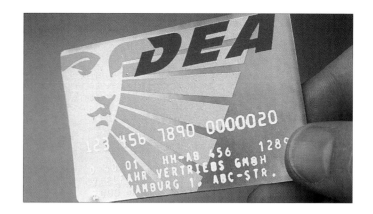

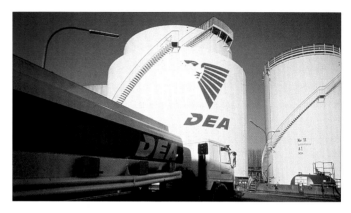

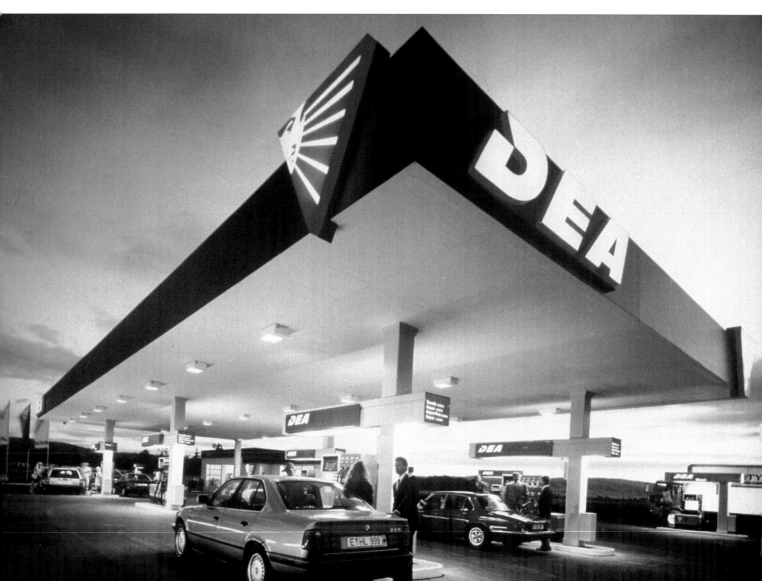

Country
Germany

Design Director
Kenneth D. Love

Designers
Vern Ford, Heather Wiedlant

DEA Mineraloel AG

Texaco Europe sold its German petroleum division (Deutsche Texaco AG) to RWE, the seventh largest corporation in the then Federal Republic of Germany. A new corporate name and brand identity was required. Based on the original name, Deutsche Erdol Aktiengesellschaft which was used by the company in the 1950s, we created the DEA brand. In Latin DEA means "goddess," a protective image that led to the visual symbology representing the friendly, service-oriented positioning of the new petroleum brand.

The client was extremely well organized and results-oriented, making problems minuscule. Because of their enthusiasm it was one of the most productive client relationships ever encountered by Anspach Grossman Portugal.

The Germans respect strong, consistent imagery and value service. These traits suggested the type of identity required for the new DEA brand. The firm's managers are noted for their organizational skills, emphasis on systems, and logical decision-making processes. They also rely heavily on research. To be successful in Germany, designers must employ an analytical approach to problem solving. It's also best to schedule periodic reviews in order to create a participatory client experience. German clients prefer no surprises. The most positive aspect about German clients is that once the design concept is approved, a well executed and thoroughly implemented program is guaranteed. After the plan for DEA was created and approved, the company immediately changed its design at all service locations. The DEA identity guidelines is a comprehensive treatise with every detail specified – nothing is left to chance. The year the program was introduced, petroleum sales increased significantly (it has become the leading brand in Germany) and the design and advertising program won an Effie, the highest creative award in Germany.

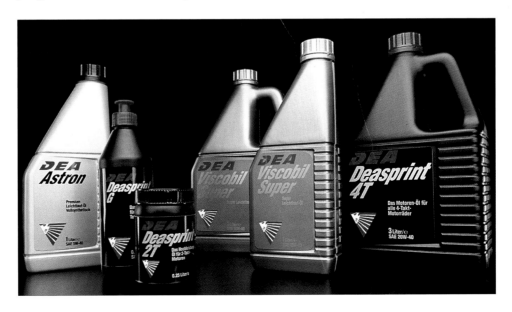

Backer Spielvogel Bates Ltd
Hong Kong

Country
Hong Kong

Design Directors/Writers
Andy Lish, Rowan Chanen,
Mike Fromowitz

Illustrator
Mr Hui

English Language Campaign

English language usage in Hong Kong is declining, but if Hong Kong is to keep its place as one of the world's leading business centers, it must communicate with the rest of the world in the language that most of the world uses for business – English. The ads use a visual device where English turns to Chinese (and vice-versa), showing that if you don't use English you may not understand others – and they may not understand you.

THIS PAGE AND OPPOSITE
*Newspaper and magazine
advertising campaigns*

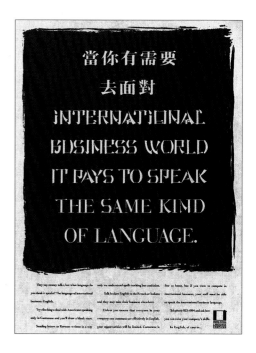

IN YEARS TO COME, WILL YOUR COMPANY LOSE THE ABILITY TO TALK TO THE 遍佈世界上 的其他商業地區?

English is the language of international business. Fact. The ability to speak it and write it is an essential skill the world over.

Sadly, however, it's one that Hong Kong has let slide. Already, English radio broadcasts have been axed and television is under threat.

Recent reports suggest our schools are turning out thousands of students who are inarticulate in English. There's a fair chance the skills of your *own* staff have also begun to fall.

Left unchecked, this could well impair your performance. Lucrative orders could be lost by a poorly answered phone call or a badly written letter. With the wrong word here or there, deals may come unstuck. Misunderstanding could cost you dearly.

English is *essential*: don't lose it. Call 822-4994 and find out how to keep talking business with the world.

HONG KONG
LANGUAGE
CAMPAIGN

Saul Bass

United States

Country
Japan

Design Director
Saul Bass

Kosé

Kosé is a major Japanese cosmetics company, which means they are in the beauty business. For a Western client, we'd probably have taken a reasonably literal approach. That is, we would have dealt with accessible metaphors for femininity. But what makes working in Japan fun is that some Japanese clients have an appreciation for ideas that are more subtle and transcend the literal. And this allowed us to deal with a less conventional, classical definition of beauty.

Kose identity
ABOVE *Logo*
RIGHT *TV tags*

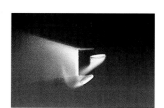

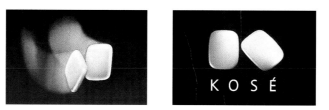

Minami identity

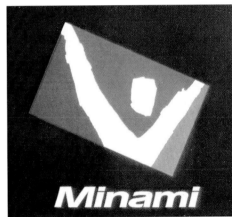

Country
Japan

Design Director
Saul Bass

Minami

Minami is in the retail sporting goods business. Rather than focus on the products they sell, we chose to capture the feelings that participating in sports can create – emotional release and exhilaration.

Maeda identity and
environmental graphics
RIGHT *Application on hard hat*
BELOW *Logo*

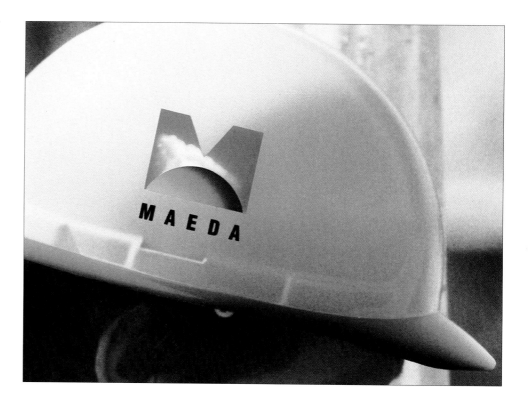

MAEDA

Maeda

In Japan, new construction sites are draped in a sort of gigantic protective netting. The density of urban construction has created the need for a more elaborate barrier to protect the environment from dirt and debris than we see in other parts of the world. We saw an opportunity to use this barrier as a form of media. In fact, it is Maeda's primary media, since they do little advertising. The trademark, which is primarily expressed on the construction site barrier, signals their concern for and sensitivity to environmental issues.

Cato Design Inc
Australia

Country
International

International Biennale Poster Exhibition

The brief for this project was open-ended. The organizers asked designers from 22 countries to create posters portraying the theme "America Today." The exhibition was to take place in Mexico City as part of the International Biennale in December of 1992.

The subject of the poster was to be a view of America on the occasion of the 500th anniversary of the arrival of Christopher Columbus in the Americas.

My response to the brief was based on what I had grown up to understand of America – that is, everything is larger than life.

The headline from "America Today" was not only the inspiration, but a large part of the artwork.

RIGHT *"America Today" poster*

Europacific Marketing Communications

Working with other nationalities has always been a great thrill, and the opportunity to work with my first Russian client was even more so.

Europacific Communications was the exclusive representative of the official Soviet Trade Promotion Organization, Sovero/Vneshtogreklama. In this capacity they are working closely together to facilitate overseas trade and investment among the countries of the former USSR and the Asia-Pacific region.

Both Europacific and Sovero are structured to offer hands-on assistance from qualified sources. They attempt to cut out unnecessary red tape and promote direct contact among potential customers, investors, suppliers, and joint venture partners.

The difficulties in this project were many. We had to deal with a Soviet view of Asia, a language barrier, and a client experiencing the difficulties of setting up a business in a multinational environment, where most of the culture was completely foreign.

Despite carefully negotiating and contracting the work, getting payments to flow between Moscow, Malaysia, and Australia proved to be very difficult. The design process was the easy part of the project; collecting the money was a completely different thing.

Chang Ho

Chang Ho Fibre Finish Ind. Co. Ltd. was our first project in Taiwan. Our task was to create a visual identity for a corporation that produces artificial fiber products and technology.

Having worked in Asia for nearly twenty years, we know that English words may not have the same meaning once they are translated into Chinese, so care with the language was of utmost importance.

The identity which we developed was heavily influenced by the Chinese character in our client's name, which translates as a combination of the sun and long life. The sun form was obvious, as was the circle, indicating an uninterrupted life.

Quite often, design programs such as this one have a very satisfactory beginning. The concept and development are embraced with great enthusiasm. But, when it comes to implementation, the difficulties begin. Often, the client's willingness to follow through is not reflected in the budgets.

This is a case of a highly professional company, with international vision and goals that must be educated about the role of design and identity; a company that does not yet understand how to implement the program, and how much that implemention will cost.

C'est la Vie

This is probably the most enlightened and exciting client I have encountered in the many years I've worked in Asia.

C'est la Vie's President, Masahiro Tsukita, is a man of vision. C'est la Vie, which builds great buildings and very expensive houses, is very sensitive to the relationship between the architectural structures they build and the people who use them.

Initially our communication was most difficult. We had a Japanese client, an English speaking designer, and a company with a French name whose owner had a great love for classic Italian style. What made this project special was an almost instant mutual understanding and respect.

In developing the identity, a very simple theme, the square, was explored. By cutting and moving sections of the square – the simplest architectural form – we were able to create different architectural statements. Taking this one step further and incorporating the use of the Chinese Tangram puzzle, we were able to use the seven geometric forms in different arrangements, so taking the total building, or square, and translating this into the shape of the people who use it.

It is true to say that the whole corporate identity for C'est la Vie evolved very much from within their own philosophy – people and their relationship with space. This was a true reflection of the company and its aspirations, and showed the company's inspiration and its ability to create a "renaissance" in Japanese architecture by incorporating the best principles and materials from other cultures.

THIS PAGE *Identity application and signage*
OPPOSITE *Product design and packaging*

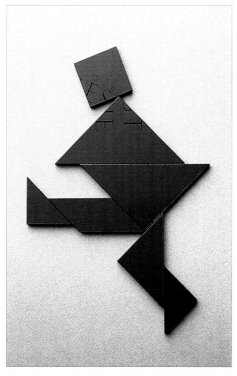

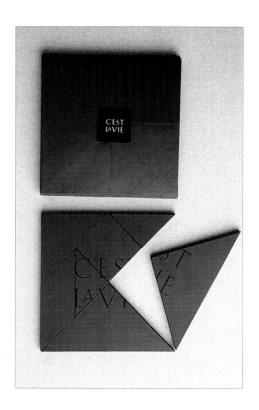

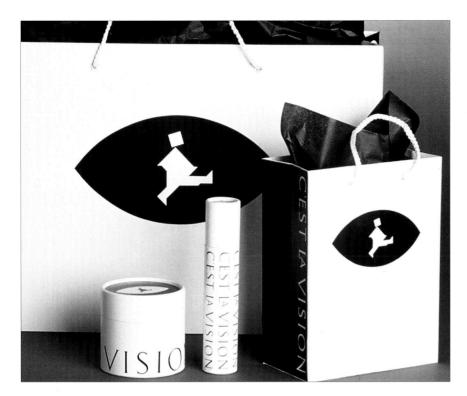

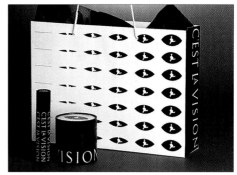

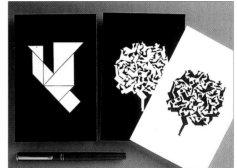

Further opportunities developed with this client. Using lateral thinking, the client decided to utilize the style of his building company and create a line of products to sell through his own stores. The name "C'est la Vie" was born, coming out of the owner's insight into what he wanted to achieve and the market that was available to him.

Through this, we extended the design program into various products that incorporated the imagery of the Tangram and other expressions of the company's basic identity.

Projects or clients like this one, with a totally different thinking process, don't come along every day, either in one's own country or in a foreign country.

As a general comment, working in Asia has required "different" thinking and this in turn, I believe, has developed creativity. In the past, Asia has been viewed as one entity. Having worked there over the last 20 years, we have come to understand that each nationality within Asia is different, each piece of land is different, each government is different, religious beliefs vary, and the meaning of color and symbols vary extensively.

When people suggest that I have an understanding of Asia, all I can say in response is that I acknowledge the differences and continue to try and learn more about the enormous complexity of the region.

Chermayeff & Geismar Inc
United States

Country
International

Design Director
Ivan Chermayeff

International Business Machines

Postage stamps, money, seeds, postcards, and other objects from the countries in which IBM operates. Modular system of assemblages.

IBM World Trade HQ
THIS PAGE AND OPPOSITE
Mural assemblages

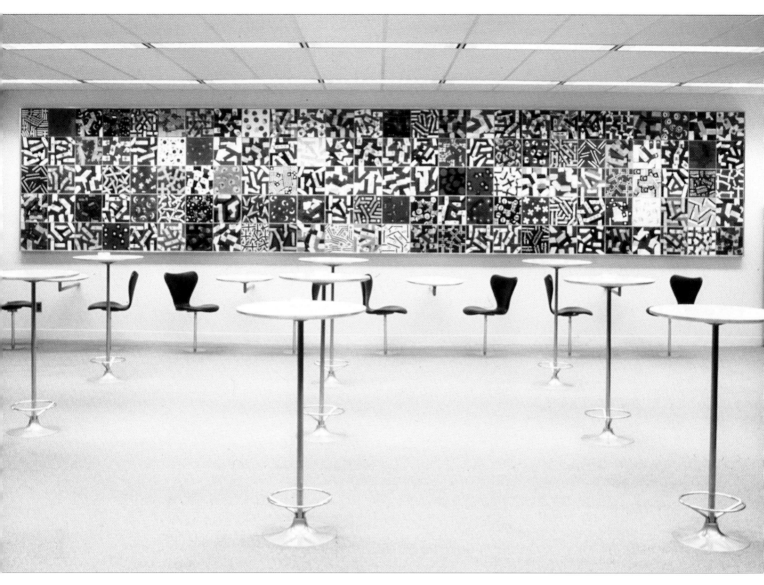

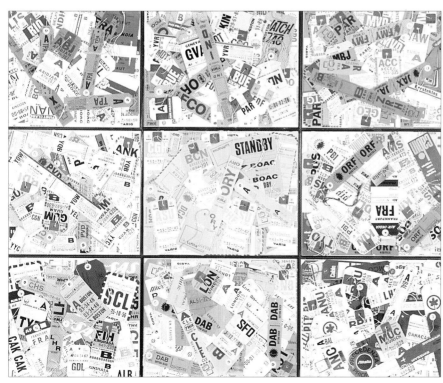

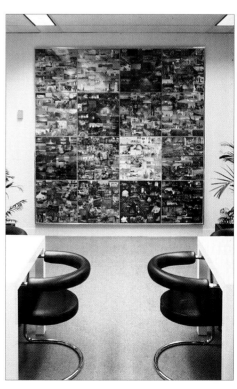

Country
Japan

Design Director
Ivan Chermayeff

Tempozan/Ring of Fire

The Ring of Fire is a symbol for the volcanic marine habitats surrounding the tectonic plate of the Pacific. The center is the open Pacific. The idea is abstracted into a graphic form that the Japanese audience is quite used to understanding.

海遊館ザ・パシフィック
OSAKA AQUARIUM
RING OF FIRE

Tempozan/ Ring of Fire Aquarium
THIS PAGE CLOCKWISE
"Ring of Fire" logo, signage, wall mural
OPPOSITE PAGE CLOCKWISE
Tempozan Marketplace logo, Tempozan Marketplace flag designs, wall murals

CHERMAYEFF &
GEISMAR INC.

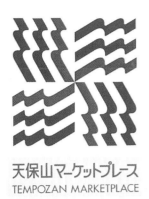

天保山マーケットプレース
TEMPOZAN MARKETPLACE

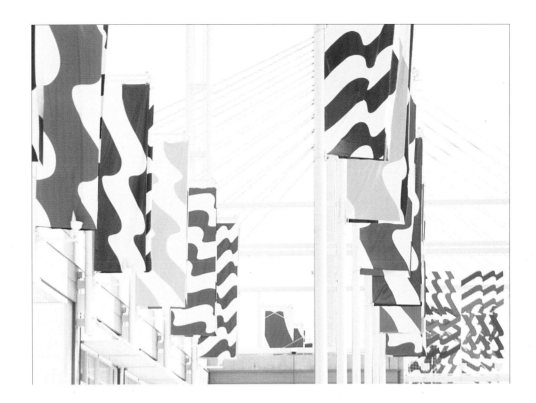

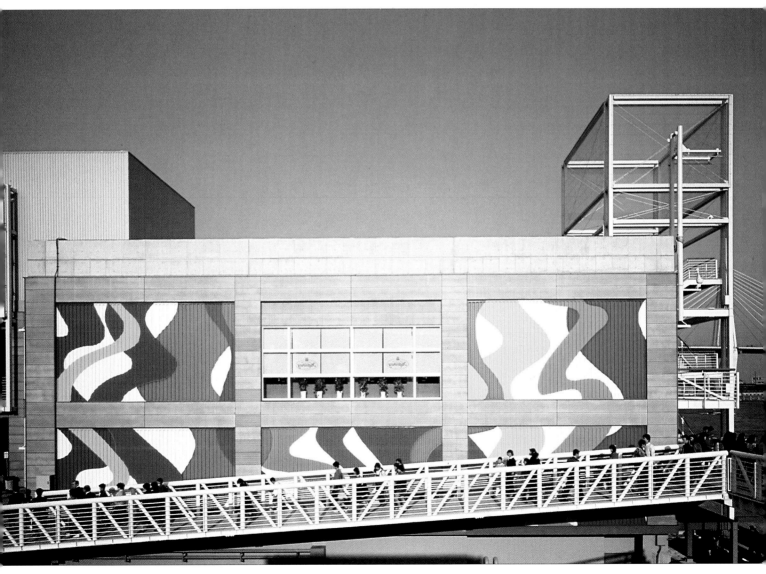

Pino Ice Cream identity
RIGHT *Package design*
CENTER *Logo*
BOTTOM *Corporate literature*

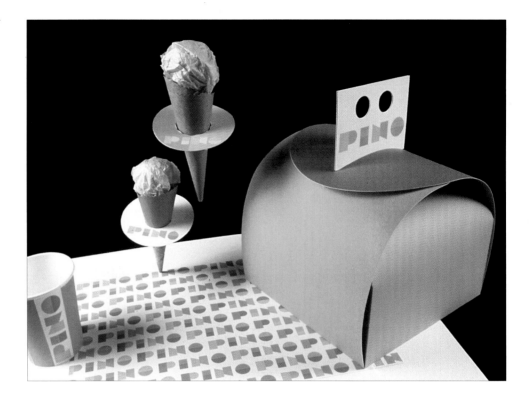

Country
Italy

Design Director
Ivan Chermayeff

Designer
Piera Grandesso

Pino

In Bologna and other Italian cities, Pino evolved as a wordmark derived from a common nickname. The colors used are spumoni colors, familiar and edible. Design is universal; the cultural and language barriers slowed up communications during the evolution of the design only minimally.

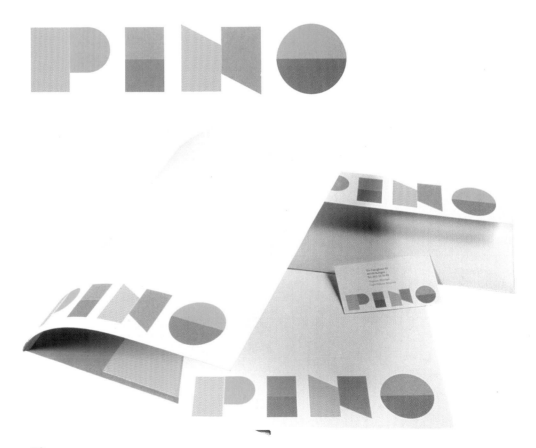

Country
Argentina/South America

Design Director
Steff Geissbuhler

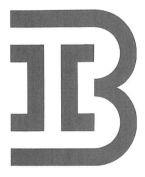

Banco de Italia identity
RIGHT CLOCKWISE *Stationery, corporate literature, signage*

Banco de Italia

We were commissioned to create a corporate identity for the area's largest privately owned bank, the "Banco de Italia y Rio de la Plata." (The name of the bank has nothing to do with Italy.) Only primitive typography, typestyles, and printing techniques were available. Some specifications included:

1. Simplify the name
2. Emphasize the word "bank"
3. Create a strong identity

Our solution was to create a strong, simple logotype with the letters B and I, emphasizing the B for Banking. We used hand-drawn lettering for the shortened name to avoid resetting it using the bad type that was available. We created and wrote very simple and basic guidelines in Spanish for the design's implementation. The idea of a system and guidelines was completely foreign to the bank – only with the help of an architect in Buenos Aires were we able to communicate the idea's importance! Only when the bank opened an office in New York could we actually see some of the implementation. It is important to work with the limited resources that are available rather than producing a more sophisticated design that cannot be implemented properly.

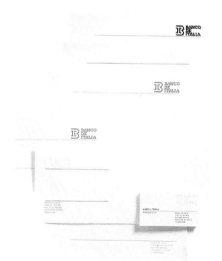
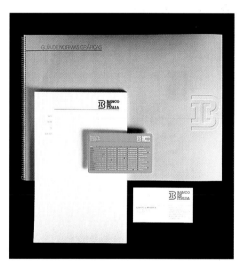

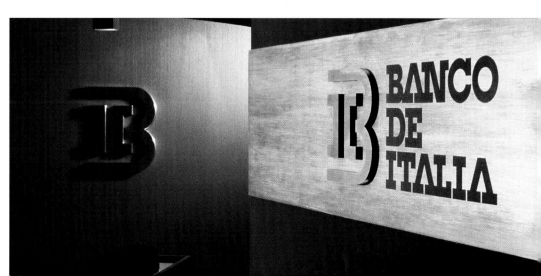

Country
India

Design Director
Ivan Chermayeff

Calico 100
RIGHT *Textile design*
BELOW LEFT *Annual report*
BELOW RIGHT *Anniversary poster*

Calico Mills

Calico Mills employs 75,000 people. This identity was designed to be the company's 100th anniversary symbol and logotype. The new logotype for Calico contains an all-seeing eye, symbolized by the dots in the round letters and in the figure 100. The logotype and the anniversary date are made as one, cohesive and unseparated. The logo is used to decorate sarees as well as many of the banners that fly all over the city of Ahmedabad.

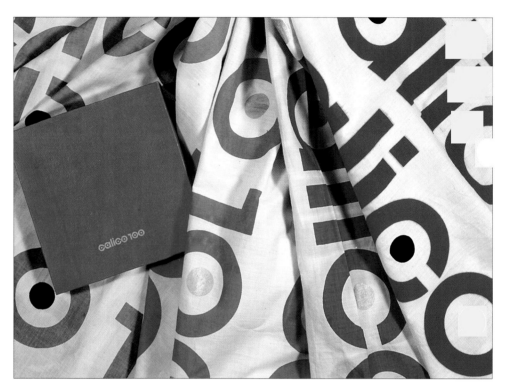

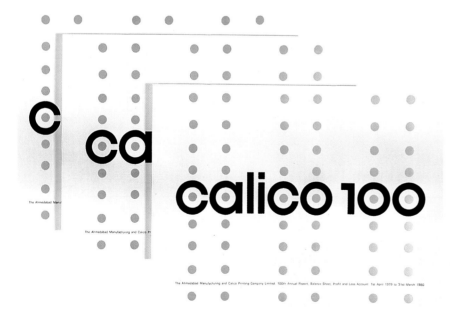

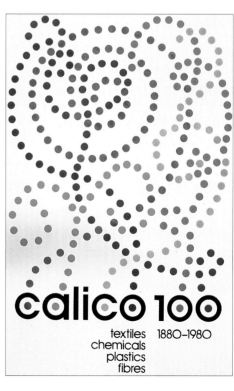

CHERMAYEFF &
GEISMAR INC.

74

Country
Spain

Design Director
Ivan Chermayeff

Expo 92

We designed a poster about the location of the fair using a montage of postcards of Seville.

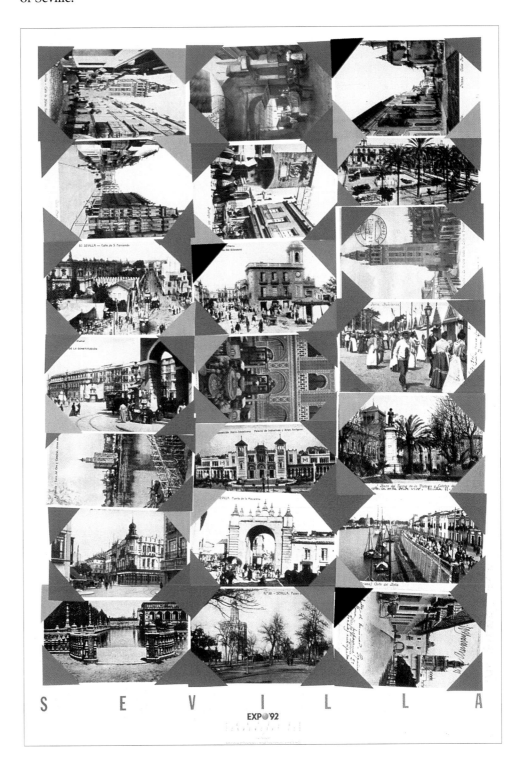

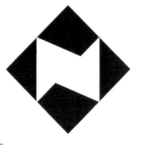

NISSAY

Nippon Life Insurance

We were commissioned to design a symbol for Nippon Life Insurance, the world's largest insurance company. We used the N for Nissay in the tradition of Japanese symbolic forms. The symbol is based on the family crests of Japan, yet it is a self-contained modern rendition of the letter N.

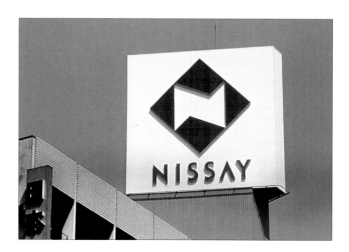

Country
Japan and worldwide

Design Director/Designer
Steff Geissbuhler

The Soshin Society

We designed peace posters in memory of Hiroshima. We learned that peace posters are tough!

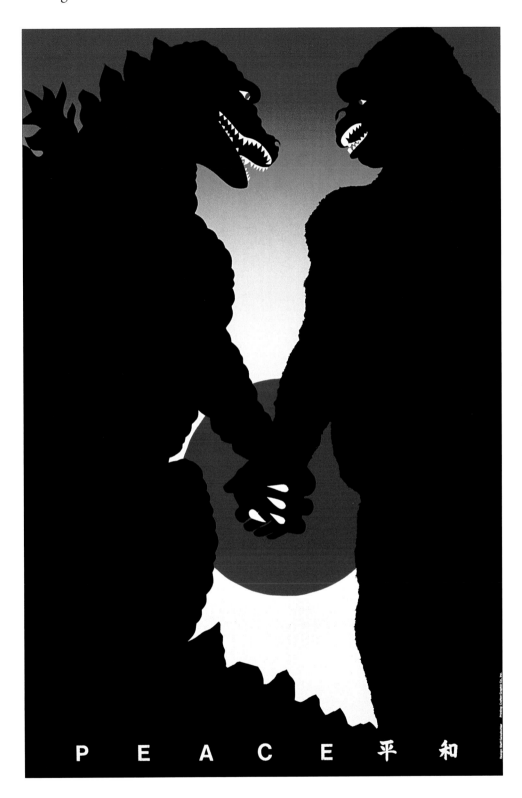

Seymour Chwast

United States

Country
Germany

Art Director/Designer/Illustrator
Seymour Chwast

RIGHT *Light beer package and label designs*

Steinhauser Beer

Steinhauser was being introduced into the U.S. market. We were commissioned to design a label and neckband for a typical German beer, for U.S. supermarket distribution. The target audience was young middle-management pseudo-sophisticates with aspirations. It was specified that the design must have the feel and look of "Old German Beer." We provided 12 design solutions, ranging from sophistication to mass appeal. The product died in a focus group – only the design featuring the six-pack was tested, and it was rejected.

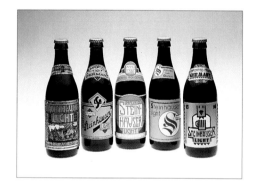

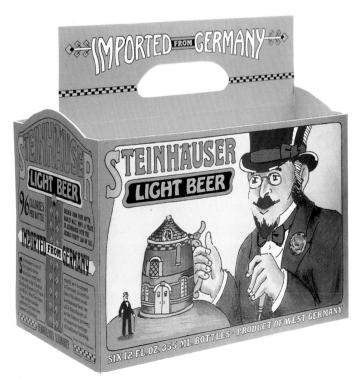

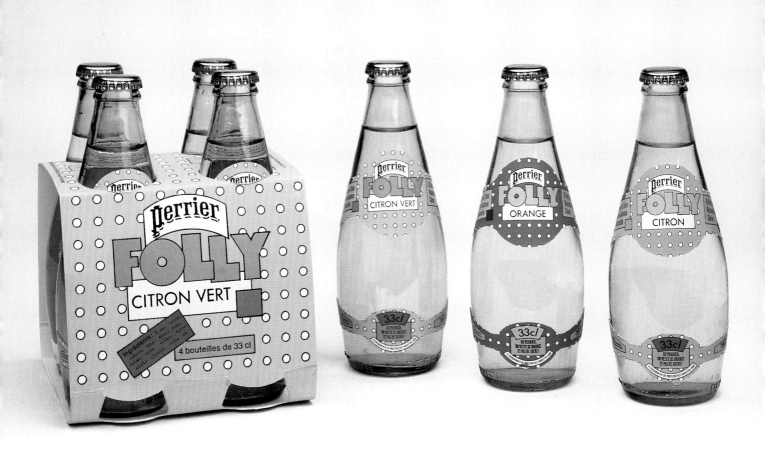

Country
United States / France

Design Director / Designer / Illustrator
Seymour Chwast

Perrier

The project was to create the label and carrier package design for a new Perrier product, flavored Perrier. The design had to retain the original logo and the shape of the traditional Perrier bottle. This product was targeted towards a young market, to play off "Folly" as the product name, with Perrier as the parent company used as a symbol of prestige. We used color and a playful design to appeal to a young but sophisticated audience, interested in non-alcoholic, tasteful, and healthy drinks.

Folly-flavored Perrier
ABOVE *Package design*

Richard Danne
United States

Country
Saudi Arabia

Design Director/Designer
Richard Danne

Saudi Progress Reports
THIS PAGE AND OPPOSITE
Report covers and inside spreads

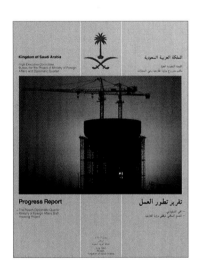

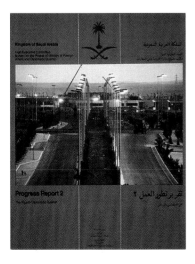

Kingdom of Saudi Arabia

Some years ago, Saudi Arabia decided to move its capital to Riyadh, and a dramatic new city for some 50,000 international diplomats was built. This was a massive undertaking, requiring the combined efforts of 100 different planning, landscape, and architectural firms. It was a remarkable project, which eventually yielded stunning results. The Ministry of Foreign Affairs selected our firm to design a series of progress reports to document the development of this amazing city. These reports were distributed to diplomats around the world and had to be written in both Arabic and English. Therefore, the books read from back to front. In our format, the Arabic columns read from right to left and were mirrored by English translation on opposite pages. The client thought our solution was very effective and something of a breakthrough. One of the difficulties we encountered was that only the infrastructure work had been completed when we designed the first report. Therefore, we used architectural drawings and models, along with excellent mood photographs of the site taken by Wayne Eastep.

Before traveling to Riyadh, I read a great deal about the history and culture of Saudi Arabia. I needed to be aware of the differences in our societies. Making presentations in an Arab country to a Royal Crown Prince requires a knowledge of protocol and a great deal of patience. It is common to wait for days on end, while being gracefully entertained. I was lucky that I was able to make my presentation within 24 hours after my arrival, and it was a success.

The real trouble began after the meeting. A shooting incident in a holy mosque created a serious reaction in the region, and Saudi Arabia went on military alert. The airport was closed. Things were very tense and there was virtually no news from outside the country. Each night I went to the airport, hoping it might be open, to find it teeming with soldiers – like an eerie scene from a bad movie.

After what seemed like an eternity, airspace was cleared and I got a flight out, thanks to military personnel. As I winged my way to Rome, I felt extremely fortunate and wiser. I was working on a unique project, learning about a completely different culture, and the visit had been extraordinary!

Oh yes, I should add that the next presentation was handled via DHL.

the expansion of the Central Area; Diplomatic
Missions Zone; and Housing Area D. Stage
Two will increase the capacity of the Diplomatic
Quarter to 125 diplomatic missions and a resident population of more than 32,000 persons.

A brief summary of the two stages of development follows.

Stage One: 1399-1403 H. (1979-1983)
- The Master Plan of the Riyadh Diplomatic
Quarter.
- Infrastructure design of Housing Areas
A, B, C and E; Central Area and Diplomatic
Missions Zone (completed); and infrastructure design of Housing Area D; expansion of
Central Area and Diplomatic Missions Zone
(in progress).
- Construction of infrastructure facilities for
Housing Areas A, B, C and E; the Central
Area and the Diplomatic Missions Zone (in
progress).
- Urban design of the Central Area and Housing Areas A, B, C and E (completed).
- Planning, architectural and engineering design of 42 public superstructure facilities (in
progress).
- Construction of selected public superstructure facilities (commenced).
- Conclusion of land acquisition and land
lease agreements with accredited diplomatic
missions for the development and construction of embassies, ambassadors' residences and staff housing (in progress).
- Planning, architectural and engineering
design by currently accredited diplomatic
missions of embassies, ambassadors' residences and staff housing (in progress), and
the construction of these facilities.
- Preparation and issuance of procedural regulations and design guidelines; zoning and
landscaping regulations for development
control in the Riyadh Diplomatic Quarter
(completed).
- Development of a strategic plan and requirements for the private development of
housing, office and commercial facilities and
services in the Riyadh Diplomatic Quarter (in
planning stage).
- Sale or lease of plots in the Diplomatic
Quarter to individual Saudi home builders (in
planning stage).

Stage Two: Post 1403 H. (Post 1983)
- Construction of infrastructure facilities in the
Southern Extension Area and Housing Area D.
- Construction of the remaining public
superstructure facilities in the Diplomatic
Quarter.
- Construction of facilities for newly accredited
diplomatic missions to the Kingdom.
- Operation and maintenance of all publicly
constructed facilities.
- Begin participation of the private development sector.

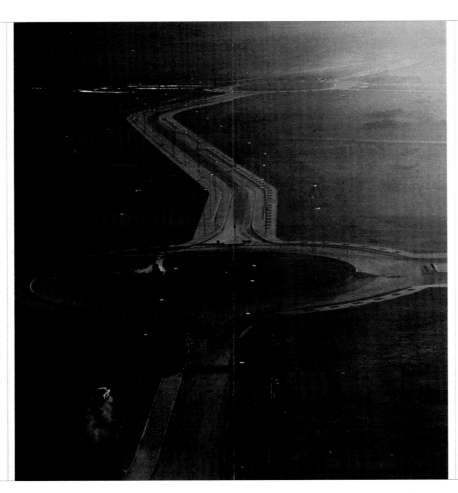

Aerial view in the Central Area's road section of two
roundabouts in the Diplomatic Quarter; land to left
is the Southern Extension Area.

The High Executive Committee: Authority and Responsibilities

By Council of Ministers Resolution no. 1650
issued on 21/11/1395 H. (1975) His Majesty's
Government approved the establishment in
Riyadh of a Diplomatic Quarter in which are to
be located all elements and facilities of all the
accredited diplomatic missions to the Kingdom. In accordance with said Resolution, a
High Executive Committee was established
with authority to prepare a Master Plan for the
development of the Riyadh Diplomatic
Quarter.

Pursuant to Royal Directive no. 3 r 4651
issued on 27/2/1399 H. (1979) by HRH Crown
Prince Fahad Bin Abdulaziz, the Deputy
Prime Minister the Master Plan for the Riyadh
Diplomatic Quarter, as submitted in its final
form, was approved, and the High Executive
Committee was designated as the government agency with authority and responsibility
to implement the Master Plans and development of the Diplomatic Quarter and the Ministry of Foreign Affairs Staff Housing Project.

The High Executive Committee, by and according to the Royal Directive, was authorized
to take all necessary action for the implementation of all construction programs in the
Riyadh Diplomatic Quarter and the Ministry of
Foreign Affairs Staff Housing Project, and to:
- adopt, amend, and enforce the necessary
regulatory procedures and other means of
control, and regulate development in the
Riyadh Diplomatic Quarter within the framework of the Master Plan.
- sell or lease land in the Riyadh Diplomatic
Quarter to accredited foreign governments
for the construction of embassies, ambassadors residences, and staff housing, and to
sell or lease land for private development.
- develop and construct all infrastructure
works and all public superstructure facilities
(schools, mosques, government offices,
community centers, clubs, landscaping and
recreational facilities) in the Riyadh Diplomatic Quarter.
- design and construct all facilities in the
Ministry of Foreign Affairs Staff Housing Project, and
- designate the Bureau for the Project of
Ministry of Foreign Affairs and Diplomatic
Quarter as the executive management organization to carry out all administrative, managerial and control functions and assignments
of the High Executive Committee.

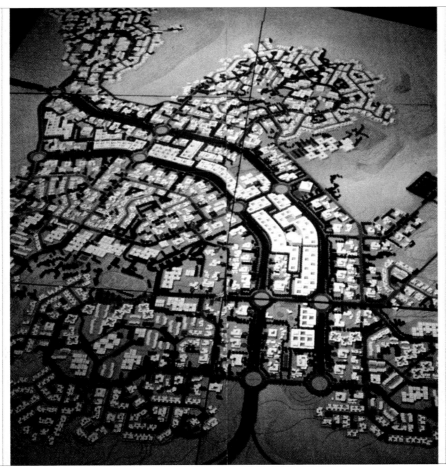

Model of the Riyadh Diplomatic Quarter showing
a central area of mixed uses (Diplomatic missions,
commercial and community facilities) and five
'Satellite' neighborhood Housing Areas.

The Duffy Design Group

United States

Country
Germany

Design Director/Designer
Joe Duffy

Designers
Sharon Werner, Rudiger Gotz

Illustrator
Lynn Schulte

The Bayerische Vereinsbank Group

The Bayerische Vereinsbank, Germany's third largest bank, was making an aggressive move into retail banking and its managers wished to capitalize on the economic opportunities developing in Europe. They also wanted a stronger international profile. As part of this move, they were changing their name to the Vereinsbank Group.

The Duffy Design Group was one of three international design firms selected to participate in a paid competition to create the bank's new logo. The logo had to portray the bank as astute, clear-sighted, and friendly. It also had to be completely different from the lifeless, abstract marks that characterize international banks. Our solutions:

1. **Centaur:** The Centaur is a dual creature, combining the head and mind of a human with the speed and strength of a horse.

2. **Bird:** The bird signifies grace, skill, and freedom. Birds fly above the earth, seeing and knowing what earthbound creatures cannot.

82

3. **Archer:** The precise figure with its bow and arrow communicates accuracy and precision.

4. **Runner:** The runner does the responsible thing, leading and winning. Runners become a source of warmth and light, showing the way for others.

5. **Face:** The face uses all senses, communicating intelligence, understanding, and access to information on many different levels.

We were confident that these designs all had strong possibilities. Unfortunately, their interpretation of these designs was unexpected.

1. **Centaur:** Appeared too militaristic, fascist.

2. **Bird:** Looked to them like a bird of prey, too menacing.

3. **Archer:** Too aggressive, hunter-like.

4. **Runner:** Reminded them of the 1939 Olympics with Jesse Owens. Concerned that it had Nazi overtones.

5. **Face:** They liked this idea the most, but suggested that it would work much better for a Spanish bank.

Obviously they had a concern about appearing militaristic in light of the reunification of Germany. As a result, images we saw as dynamic and strong they saw as hostile and war-like. Lessons we learned:

Expressive, figurative imagery in international design can pose problems because of the wide variety of unexpected cultural interpretations. It explains why boring, abstract, and safe symbols have been so popular with international banks (or international companies in general for that matter).

The Bayerische Vereinsbank
Group identity
THIS PAGE AND OPPOSITE
Proposed logos for the bank

Country
United States/United Kingdom

Design Director/Designer
Glen Tutssel and Joe Duffy

Self Promotion

When we joined forces with the Michael Peters Group of London, we wanted to create a memorable announcement. It was aimed at potential clients and people working in the creative community. Our solution was to develop a tongue-in-cheek view of the cultural differences between the United States and Great Britain. On one side of the book, the Duffy Group suggests American improvements for British institutions. On the other side, the Peters team recommends improvements for the United States. We realized that some of the suggestions actually made sense, and, in fact, didn't appear out of place at all. (Examples: Stonehenge in the painted desert and fox-hunting with a lasso.) In creating the page dealing with differences in British and American English, we realized that we truly are two cultures divided by a common language.

The Michael Peters Limited/
Duffy Design Group book
THIS PAGE *Cover and inside spreads*
OPPOSITE *Inside spreads*

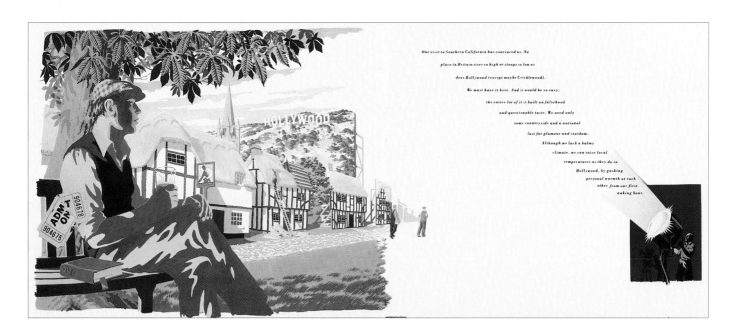

One visit to Southern California has convinced us. No place in Britain rises so high or stoops so low as does Hollywood (except maybe Cricklewood). We must have it here. And it would be so easy: the entire lot of it is built on falsehood and questionable taste. We need only some countryside and a national lust for glamour and stardom. Although we lack a balmy climate, we can raise local temperatures as they do in Hollywood, by gushing personal warmth at each other from our first waking hour.

Great Britain's Stonehenge and America's Monument Valley, straddling the Utah-Arizona border, would stand together quite nicely as a study in the relationship between early man and nature. In fact, Stonehenge would look right at home there. Since the Yanks love "yarns," we could spin one about Stonehenge being an ancient horse corral for "dino-horses." Or, perhaps a Bar-B-Q pit built by early nomadic Texans. Either way, it would add a splendid touch of culture to a land so dominated by nature.

Given the improvement of our British economy and politics, the U.S. could learn from our experience. In particular America needs a better man at the helm of its ship of state; it needs a woman. Trouble is, Americans seem unable to build a successful woman candid

So why not import a proven product from the Mother country? We're sure that after Maggie had "Thatcherized" the American government she'd have earned a spot on your largest national memorial. It could stand a kinder and gentler f

Eurocom Advertising

Switzerland

Country
International

Design Director
Bernd Ritterbusch

Credit Suisse

The oldest of the three major Swiss banks, Credit Suisse is a wholesale bank with a complete range of services, and 74 branches all over the world.

Reputed for being a reliable, solid, and efficient Swiss bank with international know-how, a clear structure, and an elevated corporate culture, they were preparing their future by building up their local and international position and raising their earning capacity. Their advertising appearance was changing from a product-oriented to an image-oriented approach.

Our concept for them was "Incredibly Swiss – Incredibly International." The ads showed Credit Suisse turning up in all the finance capitals of the world and at the same time demonstrating typical Swiss qualities. Swiss character combined with international competence also went hand in hand with the corporate marketing strategy: "We do more to keep you at the top."

"Incredibly Swiss – Incredibly International"
RIGHT AND OPPOSITE *Newspaper and magazine advertising campaign*

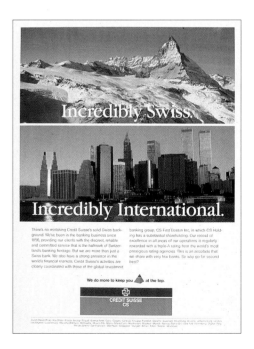

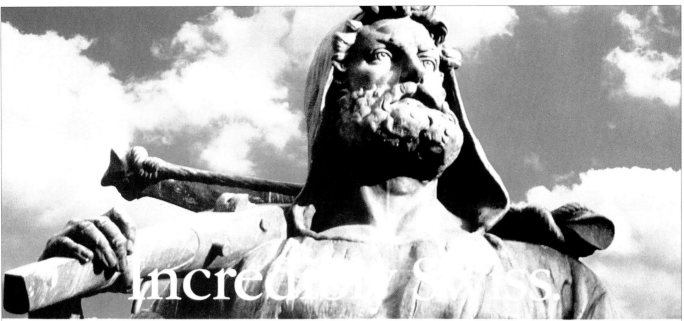

Incredibly Swiss.

William Tell Monument, Altdorf

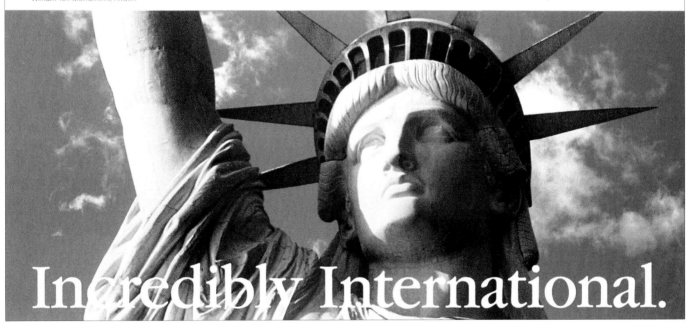

Incredibly International.

The goal was to portray Credit Suisse in these ways:

1. CS is a modern and efficient global Swiss bank, and is therefore represented in all the world's financial capitals.

2. CS has the competence and know-how to develop and realize financial strategies worldwide.

3. CS places outstanding banking professionals at their client's disposal.

The advertising medium we used was 2/1 and 1/1 four-color ads in all the important finance and business magazines and newspapers all over the world.

Lidia Guibert Ferrara

Italy

Country
Italy

Design Director/Designer
Lidia Guibert Ferrara

Alfred A. Knopf/Gruppo Mondadori

I was born in Buenos Aires and have lived in Bogotá, New York, and now Milan. Book publishing has been my professional home, and I have art directed and designed for CBS Legacy Books, Knopf, Random House, and Italy's Gruppo Mondadori.

My unusual multicultural background has made me keenly aware of the preconceptions people nurture about other cultures. When I am asked to design a jacket for a Latin American author, whether for the Chilean Neruda, the Argentinean Borges, or the Colombian García Márquez, I am expected to work with bright colors, primitive images, and paintings like the Mexican murals that depict Indian women and colorful landscapes. The feeling must be hot and "south of the border."

Because all countries in Latin America (with the exception of Brazil) share a common language they are viewed as a monolith, when in reality every nation in the region has its own history, culture, and idiosyncrasies. Failure to recognize the differences perpetuates the existing preconceptions.

The goal of cross-cultural design is to respect the subtleties of one's audience, an effort that requires constant questioning of both the designer's personal beliefs *and* the troubling misconceptions that might be lurking in the assignment.

THIS PAGE *An abstract characterization for the jacket design of the novel* Kiss of the Spider Woman *by Argentina's Manuel Puig.*

OPPOSITE *A cover for* Eva Luna *by the Chilean novelist Isabel Allende, featuring a mural by the Mexican artist David Alfaro Siquieros.*

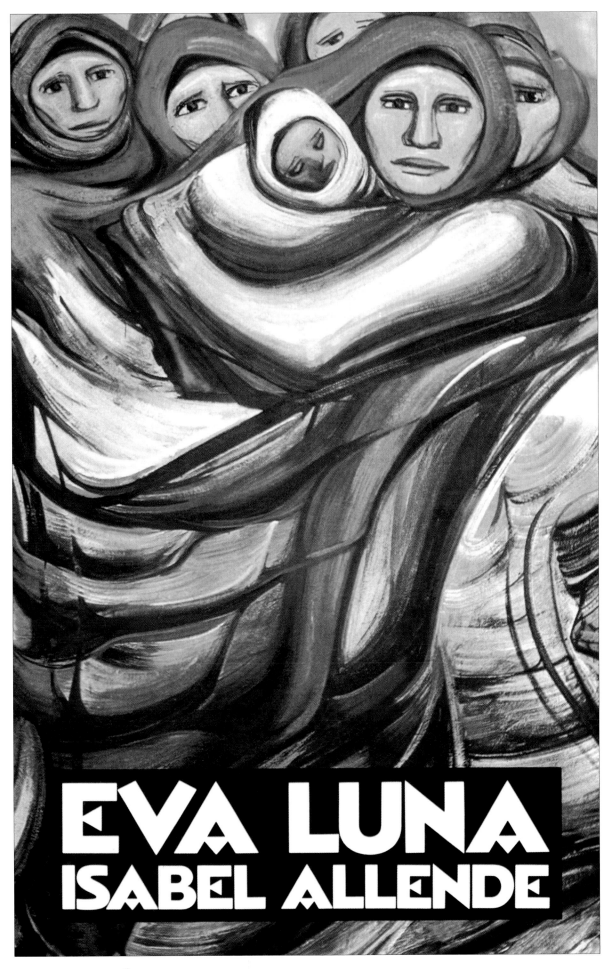

EVA LUNA
ISABEL ALLENDE

Forward

United States

Forward

Forward, published since 1897, was long considered the world's largest Jewish newspaper, with a daily circulation of 250,000 copies. But in the late 1980s, circulation had dwindled because it was published only in Yiddish. Most of its original readers had passed on without teaching the language to their children or grandchildren. Consequently, to continue the tradition of bringing home the news, the new English-language *Forward* was launched.

Here's the story in plain English: Now you can reach one of America's most influential audiences every week.

Since 1897, the Yiddish Forward has brought home the news to millions of Yiddish-speaking immigrants to America. Now, the new English-language Forward does the same for a new generation of Jewish readers.

Each week, the Forward reaches one of New York's most influential audiences. It's an effective, cost-efficient way to target upscale, highly-educated, professional Jewish men and women in the prime of their lives.

Find out how you can move your business forward with the new Forward. For a free Forward media kit, call Howard Barbanel at (212) 889-8200.

In a world of change, we must look Forward.

Forward Publishing Company, 45-E. 33 St., New York, NY 10016
Available on newsstands everywhere. To subscribe, call 1-800-272-7020, ext. 11.

Dan Friedman

United States

Country
Greece

Design Director
Dan Friedman

Writer
Jeffrey Deitch

Cultural Geometry
ABOVE *Photo/illustration*

Dakis Joannou

The goal of the project was to make *new* art understandable and/or enhanced by placing it in a Greek context. We juxtaposed new art with cultural images "found" in Greece. The book, titled *Cultural Geometry*, was written in Greek and English and was printed in Athens.

I was invited to work on this project by Jeffery Deitch, a New York art consultant, and his client, Dakis Joannou, an Athenian collector of important new work by young artists (most of whom are from the United States and Europe). The book was designed to accompany the first exhibition of this kind of new art in Athens, in 1988.

Most of the art was abstract, conceptual, and unfamiliar to a Greek audience. But there were aspects of this predominantly minimal and geometric art that were nonetheless related to ancient and modern Greek culture. This was the basis for the title, *Cultural Geometry*. This relationship provided the concept of the design, which attempted to juxtapose this contemporary art with images found both in Greek culture and also in an increasingly international culture. As a result, the Greek audience was able to connect more easily with the art, and at the same time the art was transformed and expanded by being presented in Athens – a context rather different from the one in which it had previously been seen.

The preparations were made in New York while a search for cultural images was made in Athens. The client expressed a desire to print the book in Athens. After apprehensively interviewing printers, we chose one who had experience printing local art books. The prices for color separations turned out to be about one-third of the cost in New York. The typesetting for the English was done in New York and the Greek was done in Athens – and we encountered some difficulty as we attempted to maintain compatibility. In the end, it was refreshing to find quality work accomplished in a culture where advanced graphic design and print production are still in their infancy.

91

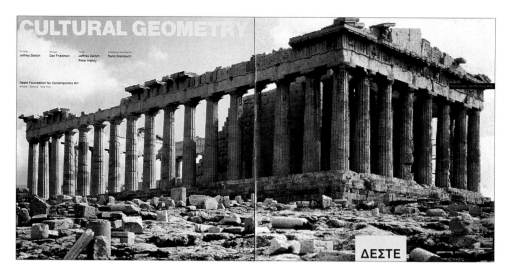

Cultural Geometry

ABOVE *Book cover design*

TOP RIGHT *Title page spread*

CENTER AND BOTTOM RIGHT
Inside spreads

OPPOSITE *Poster for Athens art exhibition*

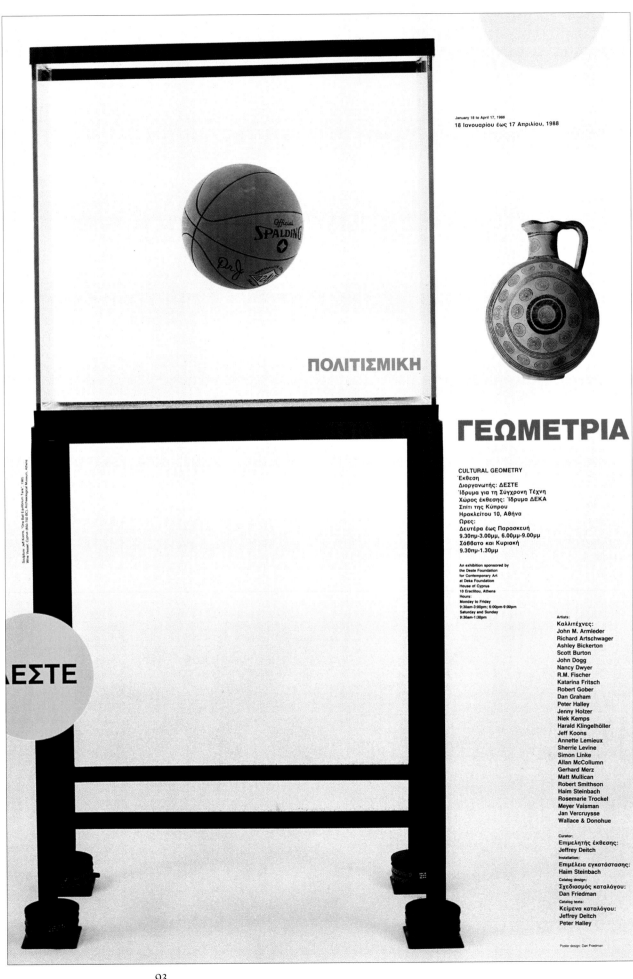

January 18 to April 17, 1988
18 Ιανουαρίου έως 17 Απριλίου, 1988

ΠΟΛΙΤΙΣΜΙΚΗ

ΓΕΩΜΕΤΡΙΑ

CULTURAL GEOMETRY
Έκθεση
Διοργανωτής: ΔΕΣΤΕ
Ίδρυμα για τη Σύγχρονη Τέχνη
Χώρος έκθεσης: Ίδρυμα ΔΕΚΑ
Σπίτι της Κύπρου
Ηρακλείτου 10, Αθήνα
Ώρες:
Δευτέρα έως Παρασκευή
9.30πμ-3.00μμ, 6.00μμ-9.00μμ
Σάββατο και Κυριακή
9.30πμ-1.30μμ

An exhibition sponsored by
the Deste Foundation
for Contemporary Art
at Deka Foundation
House of Cyprus
10 Eraclitou, Athens
Hours:
Monday to Friday
9:30am-3:00pm; 6:00pm-9:00pm
Saturday and Sunday
9:30am-1:30pm

Artists:
Καλλιτέχνες:
John M. Armleder
Richard Artschwager
Ashley Bickerton
Scott Burton
John Dogg
Nancy Dwyer
R.M. Fischer
Katarina Fritsch
Robert Gober
Dan Graham
Peter Halley
Jenny Holzer
Niek Kemps
Harald Klingelhöller
Jeff Koons
Annette Lemieux
Sherrie Levine
Simon Linke
Allan McCollumn
Gerhard Merz
Matt Mullican
Robert Smithson
Haim Steinbach
Rosemarie Trockel
Meyer Vaisman
Jan Vercruysse
Wallace & Donohue

Curator:
Επιμελητής έκθεσης:
Jeffrey Deitch
Installation:
Επιμέλεια εγκατάστασης:
Haim Steinbach
Catalog design:
Σχεδιασμός καταλόγου:
Dan Friedman
Catalog texts:
Κείμενα καταλόγου:
Jeffrey Deitch
Peter Halley

Poster design: Dan Friedman

ΔΕΣΤΕ

David Gentleman

England

Country
United Kingdom

Design Director/Illustrator
David Gentleman

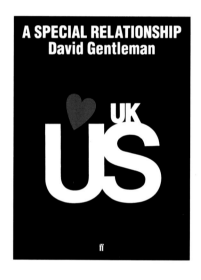

A Special Relationship
ABOVE *Cover*
RIGHT AND OPPOSITE *Inside pages*

Faber & Faber

A Special Relationship is a book of polemical images. Since it was my own idea, there was no brief. I was provoked into doing it in 1986 by a sense of outrage at my own country's supine acceptance of America's decision to use British airfields for bombing Libya. This made me realize that the supposed "special relationship" between Britain and the United States was no longer special at all – not for us, anyway. I'd already taken part in a sit-down protest outside the American Embassy in Grosvenor Square, but that seemed an unsatisfactory and ineffectual use of one's time; I wanted to make a more personal protest. I put the whole book together fairly quickly as a highly finished visual and showed it in almost ready-to-print form to a couple of publishers. Faber agreed to publish it, gave me the colors I asked for, printed it beautifully, and got it out in early 1987.

There were no obstacles or setbacks. The only input from the publisher was encouragement. I worked out the sequence of spreads on a careful flat-plan. Apart from the title, the endpapers, and the blurb I wrote for the back cover, there were no words: only a few dates here and there if they helped to make a point. The historical basis of the relationship between Britain and America was touched on, and its state shown by images – photomontage, paste-ups of old engravings, quickly drawn

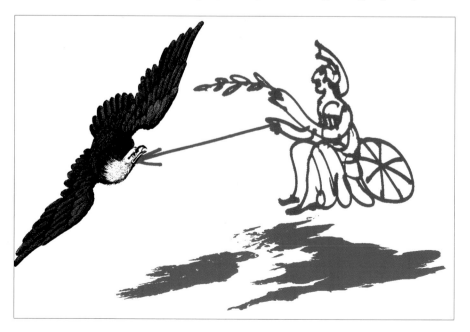

94

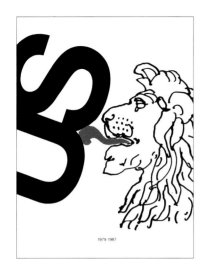

1979-1987

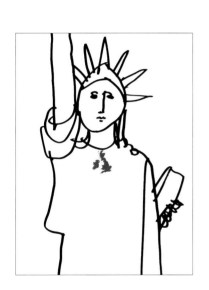

sketches in thick Pentel lines – some of which were meant to shock.

The book consisted of 64 pages, printed in four self-colors: blue and red to match the Union Jack and the Stars and Stripes, a mid-gray (*not* a tint of black), and brown (Pantone 140) for missiles and shit. The endpapers juxtaposed a page of marvellous American individuals, showing that there is much about America to love and admire, with a list of U.S. nuclear bases in Britain. Compiling the list of people was one of the more delightful tasks involved.

A Special Relationship was not dogged by linguistic and cultural differences; it was *about* them. It created a minor sensation when it was published, with comments in the national press under such headlines as "Raw Anger," "No longer a Gentle-man," and the like. The image that seemed to get up the most noses showed the British Isles going down the pan; it was drawn from the loo in my children's bath-room. The book sold reasonably well and went down particularly well with students. It also won an Art Director's Club award in New York.

Looking at it in retrospect, the more savage spreads seem to me graphically the most successful. But I'm no longer sure that the best way of demonstrating raw anger is by packaging it tidily up in book form. I now think the strongest images in *A Special Relationship* would have worked just as well, and would have been seen by more people, if they had been made into posters or T-shirts. But the argument can be sustained better at book length. I don't think the effort of making the book was wasted or has lost its point with the passage of time. It's worthwhile now and then to use graphic design to express one's own point of view instead of a client's. And the basic idea of the book – that the relationship of the United States and Britain is not only less special than we generally suppose, but is indeed quite disastrous – remains as topical as ever.

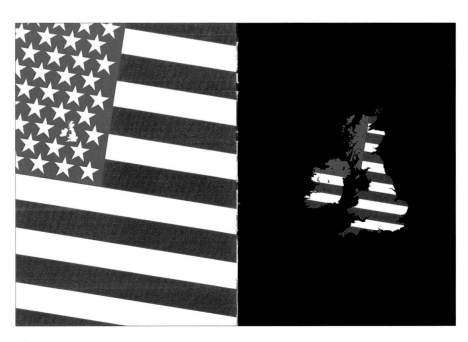

Country
Republic of Nauru

Design Director
David Gentleman

Republic of Nauru

Another cross-cultural project was designing a definitive set of postage stamps for the tiny mid-Pacific Republic of Nauru. This is an isolated island, almost on the equator, four miles across and ten miles or so around. Most of its revenue came from extracting and exporting phosphate, which was being depleted at a great rate. When I was there, Nauru didn't much encourage tourism – the only other foreign visitors were airline crews, some expatriate schoolteachers and administrators, the Gilbertese workmen who dug out the phosphate, and some Chinese shopkeepers. There were then about three thousand native Nauruans.

Nauru also gets a little income from issuing postage stamps. I went out there some years ago to design a set of definitives, with a contract that allowed me a free hand in the choice of subject matter. The Nauruan stamp committee consisted of three or four islanders, including a minister of the church who was also the proprietor of the island's restaurant and nightclub. The committee members spoke English and were friendly and welcoming, but were naturally little used to briefing designers.

Despite the visual ravages resulting from extracting all the phosphate-laden soil from the rocky plateau that formed the center of the island, and despite the obtrusive cantilevers that carried the processed phosphate out to the ships, Nauru was in many ways extremely beautiful. There were palm-fringed lagoons, lovely beaches, and a coral reef with curiously shaped rock pinnacles sticking out of the warm water; big trees, tomatoes and papayas; herons, noddy birds (sooty terns), and frigate birds that the islanders capture and tame.

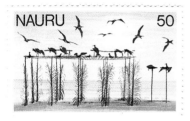

But these things didn't seem at all remarkable to the advisory committee, which would reasonably enough have liked the stamps to depict their economic achievements, like the Boeing airliners and the cargo boats they'd bought with the phosphate revenues. They felt that these things put them alongside bigger, more industrial countries. The most ticklish part of my job was persuading them that their plants and trees, their wildlife and landscape, which were not only beautiful but in some cases unique to the island, would make better stamp subjects. More of the stamps were going to be bought by foreign collectors than by Nauruans, who write few letters, and I thought that collectors would be more interested in the character and beauties of the place and its culture than in Boeing 727s and 737s or in heavy mineral-crushing equipment. Our discussions, some of them over the nightclub table, were good-humored and open, and in the end the committee was persuaded.

I found the island fascinating enough to stay there for three months, and I was paid enough for my wife Sue and our two small children to come out too. They have never forgotten this experience, which was curious but fascinating. It was also unrepeatable, because before long the island will have all been dug away and will be – as much of it is already – an eerie wasteland.

In the course of the visit, we also made a visit to Western Samoa, a three-hour flight away. Our return to Nauru was delayed in Apia because the King of Tonga was on the same flight, making a state visit to Nauru with his entourage, and he required a specially widened seat to be installed in place of two ordinary first-class ones.

There were no setbacks attached to this curious commission, apart from having to come back to London when the job was done. But I wanted the stamps to be well printed – as they were – and so I chose photogravure in preference to offset, which would have been cheaper for a shortish run. This probably ate up a good chunk of the profit from selling the stamps. I found working in this exotic tropical atmosphere, with its odd mixture of primitiveness and extravagance, fascinating and unforgettable. My advice to anyone embarking on a similar project would be to allow plenty of time to adapt to a new environment, to go with an open mind, to enjoy the cross-cultural social relationships involved, and to take thick-soled plimsolls in case you step on a stonefish.

Milton Glaser

United States

Country
United States/Italy/Japan

Design Director/Designer
Milton Glaser

Olivetti

These posters done for Olivetti typewriters had a different intention than they might if they had been designed for an American company.

In the case of the two Valentine examples, the purpose was to establish an atmosphere of sophistication and elegance that would intrigue viewers but not necessarily move them towards a purchase based on the effectiveness of the product. One can imagine the conversation that would occur in the United States if we proposed either of these two solutions. In the case of the one based on marquetry, the absurdity of showing the product made of wood would immediately produce a rejection.

In both of the Valentine posters, there is a reference to Italian art. The inlaid wood poster is based on the remarkable interior of the Duke of Montefeltro's library. The mournful dog at the feet of its dead (ok, sleeping) master is taken from a detail of a painting by Piero di Cosimo. My assumption was that some part of the Italian audience would recognize these obscure references.

In the case of the Lexikon 82, there is a somewhat more market-directed intention. In all three instances, the attempt is to emphasize a primary characteristic of the typewriter, the moving ball. While the reference is essentially symbolic, the assumption was that the audience could eventually figure it out. Incidentally, each of the falling figures with trailing ribbons represents the range of printing colors available.

The Praxis 35 was an attempt to position Olivetti's first electronic typewriter in a style that suggested its progressive nature. The central icon in the middle is a view of the typewriter case as seen from the end.

The silkscreen of the cow is a four-part print. It was one of several gifts that Olivetti annually gives to its friends and clients. The idea behind the print is that each piece looks like a landscape by itself, and only when it is assembled does the total picture become complete. The assembled print measures 71" x 48.5". It was intended for the Japanese division of Olivetti. After it was produced, Renzo Zorzi, the director of marketing, observed sadly to me one day, "Milton, do you know how small a Japanese house is?"

In all of these cases, what is evident is Olivetti's willingness to create a spirit of adventurousness, even at the risk of not selling its product in an obvious way.

Country
France and worldwide

Design Director
Robert Palmacci

International Herald Tribune

The objective was to promote the internationalism of the newspaper by celebrating the fact that it has had the word "international" on its masthead for 25 years.

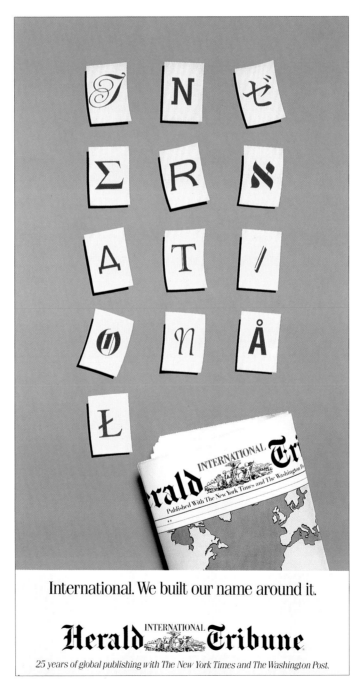

Eiko Ishioka

Japan

Country
Japan

Parco

Named after the Italian word for park, the first Parco was created in 1969. It was a unique establishment, composed of a theater for the performing arts, fashion boutiques, galleries, restaurants, and book shops, all in one building. Parco was a mecca for the new generation, and over the years more Parcos have opened in Japan. The idea behind Parco was to use profits from commercial ventures to subsidize and support theater, book publishing, art exhibitions, and film showings. The owners felt a responsibility to use the profits from Parco's restaurants and shops to help develop culture, as the Japanese government rarely supports these kinds of projects. I was the main art director for Parco during the 1970s. The owners gave me the freedom to develop my ideas and build a completely special company image. Consequently the fashion advertisements I created for Parco look considerably different from others made solely to sell clothes.

While I designed advertisements to present Parco's appeal, I was also involved as the art director in their other projects such as theater productions, book publishing, and various types of exhibitions; lots of mixed media was involved. After over eight years of collaboration as an independent art director, I left Parco in 1980.

Parco Poster

HENRY STEINER This poster used Faye Dunaway, a foreigner, with Japanese children in costumes designed by your friend Issey Miyake. The target culture was Japan. What was the message?

EIKO ISHIOKA For this poster, I felt that having a Western movie star at that time "wear East" was an important experiment, and it accurately expressed Parco's philosophy. Faye Dunaway was transformed into a majestic Kwannon, the goddess of mercy. My two nieces played the roles of doji, the children who serve Buddha in a temple. In a Hollywood studio Faye underwent an Oriental metamorphosis.

When Japan lost the war, we also lost our sense of values and our Japanese perspective. Ever since, we have been striving to rebuild our country and re-establish ourselves with the rest of the world. Japan has learned from the West, but the situation is now changing. Trends show that the West is starting to look East. Our rather bold question, "Can West Wear East?" is being asked by the new Japan, which looks forward to the future and to a time when East and West become one.

This was the last advertising campaign I did for Parco. At that time, many companies tended to use famous personalities for hard-sell testimonial advertisements – for example, movie stars would hold a beer bottle. That is a primitive form of advertising employing a traditional technique, well known even in the Meiji and Taisho eras – my father's generation was very familiar with this approach.

Here I've used my own style, not a typical hard-sell technique but still using a famous movie star for a personality campaign. The design came out just the way I wanted and was very successful. Faye Dunaway was very cooperative and together we created this unique advertisement which was unlike typical celebrity endorsements.

H. S. Was there a bigger impact because you used an American rather than a Japanese star?

E. I. I was very keen on the concept which required a Western movie star. An American Hollywood star is internationally well known. A Japanese star would have been too local. An internationally famous personality is more symbolic, helping me to illustrate the meaning behind my statement. That's why I wanted to use Faye Dunaway rather than, say, Seiko Matsuda.

Parco Advertisement

E. I. This is a full-page Japanese newspaper advertisement. It's black and white. It's simple, straightforward, fresh, radical, and ironic, in contrast to the slick and complicated style of art direction prevailing at that time. Just a famous movie star holding an ordinary Japanese baby with the headline, "This is a Picture for Parco."

Smart audiences will understand this sophisticated minimalist approach. I needed the face of a movie star like Faye Dunaway, well known to the Japanese at that time. In the session, her expression changed from the inside. At that time she told me she wanted a baby and she also loved the Japanese people; holding this Japanese baby affected her deeply. She still looked at the camera with her "movie star" face, but with more complicated emotions.

H. S. Was there a strong reaction from the Japanese audience?

E. I. Yes, the reaction was connected with the contrast between a Japanese baby and a Western movie star – the ad has a very intimate, trusting feeling. There is an interesting mood created between the Hollywood star holding this sleeping Japanese baby. This was my art direction: an idea to create a unique mood.

H. S. Do you always try to get some contrast?

E. I. For this kind of job, yes. Advertisements should be strong, simple, and clear; otherwise the audiences will not understand what you are trying to say. I use strong contrast, a motif to pose an interesting relationship.

"THIS IS A PICTURE FOR PARCO"
FAYE DUNAWAY

Eiko by Eiko

E. I. *Eiko by Eiko* was done in 1983, after a two-year vacation in New York. There has been a communication of Japanese culture to America for a long time. One of the experts in Japanese cultural traditions is an American, the former head of the Japan Society, Rand Castile. He asked me to lecture to the Society. Rand wanted someone as a symbol of contemporary Japan, seeing design as a mirror of the times. People in New York could therefore understand the modern Japanese through my work.

After spending two years in New York, I was surprised at the one-sided relationship of America and Japan. The Japanese want to get everything from America, and the Americans just don't care about my country or what is happening to modern Japan. Americans are only curious about the Kamakura or Edo periods in the traditional, old Japan. They seem to hate modern Japan. This angered me. If the Americans only love the traditional Japanese culture, this kills our hope for the future.

When Castile asked me to give a lecture in New York, I gave a very strong lecture based on this concept. I was fairly unknown at the time. The response was remarkable. The Japan Society's auditorium has a capacity of only 500, so I gave the lecture twice in one night, once at seven o'clock and again at nine o'clock.

In the packed audience of cultural leaders was Nicholas Callaway, a young, ambitious publisher – he was 28 at the time. He approached me wanting to publish a book about my work. The contents had originally been created by me only for Japanese audiences. Callaway was excited by my ideas and he gave my book the title *Eiko by Eiko*, meaning the contents by Eiko inspired by Eiko. I had complete freedom; the book was almost like my child. It has become a famous coffee table book in America; it weighed 3 kilos, cost US$90 and the price was double in Europe. There was a strong reaction from the Americans; movie directors and producers, Broadway producers, and rock stars saw the book. My reputation grew by word of mouth and eventually led to the movie *Mishima*.

Mishima

RIGHT AND BELOW *Film sets*

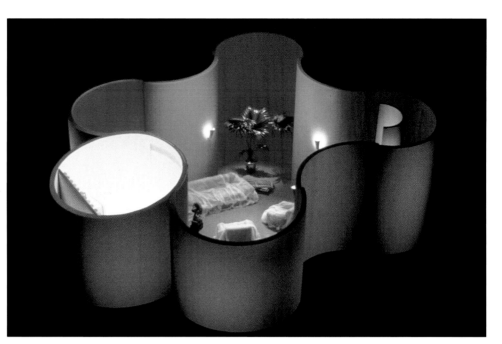

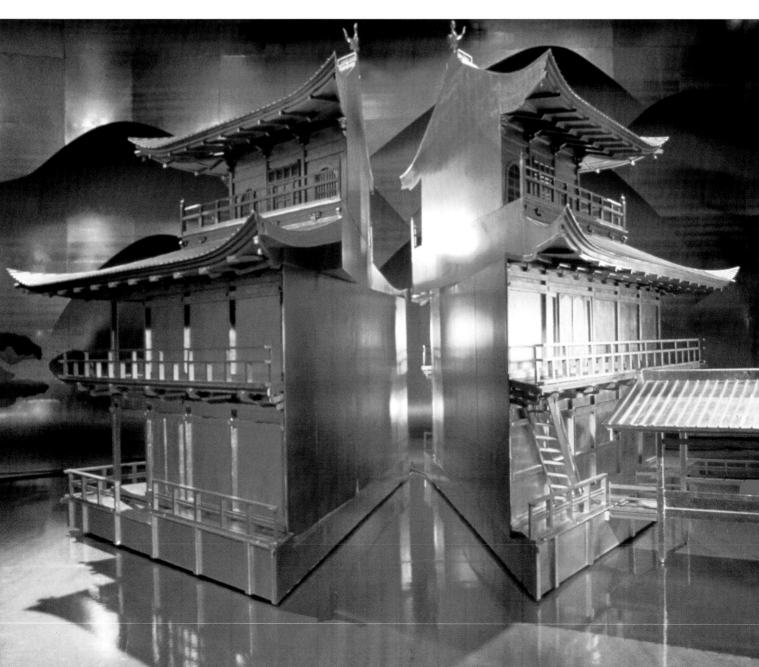

Mishima

E. I. *Eiko by Eiko* just covers my work in and for Japan during one decade, the 1970s. I took that long vacation between 1980-82, like a sabbatical. I wanted to freshen up my mind, to decide and plan for my future. I didn't want to stay as a designer doing advertisements or graphic design. I wanted to develop more stimulating areas.

H. S. Was it because you were bored?

E. I. Yes. Advertising is an interesting training area but not the ideal discipline to spend my life, time, and energy. I wanted to find other valuable areas. I didn't want to be passive, taking outside jobs. I wanted to start attacking the public, the audiences. I wanted a challenge after the two years of rest. Suddenly, Paul Schrader called me up and asked me to act as production designer for his new movie *Mishima*.

This was a sensational subject for me and a stimulating experience. I really enjoyed working with Paul. The movie perhaps wasn't perfect but the scenario was very fresh, with an innovative structure. My design was unique and I received an award at the Cannes Film Festival. So I became well known in Europe and America, and so I ended up with more international jobs coming to me.

H. S. Did you have *Kabuki* as an inspiration for these sets? Were you using tradition or were you trying to be different? What was your tactic here?

E. I. I can use everything from my body, my soul, my mind, my memory. I was raised in Tokyo under remarkably mixed cultural circumstances. It is a unique city, where East meets West. Francis Ford Coppola calls the great struggle in Tokyo a "tug-of-war." A new culture has emerged from the two teams. Since the war, my generation has lived this back and forth struggle.

I am a pioneer, a creator; when I receive this kind of job, I don't need to analyze or study specific details. Technique comes second. The first thing which is very important is to be able to develop a unique, strong concept. I consider myself to be a unique person, from a unique generation; therefore my creation will be equally unique because it reflects me. I didn't worry about using *Kabuki* or Victorian techniques. I don't need it! I hate using specific styles, it's too stereotyped. I choose freely for my inspiration, like with colors, or cooking – a mixture of experiences and not just one particular style.

M. Butterfly

E. I. I wanted to work on a sensational play, on Broadway, in the center of the theatrical world. I was waiting for a good one to come along. I wasn't really waiting for an East/West subject, just a good play. I've been so lucky with my timing! Producers liked *Mishima* and it received good reviews. Then I was asked to do the sets and costumes for *M. Butterfly*. It was a great opportunity. I loved the subject and, as a Japanese designer, I wanted to do it.

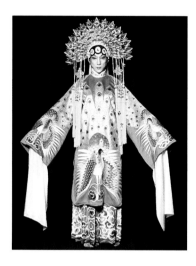

The director was John Dexter, who had directed *Equus*. Maintaining a good relationship is important for international projects, so I always want to meet the key people, like the director, the producer. . . Although I didn't have much experience with Broadway productions, John said not to worry, what matters is the concept. I was not technically veteran enough – many other professionals had more technical experience – but I could create an innovative concept. So I had technical support from the experts and it was left to me to come up with the original ideas and innovative concepts. This had also happened with Paul Schrader. There are millions of technical designers but very few creative artists with sensational ideas.

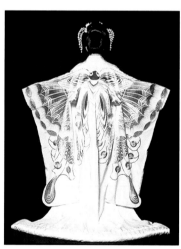

The play was by David Henry Hwang, who is American Chinese, but had never been to China. I had a tight brief from John Dexter; he had strong ideas for the sets. He wanted different levels, minimalist sets. He had many conditions, using traditional ideas, like scrim backdrops; old-fashioned ideas but I incorporated them in a new way. I visited John's house in London; he had worked with David Hockney. John liked to work with Bertolt Brecht's ideas, like banners, for example. As in *Mishima* I wanted everything symmetrical: the slope of the ramp was the only asymmetrical element. American critics said it was a yin-yang shape. Details like the costumes and furniture were fairly straightforward and realistic; they used my interpretation of traditional styles to keep the story line clear.

I also designed a curtain like those used in *Kabuki* or Chinese Opera. John Dexter wanted to use a curtain and remembered the famous Chinese Opera female impersonator, Mei Lan Fan. He pushed me to do something in this operatic style even though I wasn't keen on the idea . But then I had the idea of using something like a gigantic scarf, with a huge butterfly made up of flowers and birds, like a collage. I hired a super-realistic illustrator in Japan for the drawing and the curtain was dyed in New York.

M. Butterfly

OPPOSITE *Costume designs*
THIS PAGE *Stage set and curtain*

Koyannisqatsi

E. I. When I was in Japan I graduated from the Tokyo University of Fine Arts and Music and joined Shiseido. I wanted to be a "star" artist in the company but when I began getting recognition and fame, people started to label me with Shiseido instead of seeing my unique character. I wanted to escape when I started to get branded, that's my nature. Then I became identified with Parco. During the 80s I wanted to get away from Japan, even though my career was going higher and higher. I wanted to go back to zero, start over – feel hungry to build something for myself. I closed my studio and went to New York. After *Eiko by Eiko* my career as an "international" artist started. But I am still Japanese – most people continue to see me as an Oriental artist, for Oriental subjects.

I began giving interviews to Western writers who questioned my being an "international Japanese." I have a worldwide style; I want to be free, not to have a narrow style. Some people, like Francis Ford Coppola and Philip Glass, understand this. All the world is my studio; all motifs on Earth can be the motifs I use in my creations. There was no gap between my work in Japan and my international work. I adjusted immediately. I am good for all subjects, not just those which are Oriental; people's image of the East is so narrow-minded. "East meets West" is easy to say. But who can say what is East or what is West? That's not so easy. China and Japan are both the East, the Orient. But there is a big difference between the two!

Koyannisqatsi is not so obviously Oriental or Western but is an international subject (also connected to Native Americans who are still Mongol) and a gigantic image. The director was an American priest. He wanted to teach audiences about his beliefs through film. This is a very strong medium. He raised money from personal, rather than corporate, donations. He wanted to make a film about human civilization being endangered. I was amazed by this film. It communicates without any dialogue. He asked me to make the poster. Ideas came immediately because I agreed with his concept.

Country
United States

Aid & Comfort

E. I. *Aid & Comfort* was a big concert for AIDS, in Berkeley. It featured American musicians like Herbie Hancock, John Adams, and Philip Glass. I was asked to direct the whole concert in order to raise money for victims. The idea for the poster is an image of meditation.

RIGHT *Poster*

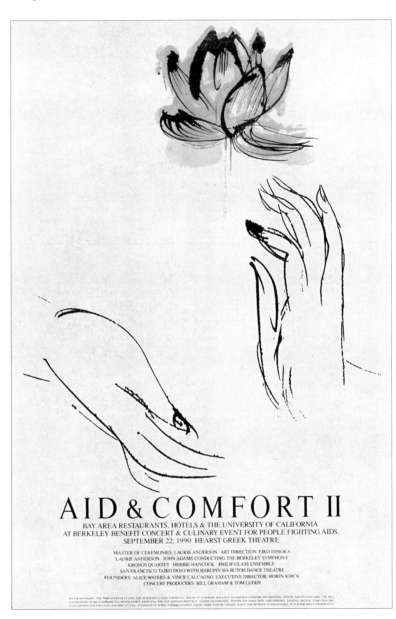

L'Inhumaine

E. I. *L'Inhumaine* was a famous silent French film made in the 1920s. A French producer wanted to revive this film and asked the only man involved with the original production who was still alive to help restore the original film. He wanted to collect all clips still in existence, hand color, and remake the film. The producer found a young French composer to do completely new music. The performances were quite successful.

But the producer was quite ambitious, wanting to bring it to Japan and show it at the Bunkamura in Shibuya, the biggest opera house right in the center of Tokyo. The Japanese producer was even more ambitious. So the two producers asked me to build something visually sensational, a new kind of stage environment, a multimedia stage production around the film. Issey Miyake, Shiro Kuramata, Eiko Ishioka; three designers joined together to conceive, direct, and build entire sets. It was a sensational stage production. I really wanted to take it to other countries but it was too expensive. It is a technique similar to Abel Gance's *Napoléon,* but the final effect is very different. The poster – metal breasts in a see-through chair – symbolizes the dehumanizing of a woman who has become merely a sexual object, what the Japanese call "a slave for many men."

L'Inhumaine
RIGHT *Film poster*

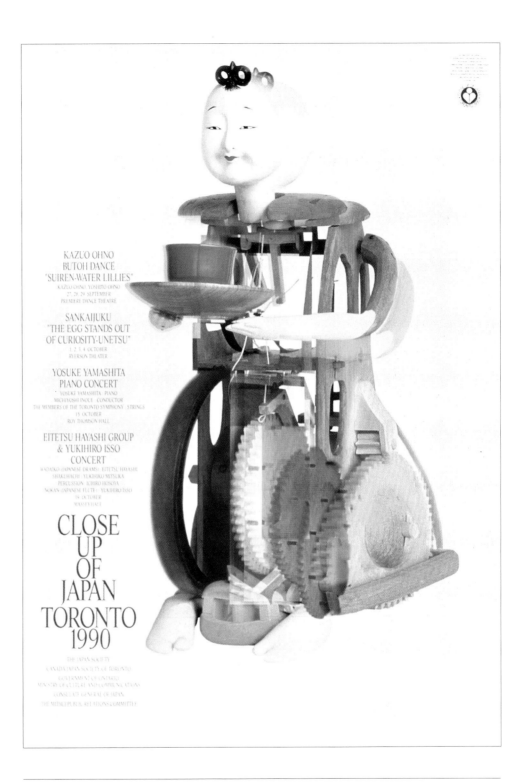

Country
Canada

Close-Up of Japan, Toronto

E. I. *Close-Up of Japan, Toronto* was the subject of a symposium on Japanese culture. I wanted to shoot a naked Japanese automaton. I took off the kimonos, played around with a computer, and worked out a mixed cultural concept: old and modern technology; the industrial revolution married to the new computer technology. Mickey Mouse was overlaid on the image of the Japanese automaton using computer graphics.

Closet Land

E. I. I have been involved with just three films. *Closet Land* is one of my favorites done in 1990. It should be famous but the subject, political torture, is too serious, too heavy. *Closet Land* is an independent, low-budget film, shot in Hollywood, entirely with non-union people. There was no Asian content in this film even though the director was an Indian woman, Radha Bharadwaj. She wanted to speak of this human drama through a more international, global expression. We didn't know what a global style was, but we had long discussions. When I received the scenario for the film, which was excellent, I didn't want to use the obvious realistic solution: a traditional prison setting. This is my own idea of a prison; psychological, claustrophobic.

I designed one big set, the props, and the costumes. The film had two actors, acting for two hours just on this one set. It was psychologically very powerful. When this film was released in America, the Gulf War had just started and it was winter; people just hated to go out and this film suffered.

H. S. What would you like to do next? What is your direction now?

E. I. Before I was nominated for the Oscar I was not concerned too much about awards, but after the nomination I became very apprehensive; I wanted to win. After I won, suddenly I felt confused; now which way should I go? I received a film proposal, a typical commercial Hollywood project. I said no immediately, and rejected five or six more such projects. Now I don't receive any more stupid job offers. People are now very careful about calling me. But on the other hand, I have received five very delightful projects: two movies, one Broadway production, one Robert Wilson play, and the architecture for a private museum. Still, I can't do everything. Now I really want to find out what I want to do by myself. From me to the public. The time has come for me to develop by myself. I am receiving many interesting jobs, but I am only one body. It's a little chaotic.

Closet Land
RIGHT *Film set design*

H. S. Do you still feel passive, accepting things as they come?

E. I. I can't just reject everything. I don't have a strong personal project planned yet and this is another reason I am accepting so many projects. It can be confusing. Time passes so quickly, and honestly, when I look to the future my direction is not quite clear yet. But I feel this is not a bad situation. My friends remind me that my past is unique, very varied: Broadway, opera, films, graphic design, interviews, documentary projects. I have received three major awards already – Grammy, Cannes, Oscar, not to mention Tony nominations. This has never happened to a visual artist before in history. My friends say I should continue as a designer and keep my unique position in the field instead of choosing a new area and rejecting everything else, like a horse with blinders. This may be good advice but for myself, I don't know; I am still very open. I would love to direct a film. In the past ten years I have found a couple of subjects. But if I direct a film I want to direct a really good film. So, the past two decades may have been a training for my film direction.

H. S. Which film would you like to have directed? What's your favorite movie?

E. I. There are many, many that I like. When I started working with Francis Ford Coppola on *Dracula* he said there were two movies I should see as background for *Dracula*, so we saw Eisenstein's *Ivan the Terrible* and Mizoguchi's *Ugetsu Monogatari*. Francis said I should consider these films seriously, so I saw them over and over again. I recognized that *Ivan the Terrible* was a remarkable film. Eisenstein was the director, cameraman, and designer. He could do it all by himself, an almighty kind of man. The film has my type of vision: strong direction, scenario, design, and acting, as well as sensational camera work. These five different elements of the film maker's soul have equal power to connect together and the film is still so fresh. Not all of Eisenstein's films were great but this was sensational, my ideal film.

H. S. Earlier, you were saying Francis Ford Coppola gave you some advice about directing.

E. I. Francis asked me to join him for dinner after a preview of *M. Butterfly* one evening. Fred Roos, producer of *The Godfather*, said, "Why don't you direct a film?" I was so embarrassed because he was asking me in front of such a famous film director. I said, "Are you asking me? Can I do it?" Francis said, "Why not?" He said that film making is like doing a poster to change the world, that they have the same power: one poster, one film. He said, "You can direct a film, why do you hesitate so much?" Anyway, Francis hired me for *Dracula*. He gave me a chance to watch and study film making from a designer's point of view. I even got to sit in and watch him direct the love scenes.

Dracula
ABOVE *Dracula's dragon crest*
BELOW RIGHT
Lucy's 'Snake Dress' evening gown
BELOW FAR RIGHT
Dracula's body armor
OPPOSITE LEFT *Coachman's costume*
OPPOSITE RIGHT *Lucy's wedding dress*

Dracula

E. I. People said this was the first time I could get out of Oriental subjects and get into Western subject matter, but when I researched the story of *Dracula* I saw it spans the 15th and the 19th centuries, two different periods of time, starting in Istanbul, a very eclectic place. There was a big Mongol influence in this city, not Japanese but still Oriental. I wanted to join my own style, my soul, with the ideas of *Dracula*. I want to be a messenger to teach people that cultures can overlap and connect; not specifically an Oriental or Western subject, but a *human* subject. All my projects connect deeply in some way.

The trouble is I just want to belong all over the world – be just Eiko, not Japanese Eiko. I really want to be like that. A leader for international culture, new culture, a global culture. A mixture, like food; Japanese cuisine mixed with French to develop some kind of new cuisine. The meaning of our global culture is still chaotic, nothing is clear yet.

H. S. Is there a danger that this culture will become like a minestrone; everything mixed up with no individual character? In a way, what gives culture a personality is not only what's included but also what is excluded. If you include everything there is no character. It's like sex; a man is a man because he does certain things and doesn't do others. Once he does everything, wears anything, there's no character left. Do you see that as a challenge to your work?

E. I. It depends on the level – if you mix to the extent that there is no flavor, it is like bad-tasting minestrone. But if it is a good mixture, the final taste or visual solution should be something new. It depends on the combinations, it should be a new approach. My goal is always to find a new, delicious combination. Like the 60-second TV commercial I did for Parco with Faye Dunaway eating a hard boiled

egg. When I worked on this TV commercial, I was the director and I cast this movie star. The whole technical crew was American. When I explained my idea to the crew, everyone could understand because it was a completely international idea.

H. S. Don't you think that your idea had more power because of your intended audience? In the Japanese context might it have an impact that it wouldn't have had in America?

E. I. When I showed it to an American audience, they thought that it was perhaps the most sensual picture in Faye Dunaway's history. The American audiences understood my humor much more; they enjoyed it ten times more than the Japanese. When I collaborated with my crew on this idea, there was no gap in our communication with each other. But if my idea had been something about a Ninja eating noodles, an American crew would not relate to it.

I get out of Japan often and have had opportunities to collaborate with many international teams. Take *Dracula*, for example: the cameraman is German, the set designer Italian, the director is American-Italian, the editor is French, five members of the cast are English, and two are American. The costume designer is Japanese. This group of people had to work together and communicate together to collaborate on this international project.

Dracula is concerned with a religion: Christianity, about which the Japanese don't really care. The reaction from the Japanese audience was very different from the American audiences. The cross being stabbed and blood running out of it is a very moving image for the Christian mind, but for Japanese people this symbol has no meaning. There is this kind of cultural difference where communication is not on the same level.

E.I. My recent work has become very Japanese. The last time I went back home to Tokyo, I looked at the cherry blossoms and bamboo and I was very moved. The latest posters I have created use rice paper, brush drawing, traditional motifs. Now I am becoming like a *gaijin*. I am a Japanese with blue eyes!

H.S. In my opinion, you began Japanese; then you interpreted the West to Japan; then you interpreted Japan to the West, and now you are an international Japanese with "blue eyes." But don't you also feel there's that something about you as a woman which moves you towards certain subjects? The fact is that Mishima was a homosexual; in *M. Butterfly* you have a transsexual. Is there something that draws you to these subjects? You have worked with Leni Riefenstahl and Radha Bharadwaj. What is your feeling about being a woman and a designer?

E.I. I have rejected all the offers which present me as a woman or even talk about the future of women. All the time, I have never wanted to be part of any women's group. I want to be independent, I want to be Eiko Ishioka instead of a woman, but I don't want to become a man either. I just want to be a human being! I want to clarify my life, my possibilities.

My goal is to be a great artist, director, creator, designer, whatever. I want to communicate with someone who recognizes beautiful work, is moved or influenced, then starts researching and eventually discovers that this beautiful work was created by a Japanese, a woman! This should be the order. Great work first, my identity second. Since I was young, I have strongly felt that the fact that I am a woman should not come first, although I am very happy as I am and don't hate myself for my gender. In fact, when I am working, I completely forget whether I am a woman or a man.

When I was 25, I received a very important design award called *Nisembi*. I was the first and the only woman winner. It was a great recognition. It's as though I was the only woman to win the graphic designers' Grand Prix. Suddenly all the media and journalists came for interviews and I became famous.

One evening we went to a restaurant for dinner to celebrate my award. A graphic designer, my age, was very drunk and came to my table, touched my shoulder and said, "I envy you because you are a woman. If you were not a woman, journalists wouldn't talk so much about your award." It opened my eyes; if my talent was not exceptional they could say I had an unfair advantage as a woman. I didn't want to hear more uncomfortable remarks like this because he literally represented the general opinion. The only way I can shut them up is by becoming a world-class designer. I promised myself that night that I would become such a creator!

Interviewed by Henry Steiner, 17 May 1993, New York

Kiyoshi Kanai

United States

Country
International

Design Director/Designer/Illustrator
Kiyoshi Kanai

World Wildlife Fund

My goal was to make people aware of the continued use of ivory in Asian countries. These Asian countries are destroying African elephants to market items made from their ivory tusks. People who buy these items are continuing the cycle. My design/illustration was created by using signature seals (or chops) that are carved from elephant ivory. The image of the charging elephant is made up of impressions of various chops. I am constantly aware of the indifferent attitude of Asian cultures towards urgent issues such as vanishing wildlife.

"Don't Buy Ivory"
RIGHT *Poster*

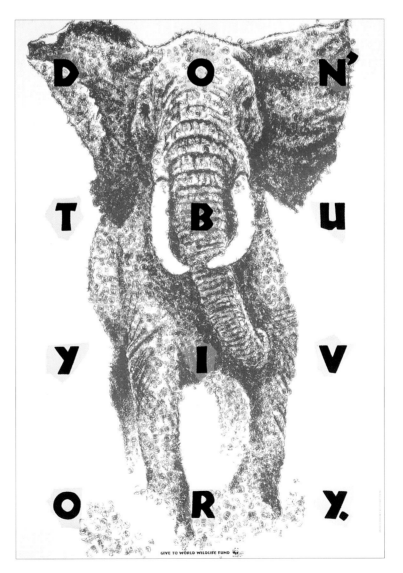

Ivor Kaplan

England

Country
United Kingdom

Design Director
Ivor Kaplan

Silence by Shusaku Endo, 1976
RIGHT *Jacket design*

Peter Owen Ltd

Book jacket for a novel about Christian missionaries in seventeenth-century Japan.

KARO

Canada

Country
Canada

Design Director
Jurgen Grohne

Canadian Pacific Airlines

In 1964, Canadian Pacific commissioned Lippincott & Marguilies to design a corporate identity for their entire group, which was then dominated by the railway but also included shipping, hotels, real estate holdings, and Canadian Pacific Airlines. A distinctive "MultiMark" was developed, with color coding for their different divisions, accompanied by abbreviated names – CP Rail, CP Hotels, and CP Air. Almost 25 years later, CP Air developed new corporate directions and decided on a name and identity change. They were targeting the upscale and business markets, and invited three Canadian design houses to develop preliminary directions and ideas.

Times had changed significantly in the airline business. Deregulation had increased the competitive challenges and opportunities. The Asian market, pioneered by Canadian Pacific as an adjunct to their traditional Far East shipping routes, developed new significance. Throughout the political unrest in many parts of the world, and amidst the belligerent power struggle between East and West, the Canadians' image as independent, peaceful people and their country's good reputation had remained intact. We suggested, therefore, that we reclaim the airline's original name – Canadian Pacific Airlines – and that we retain some identifiable element of the MultiMark as well. Our suggestions won us the assignment to redesign the visual identity of the airline. That identity included the design of what we called the "Motion Mark," which retained the CP triangle and set it against a field divided into five horizontal bars, one for each of the airline's destination continents.

Within the next 12 months – during which time the airline also decided to become fully bilingual and assumed the French name *Ligne Aerienne Canadien Pacifique* – it was merged with Pacific Western Airlines. Once more, a new identity was required, including a new name and symbol. As may be imagined, there was a great deal of internal turmoil connected with the merger of the two airlines. Personnel cuts were expected, and jealousies between the "old" and the "new" people

flourished. It was our opinion that a truly new identity should be found. As design consultants of record, we were commissioned with the task of creating a new identity. A few weeks later we presented our solution, which was driven by the objective to find a name fully acceptable in both English and French.

It was our recommendation to avoid all attempts at fashioning a hybrid, either in name or in mark. We suggested that the airline simply be called Canadian Airlines, or Canadian for short. To make it fully bilingual, we substituted the contentious letter a or e with a symbol, to read Canadian. Our submission for the full name showed a maple leaf in place of the letter.

This solution was accepted by the original management group, but not by the new owners. The search for a new name and a new symbol was now expanded. Other design consultants were invited to make submissions. We were given the opportunity to reconsider our proposal. When all the new proposals were reviewed, no acceptable alternative to our name proposal had emerged. We had resubmitted our proposal, indicating that as their consultants we still felt that a hybrid symbol made of the orginal two airlines' logos would not serve the airline well, insisting instead that:

- Our solution for the bilingual problem was still valid, and that a maple leaf (different from Air Canada's) was most appropriate;

- As "Canada's flag-carrier" to worldwide destinations the airline should show the country's flag, recognized and valued globally;

- None of its international destinations were duplicated by Air Canada, the government's airline, hence there was no potential confusion.

RIGHT *Lippincott & Marguilies'*
1964 "MultiMark"
BELOW RIGHT *KARO's first redesign*
using the airline's original name and
modified "MultiMark"

The End Result:

1. The airline adopted the name suggested by us and added "International" to it in the legal version. The name became Canadian Airlines International, or Canadian for short.

2. The airline adopted our solution for the bilingual problem by substituting a symbol for the letters a or e in the word Canadian.

3. The airline's new owners concluded that our insistence on the maple leaf was inappropriate, told us that our services were no longer required, and commissioned one of the competing design firms with the redesign of the new airline with this mandate:

a) Here's the name: Canadian.
b) Solve the bilingual issue by substituting one letter with a symbol.
c) Design a symbol to fill the space. And NO maple leaf!

The symbol designed at that time, and now in use, is a hybrid made of PWA's winged arrow over the Motion Mark field designed earlier by us for Canadian Pacific – exactly the type of solution we wanted the new airline to avoid.

Lessons to be learned:

- If you want to stick by your professional opinions, be prepared to lose an account.

- If you don't want to lose the account, bring along some alternatives you can live with.

RIGHT *Bilingual wordmark created by* KARO *for newly merged Canadian Airlines* BELOW RIGHT *Wordmark eventually chosen by client based on several ideas*

Clarence Lee

United States

Country
United States

Design Director
Clarence Lee

Illustrator
Bun Lau

The United States Postal Service

The stamp project began with a strong Chinese political group out of San Francisco and New York called the Organization of Chinese Americans. The group lobbied for over four years to get the U.S. government to recognize the contributions of Chinese Americans in the United States. The result was a stamp that recognized the cultural contributions of Chinese Americans by commemorating the Year of the Rooster. San Francisco was chosen as the city for the first-day issuance because it is the cornerstone of the Chinese-American community in the United States.

Although the date celebrated varies widely depending on the country and its beliefs, customs, and calendar, New Year celebrations are among the oldest festivals in history. The U.S. Postal Service has previously recognized several holidays on stamps, ranging from Valentine's Day to Mother's Day to Christmas. However, this Chinese New Year stamp marks the first such philatelic tribute to this widely celebrated event. The colorful design features the Rooster, one of the 12 animals from the Chinese Zodiac that represent a Chinese year.

The design of the stamp incorporates Chinese heritage by using traditional red and yellow colors on a paper-cut. The idea of a paper-cut rooster was inspired by Lee's trip to China several years ago. Paper cutting is a Chinese folk art that dates back thousands of years.

RIGHT *Year of the Rooster postage stamp*

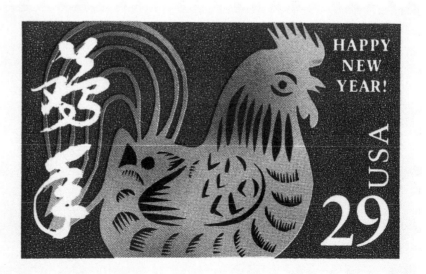

126

M & Co

United States

Country
International

Design Director
Tibor Kalman

Designers
Gary Koepke, Emily Oberman

Benetton

Our brief was to create an independent-thinking multicultural magazine for Benetton that would embrace the idealism of the company, be truly global, celebrate diversity, and encourage progressive thinking.

Our first issue was not as well translated as we would have liked. We misunderstood the time, effort, and complexity that translation would entail. Otherwise we didn't encounter obstacles except our own inbred racism and cultural imperialism. The client didn't hold us back, they pushed us forward. For once the things that went wrong were our fault and not the client's.

THIS PAGE *"Colors" magazine cover*

what are you doing right now?

(we are making a magazine about what
is going on in the rest of the world)

what time is it?

(it's 7p.m. in new york city)

where on earth would　　you like to be?

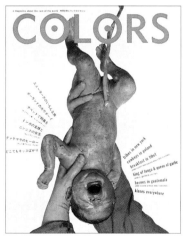

Colors Magazine

THIS PAGE ABOVE　*"Colors" magazine
number 1, inside spread and cover*
OPPOSITE　*"Colors" magazine number 1,
inside spreads*

Actually "client" is the wrong word. They're sponsors. Our sponsors are Italian. They don't like to order entrees until after they finish their appetizers. We found out that this system is better. Our audience is *everywhere* (90% outside of our country), and our staff is quite international – they speak ten languages. We tried to make the subjects international; we used a *lot* of pictures. We tried to keep the writing simple yet intelligent. (Our magazine appears in five bilingual editions: English with Italian, Spanish, French, German, Japanese.)

Lessons learned include:

1. Use your ears and eyes more than your mouth.
2. Assume you understand nothing. Then you might learn something.

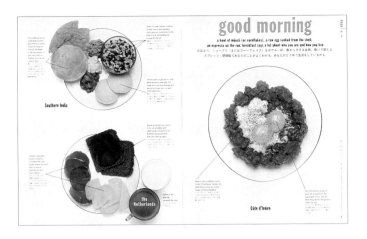

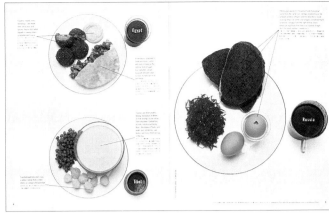

good morning

a bowl of muesli (or cornflakes), a raw egg sucked from the shell,
an espresso wa the rua: breakfast says a lot about who you are and how you live

おはよう。「ミューズリ（またはコーンフレイク）」をボウル一杯、殻からすする生卵、強いて冷えし
スプレッツ・初体験てあなたのことがよくわかる、あなたがどういう生活をしているのかを。

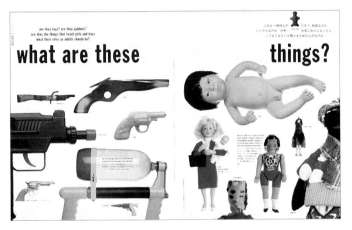

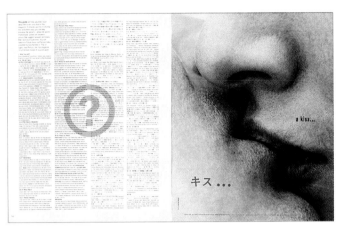









これは一体何なの たち 玩具なのか
シンボルなの 少年 少女
少女に大人になったら、
こちらなりなさいと教えるためのものなのか。

"a kiss..." "キス..."

 Southern India, the Netherlands, Côte d'Ivoire, Egypt, Russia, Tibet.

are they toys? are they symbols?
are they the things that teach girls and boys
what their roles as adults should be?

what are these things?

a kiss...

キス...



 Southern India, the Netherlands, Côte d'Ivoire, Egypt, Russia, Tibet.

Magnus Nankervis & Curl Pty Ltd
Australia

Country
Thailand and worldwide

Design Director
Ted Curl

Writer
John Nankervis

Photographers
Mike Skelton, Peter Luxton

Thai Airways International

The objective of this campaign was to communicate the airline's superb service values, which derive from both Thai culture and high technological expertise. The solution was to show the logo split in two parts, with the top half representing a traditional Thai art form and the bottom half symbolizing a high technology design. The simple, graphic images communicated strongly.

130

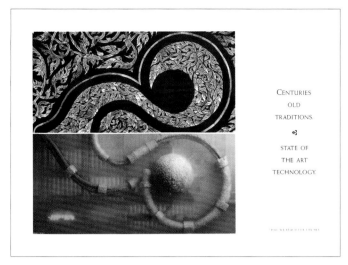

CENTURIES
OLD
TRADITIONS.

❧

STATE OF
THE ART
TECHNOLOGY.

THAI. WE REACH FOR THE SKY.

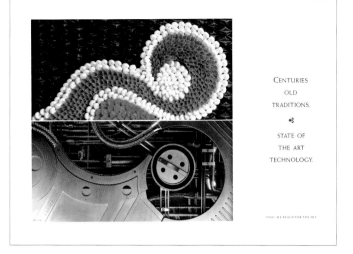

CENTURIES
OLD
TRADITIONS.

❧

STATE OF
THE ART
TECHNOLOGY.

THAI. WE REACH FOR THE SKY.

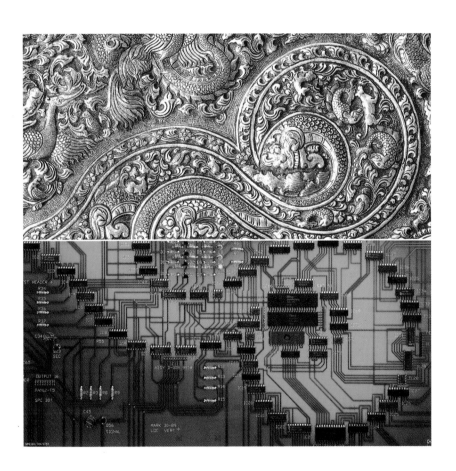

CENTURIES

OLD

TRADITIONS.

❧

STATE OF

THE ART

TECHNOLOGY.

THAI. WE REACH FOR THE SKY.

Thai Corporate Logo Campaign

THIS PAGE AND OPPOSITE
*"Centuries Old Tradition/ State of the
Art Technology"*

Country
Thailand and worldwide

Design Director
Ted Curl

Writer
David Bourne

Photographers
Peter Luxton, Mike Skelton

Thai Airways International

The goal was to build awareness of each area of Thailand's tourist attractions. Our solution was to juxtapose a crass image of an "everyday" Western scene (from which travelers would wish to escape) with exotic versions of parallel scenes in Thailand, thereby demonstrating that even everyday life is more pleasurable in Thailand. One pertinent lesson learned in this campaign was the importance of being consistent over an extended period of time in order to maximize the campaign's influence.

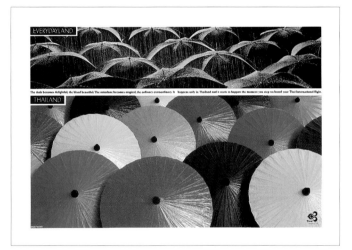

Corporate Logo Campaign
THIS PAGE *"Everydayland/Thailand"*

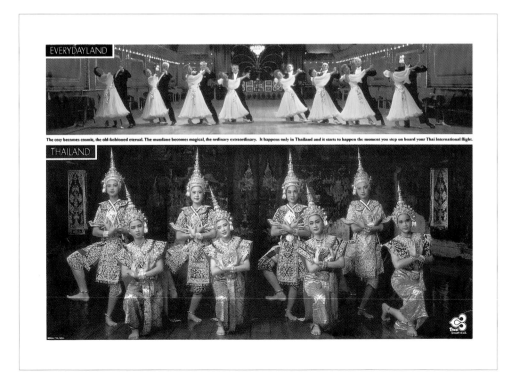

Fernando Medina

United States

Country
United Kingdom

Designer/Illustrator
Fernando Medina

Michael Peters Ltd

Michael Peters asked me to design a 12" x 8" sign-plate to label the men's and women's toilets in his new London design office. He didn't give me any further specifications. Since the users were designers and the sign would be part of a design studio, I was able to come up with a non-conventional design. My "client" was British and I am Spanish, but this did not affect my design. It was supposed to be a simple and clean sign, comprehensible to all, no matter what their language or culture. Designers from different countries were chosen to do signs for other areas in the office including the main studio, the reception area, and the kitchen. I was able to learn the different styles, solutions, and interpretations of all these designers.

THIS PAGE *Men's/Women's toilet signage*

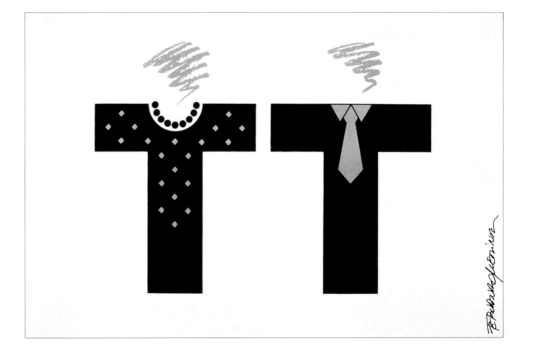

133

Country
Mexico

Designer/Illustrator
Fernando Medina

Trama Visual

As a result of a series of lectures and workshops I gave in Mexico, I was invited to design a poster to commemorate my visit to that country. The only specifications I received for this project were the dimensions of the poster. Due to a tight schedule during my stay in Mexico, the poster was designed and printed in record time – two hours for design, two hours for artwork production, and a few more hours for printing. I didn't have any linguistic difficulty, since my native language is Spanish. As for the culture, I felt no problem.

In this case, I learned that sometimes it is possible to do efficient work with little time and a small budget. I must add that in the concept and development of this project, I kept in mind the strength of the Mexican culture that influenced me. I wanted to reflect this through the pyramid that I used as a letter M to symbolize Medina and Mexico.

BELOW *Fernando Medina en Mexico poster*

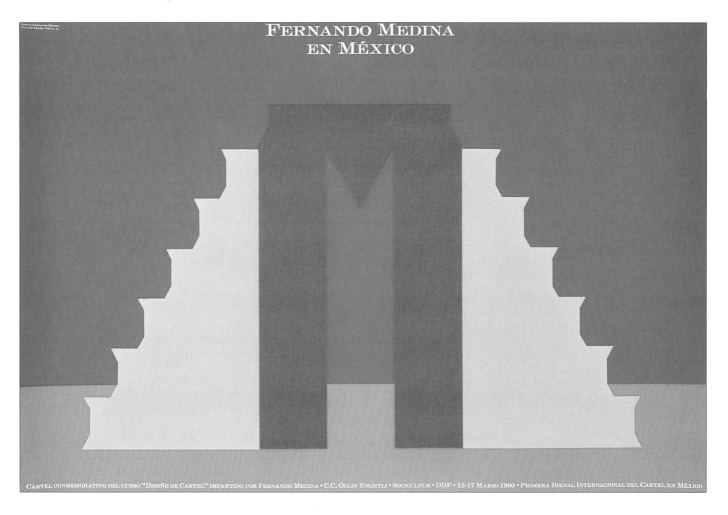

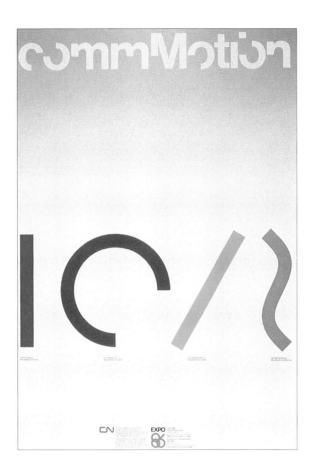

Canadian National Railway

I was instructed, in the briefing for this project, to design the logo and a poster for the Canadian National Railway Pavilion (CN). The theme was Communication and Motion – thus the word "Commotion." In the pavilion's exhibits, the public could see the four forms of movement identified by Newton: Vertical, Circular, Acceleration, and Oscillation. The client gave me enough time and freedom to design the visual identity of this pavilion.

In this first stage, I designed the Commotion logo. Then I designed the four symbols identifying the four movements. With these two basic elements conveying the pavilion's visual identity, I designed the CN poster. In this particular project, I collaborated with the industrial designer who designed both the pavilion itself and the four exhibits. He suggested including a grid in the background of the poster, but I refused. Finally, he insisted that I add a graduated gray background to the poster. I never agreed with the background, nor the gray color.

This project was done in Montreal, Canada, in early 1985, right after my arrival in the country. In those days neither my English nor my French were very good, but since the design profession doesn't require much talk around the development of a concept, I don't recall having had any problems aside from the disagreements about the poster. I was closely involved in the Commotion pavilion design. This project has enriched my perspective when I look at design, making my experience wider in three dimensions.

135

謹賀新年

1987年 元旦

本房 和子
株式会社本房事務所
東京都港区南青山6-7-5 TEL.03-406-3001

Country
Japan

Designer/Illustrator
Fernando Medina

Igarashi Design Studio

The Japanese designer Takenobu Igarashi gave me the assignment of designing his studio's 1987 New Year greeting card. The only specifications given to me were the card's dimensions. I developed this project during my stay in Tokyo in 1986. The red brush stroke is the Igarashi Design Studio symbol. I decided to include it as one of the two elements that form the number 7. Because I was allowed to develop this project with total freedom, and because design is a universal language, I didn't have any significant difficulties creating this greeting card, even in a country and a language so different from my own.

My stay in Japan was indeed a learning experience, not only professionally, but in human terms as well. Working with Takenobu Igarashi and his staff, on this and other projects, allowed me to view in more depth some of the Japanese designer's criteria and points of view.

James Miho

United States

Country
United States

Japanese American National Museum

The problem posed was to design a logotype that expressed the experience of Japanese immigrants in the United States along with the experiences of the following generations (1st generation: Issei, 2nd: Nisei, 3rd: Sansei). Since airplanes did not exist in 1895, immigrants traveled the Pacific by boat to reach America. Even until 1941, the water route was used, so, inspired by Hokusai's wave print, I designed a wave logo. I used each wave as a metaphor for each generation's immigration. Some years (or generation's) immigration was a big wave, and some years it was smaller. I showed six waves to balance out an optical heart – the immigrants all have feelings for Japan but once they are here they become totally American. This balance is often tested just as WWII tested their loyalty. In 1941 there were 108,000 Japanese-Americans – today there are 847,000.

Clement Mok

United States

Country
International

Design Director/Designer
Clement Mok

Writer
Steve Goldstein

Photographers
Michael Lamotte, Tom Zimberoff,
Steve Underwood

Expervision Corporation
OPPOSITE *Capability brochure*

Expervision Corporation

We were commissioned to create a corporate capability brochure that would position the client as an established international software company, whose business is in developing state-of-the-art optical character recognition (OCR) technology for desktop computers. The foundation of the business is based on a core of technology that recognized any characters, any font, in any language – including Kanji characters! As a matter of fact, the technology was developed around the ability to recognize Kanji characters. The client is an American company based in Silicon Valley and employees have diverse technical and management backgrounds. The key concern was the fact that this company is managed and operated by Asian-Americans, and the client did not want to be portrayed as a foreign company. How do you avoid racial stereotyping (Asian techno-weenies) and at the same time explain the technological innovation and the operational strength of an organization? Since this capability brochure is geared for CEOs and MIS managers, it's critical to show the technical, management, and financial strengths of the company. People want to do business with a smart company and people don't want to do business with a faceless organization. What is not shown and said can be perceived as a weakness – particularly in the technology business. Our solution has four main points:

1. Focus on the innovation and the features of the technology.
2. Use the visuals of management and facilities as a support.
3. Be as direct and as simple as possible.
4. You cannot change or hide ethnic background. You are what you are.

The fears about being perceived as a foreign company were signs of insecurity on the part of the owners of the company. The Japanese and the European audiences thought that they were an American company – a little quirky but definitely American. The American audience, however, did perceive the company to be owned by Japanese. This did not really affect business transactions; if anything, it was seen as an asset.

PRESENTING
TYPEREADER.

THE FIRST OCR
SOFTWARE THAT
CAN READ ANY
PAGE OF TYPE.

EXPERVISION

Country
International

Design Director/Designer
Clement Mok

Writer
Steve Goldstein

Photographers
Michael Lamotte, Tom Zimberoff,
Steve Underwood

Expervision Corporation

The problem posed was to create a product brochure to explain OCR software that can recognize Kanji characters. The brochure needed to explain the technology visually and textually. The brochure must be able to be localized or updated with black-plate changes as necessary. For our solution, we determined a few guidelines:

1. Focus on the message.
2. Visually illustrate the features of the technology.
3. Don't show Kanji characters – just reference them. Ninety-nine percent of the business world doesn't care if the product can recognize Kanji characters or not. Only the Japanese market does. English is the global business language. Focus on the product's strength with OCR mainstream business documents.
4. Make the documents and props visually identifiable.

Lessons learned included the fact that focus translates into results: there were 10,000 inquiries at COMDEX (the computer industry's largest trade show) and 20 percent were from Japanese customers. We also learned that the language of technology is English. Localization is not really necessary, provided that the visuals and diagrams are structured and designed in a way that is universally understood.

Bruno Oldani

Norway

Country
Norway

Design Director/Designer
Bruno Oldani

Bruno Oldani Design Studio

Every year on 17 May – Norwegian National Day – I throw a "fiesta" party for my friends. To keep the "natives" in good spirits, I made the invitations a bit naughty by reminding them of the time when their country still belonged to Sweden. (It's a bad joke – they don't like to think about that.) The two countries had a peaceful "divorce" in 1905. Before then, Norwegians had to use the flag of the Union of Norway and Sweden, which was a Norwegian flag with the hated symbol of the union in the corner. This flag the Norwegians satirically called *sildesalaten* (the herring salad). So, as a Swiss citizen living in Norway for the past 35 years, I send out invitations for a Norwegian National Day party to remind them that they could easily be overtaken by the Swiss that very day!

By the way, my party has the reputation of being one of the best in town. Friends with their children, students, and clients (approximately 120 to 150 guests) come to my office for food and drinks and celebrations and to watch old Chaplin movies. The office is completely decorated as a Swiss/Italian Ristorante. Outside the door is a big Swiss flag decorating the façade together with a sign announcing the "Ristorante del Popolo" (People's Restaurant). This is a sensational contrast to the rest of Norway, which is decorated with Norwegian flags on every house.

Norwegian National Day Celebration Party
RIGHT *Invitation*

141

Country
Norway and International

Design Director/Designer
Bruno Oldani

40th Anniversary Congress of AGI
in Oslo, 1992
RIGHT *Poster*

Alliance Graphique Internationale

Norwegian traffic signs indicate areas where you are likely to encounter elk on the road. In this case, the elk is dressed up for the AGI anniversary celebration.

Country
Asia – Pacific Rim

Design Directors
Alan Fletcher, John McConnell

THE MANDARIN

HONG KONG

Mandarin Oriental Hotels
ABOVE *Hong Kong corporate identity*
RIGHT *Signage*

Mandarin Oriental Hotels

There is a commonly held belief that a set of rules assembled into a manual provides an effective instrument to apply to a corporate identity. However, like a musical score, the way it is interpreted depends on the players.

Our client was a British company that operates hotels in the Pacific Rim. Two of their hotels, The Mandarin in Hong Kong and The Oriental in Bangkok are considered among the best in the world, with a reputation for superb service and luxurious facilities. Nevertheless, customers and the travel business had a confused perception of the group as a whole. Many hotels in the Far East are named "Mandarin" (or "Oriental"), as are restaurants, nightclubs, take-aways, flophouses, and laundries. Even some of the upmarket competition had adopted the same names, and in a few cases even copied the decor and style of the Hong Kong Mandarin. This confusion was further compounded by differences in standards between the hotels, and the lack of a cohesive graphic identity.

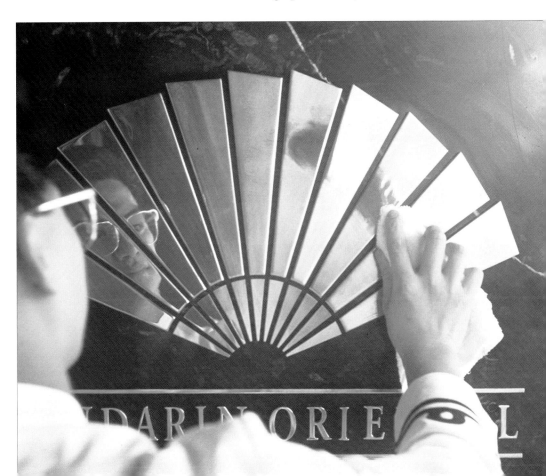

Mandarin Oriental Hotels

ABOVE LEFT *Corporate identity*

ABOVE RIGHT *Stationery*

RIGHT *Corporate identity system*

OPPOSITE *Corporate literature*

The design, as a new identity, acts as a catalyst. It makes an organization focus on what it does, who it is, and where it's going. The first decision taken by the company's management was to change the corporate name from "Mandarin International" to "Mandarin Oriental" to maximize on the goodwill of the two leading hotels. The other hotels were brought into line by changing their names to "Mandarin" or "Oriental," and those that did not measure up to customer expectation were sold off. The task was to design a symbol and corporate identity to represent the newly restructured group.

To acquaint themselves with the market, Alan Fletcher set off west via "The Mandarin" in Vancouver, and John McConnell went east via "The Oriental" in Bangkok. Each local manager voiced his views and organized a punishing roster of meetings with staff, local travel bureaus, and advertising agencies. Despite the classy accommodations, it was hard work. The designers rendezvoused in Hong Kong to

compare notes. One factor that clearly emerged was that whereas the head office was convinced of the need for a single standard identity, the hotel managers felt quite the opposite. They considered their hotels unique and individual, and in no way wished to be perceived as components of a characterless hotel chain. This was the nub of the problem.

The design of a corporate identity is not an arbitrary stylistic decision, but seeks to express the nature and character of an organization. In this case the client was looking in two directions at the same time. Since a new design depends on the support of those it represents, it seemed appropriate to strike a balance between the conflicting ambitions of standardization and individuality. With this in mind, the first approach was to create a family resemblance rather than corporate uniformity. A different device was designed for each hotel, but each was drawn in the same style within a circle to provide a cohesive appearance. There was a palm for Singapore and a star for Vancouver, along with other appropriate icons. The chief executive, although sympathetic to the designs, insisted on a symbol with fewer variants.

In the second round a set of designs was developed using geometric interpretations of flowers. The concept was that the flower provided an overall theme, while the species provided the individual symbols. There was a lotus for The Mandarin in Hong Kong, an orchid for The Oriental in Thailand, a cherry blossom for a possible new hotel in Japan, and so on. Again the scheme was rejected. The chief executive was concerned that the flowers might be perceived as effeminate. On the plane back to London, John McConnell revived an idea that had been

abandoned in the initial stages. He suggested using a fan. Alan Fletcher remembers how "On arrival back in London, John tried to convince me he'd found the answer. I thought that he'd had a touch too much of the 'midday sun.' How would a client uncomfortable with flowers react to a fan?" Anyway, as every designer knows, trying to second-guess a client's reactions is notoriously unreliable, so it was decided to go for the fan. Fans come in all sorts and shapes, and after working on several different versions it was decided to focus on a generic form. This time the client was both satisfied and delighted, except for a local cultural snag. The fan had been designed with fourteen segments, an unlucky number for the Chinese. The final solution ended up with eleven. Superstitions cannot be ignored – after all, The Mandarin has no thirteenth floor.

After the gaff over numbers, the selection of colors was treated with caution – color is emotive stuff. Muslims have a great affinity for green, Chinese associate blue with death, and Indians get buried, not married in white. As the hotel managers were miffed because they had a common symbol, it was thought prudent to enlist their help in choosing the colors. The manager in Hong Kong expressed a preference for "Chinese Red" but couldn't specify the precise hue. A sample cut from the menu of the Peking Garden Restaurant, situated behind the hotel, eventually provided the answer. A swatch of orange fabric used for the robes of Buddhist priests was the sample for The Oriental in Bangkok. The Swiss manager of the Singapore hotel was keen to have the same maroon as his favorite tie but declined to provide a clipping. San Francisco wanted the same red as in the 'stars and stripes.' And the daughter of the hotel's business associate in Malaysia proposed a delicate salmon pink. At this point, she was also going to marry the chief executive, so it seemed ungracious not to accept her suggestion.

Mandarin Oriental Hotels
ABOVE *Package designs*
OPPOSITE *Door signs*

The elements of the identity and the general design principles were codified and assembled into a simple guide. Since this was to be used by suppliers whose knowledge of English was often rudimentary and whose design expertise was nil, every conceivable combination of symbol, type, and color was illustrated to minimize misunderstandings. The tools, so to speak, were in place. But the fashioning and production of items to the necessary standards of graphic excellence proved to be something else. Converting theory into practice is never simple, and the implementation of a new corporate identity at arm's length, in nine different countries at the same time, is even more difficult. Several countries prohibited the import of printed materials, and specifying Garamond in Jakarta generated proofs in Cooper Black; it was difficult to obtain decent die-stamping in Hong Kong, and there was a virtual state of civil war in Manila. The most practical solution was for Pentagram to open a temporary office in Hong Kong, but in a deteriorating economic climate the client was not enthusiastic. The second plan under consideration was to design all the items for The Mandarin in Hong Kong, which would provide a working model for the other hotels to follow. However, circumstances took over and both options went out the window. The Hong Kong Stock Exchange headed for a crash, and the chief executive first cut the budget severely and then left the company. Drastic financial constraints combined with the rapidly approaching deadlines obliged everything to be designed locally through the guide manual.

As Alan Fletcher put it, "Design by rote is analogous to a deluxe restaurant replacing the chef with someone mildly interested in cooking, and then giving them a book of recipes. The difference of course lies in the results. As the French proverb says, there is no such thing as a pretty good omelette."

Country
Kuwait and worldwide

Design Director
Alan Fletcher

Commercial Bank of Kuwait

It might be thought that a designer's main problem is the generation of creative ideas. Wrong. The problems lie in negotiating the hurdles to get them realized. Throw in a few thousand miles between designer and client, include linguistic and cultural factors, and by contrast the design process is comparatively simple.

Designing in the Middle East requires certain cultural adjustments to one's normal working pattern and life-style. The Gulf States are seven hours flying time from London with a time difference of three hours. Traveling on Arabic airlines is like arriving in the Gulf before you've left. It's a dry journey – there is no alcohol. At midday Muslim passengers are likely to say prayers while prostrated in the aisle – one wonders about the flight deck! Normal working hours are 8:00 AM to 1:00 PM, and even then a government survey indicated that the oil-rich Kuwaiti works only an average of ten minutes each day. Friday is a holiday, but they work on Saturday. Appointments are not necessarily appointments, and frequently involve hours (if not days) of waiting. The Commercial Bank of Kuwait had only catered for institutions and businesses within the Gulf States until they decided to expand into international markets and enter retail banking. The new policy created the need for an appropriate visual identity. Since the Bank had neither the experience nor resources, it appointed Tony Vines (via Ogilvy & Mather, New York) to set up a marketing department and create a new identity within 18 months. Vines flew to London, interviewed various advertising agencies and designers, and on reaching a rapport with Pentagram commissioned us to work on the program. His fast response in locating a design resource set the pace for the hectic schedule that followed.

Commercial Bank of Kuwait identity
BELOW *Symbol*
BOTTOM AND RIGHT *Signage*

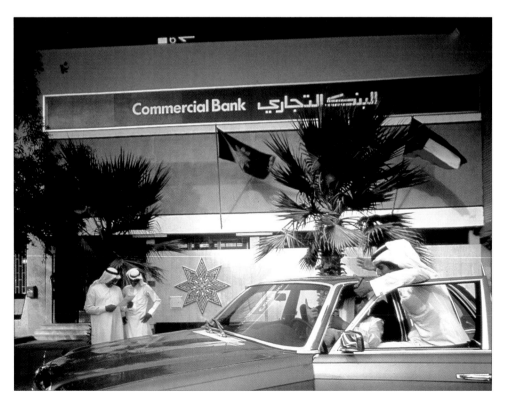

Commercial Bank of Kuwait identity
RIGHT *Stationery*
BELOW *Corporate literature*
BELOW RIGHT *Customer products*

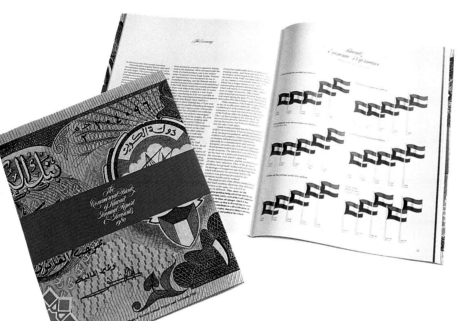

In architecture the term "fast-tracking" describes the method of designing in which the architect keeps one jump ahead of the builder. In this case the severe deadlines and cultural differences made it more a jump in the dark. The brief stipulated that the corporate identity and design style should be Arabic in flavor, while also communicating internationally. The symbol, in particular, was required to mean something to both an Arab and a Westerner. Designing within these constraints reduced the normal available options. The two different scripts precluded using the alphabet to form a logotype such as Unisys, or initials such as IBM. An abstract mark would take too long to establish. A pictorial device might have encouraged the client to insist on a heraldic solution such as a scimitar crossed with palms. However, the design of the symbol proved to be the least of the problems. Designing from right to left, in a script and a language one didn't understand, within an unfamiliar culture, required keeping one's head fast on its feet.

149

Pentagram
New York

Country
International

Design Director/Designer/Illustrator
Michael Gericke

New York Art Directors Club

The project was to design a poster that would invite entries for an international design exhibition. Given the habits of many designers, entries would most likely be sent at the last minute by air courier. The poster image is of many international flags folded into paper airplanes, all flying towards a single target. Flags are memorable, familiar, and symbolic images representing various cultures.

New York Art Directors Club
International Exhibition
ABOVE *Call for entries poster*

Hotel Hankyu International identity
RIGHT *Identity System*

Country
Japan and worldwide

Design Directors
Michael Gericke, Colin Forbes

Designers
Michael Gericke, Donna Ching

Illustrator
McRay Magleby

Hankyu Corporation Group

Hankyu Corporation Group, a conglomerate of 305 diversified businesses, is one of Japan's leading railway companies, and is active in real estate, retailing, and leisure industries. Hankyu currently operates 15 midscale business hotels in Japan and wanted to establish the Hotel Hankyu International as the Group's flagship luxury hotel. This venture tied in with the renewal and development of the fashionable area surrounding the site of Japan's new international airport.

Osaka-based Dentsu, Hankyu's advertising agency, invited Pentagram to become involved in the project soon after its inception. In a reversal of the usual procedure, the client commissioned the graphics program before other design projects and even used it as a reference during development of the hotel's interior design and architecture. The Hankyu Group chairman, Kohei Kobayashi, briefed us and asked that his hotel be positioned as an international luxury hotel, not as Japanese. (It was interesting to note that the Japanese perceive American graphic design as the "international" style and made a conscious decision not to hire a Japanese designer.) Typical guests would be corporate leaders, diplomats, entertainers, and sophisticated travelers. Mr. Kobayashi's only other design directive was that he wanted the hotel's emblem to be a flower, a symbol he thought

151

Hotel Hankyu International identity
CLOCKWISE *Package design, room numbers, luggage tag*

transcended nationalities. Pentagram was commissioned to design a complete hotel identity program, including symbol, alphabet, colors, and a decorative motif.

Pentagram Associate Michael Gericke and his team developed a system of six stylized flower symbols, one for each floor, and a custom alphabet to be used with the symbols. The concept was to express luxury by differentiating every item in the hotel with a special detail. Applications include signage, room folders, stationery, packaging, menus, and other amenities. The program has won design awards from ID magazine, Communication Arts 91 Design Annual, Print's Regional Design Annual, and Siggraph 91 Art and Design Show.

Managing a project across continents takes careful planning and teamwork. Mr. Kobayashi also asked us to select an interior design firm that would meet his international expectations. Los Angeles-based IntraDesign, a firm whose luxury hotel experience includes LA's Four Seasons Hotel, was chosen for the job. The project was a collaborative effort by Americans and Japanese. Pentagram spearheaded the design team. It included Dentsu, who coordinated the team's work with the Hankyu management; IntraDesign; Tokyo-based OUN Design Corp., the project managers; Osaka graphic designers NON Associates, who handled Japanese type translations and supporting graphic design; and Osaka architects Takenaka Corp., who designed the building.

The language barrier was initially an obstacle. During early meetings the team members acted as translators. Conversations became abbreviated translations and

because of the subtleties of each language, the personal or interactive component of the meetings was lost. The translator would interpret a five-minute comment with one or two sentences and, similarly, the five-minute response was translated into one sentence. The meetings were slightly awkward but efficient.

Later in the project, an outside translator who interpreted meetings verbatim was retained. This proved to be very valuable – we had positive discussions and could even understand (and laugh at) each other's jokes.

Executing communications in a language that has no graphic resemblance to Western culture was also a challenge. To help guide us, a Japanese graphic design firm, NON Associates, was retained to source available Japanese fonts, prepare translated typesetting, and produce the many bilingual forms and collateral the hotel required.

Creating appropriate images or messages that are used within other cultures requires thoughtful research, planning, and advice from individuals from that culture. You must understand your audience if you wish to surprise them.

THIS PAGE *Guest amenities*

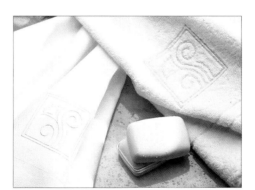

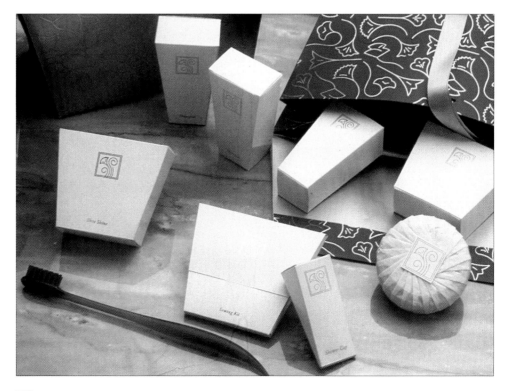

Pentagram

San Francisco

Country
United States

Design Director/Designer
Linda Hinrichs

Designer
Natalie Kitamura

Photographer
Barry Robinson

Pentagram Papers

The goal was to present the design imagery of the Mao political culture, along with the variations within the theme and purpose. We tried to simplify the symbology and the story behind the images – and to present the "feel" of the *red* and the *imagery* and the impression one gets upon seeing the whole collection. The solution was a collective experience and a special opportunity to present an especially graphic part of history.

Introduction from the Book:

"Two years ago Jenny Wong, a student in Kit Hinrichs's design class at the California College of Arts and Crafts, asked if she could bring Kit a souvenir from Shanghai, where she grew up and her parents still lived. 'A Mao button or Red star,' Kit requested. To his surprise, Jenny returned with a hand-crafted wooden case filled with buttons. What she hadn't revealed to him before she left was that her father, Xue-shi Shen, was an artist/craftsman who designed Mao buttons during the years of the

Pentagram Papers #17:
The Many Faces of Mao
BELOW *Cover*
RIGHT AND OPPOSITE
Inside spreads

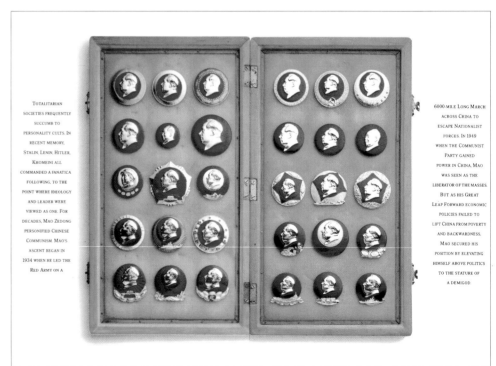

TOTALITARIAN SOCIETIES FREQUENTLY SUCCUMB TO PERSONALITY CULTS. IN RECENT MEMORY, STALIN, LENIN, HITLER, KHOMEINI ALL COMMANDED A FANATICA FOLLOWING, TO THE POINT WHERE IDEOLOGY AND LEADER WERE VIEWED AS ONE. FOR DECADES, MAO ZEDONG PERSONIFIED CHINESE COMMUNISM. MAO'S ASCENT BEGAN IN 1934 WHEN HE LED THE RED ARMY ON A

6000-MILE LONG MARCH ACROSS CHINA TO ESCAPE NATIONALIST FORCES. IN 1949 WHEN THE COMMUNIST PARTY GAINED POWER IN CHINA, MAO WAS SEEN AS THE LIBERATOR OF THE MASSES. BUT AS HIS GREAT LEAP FORWARD ECONOMIC POLICIES FAILED TO LIFT CHINA FROM POVERTY AND BACKWARDNESS, MAO SECURED HIS POSITION BY ELEVATING HIMSELF ABOVE POLITICS TO THE STATURE OF A DEMIGOD.

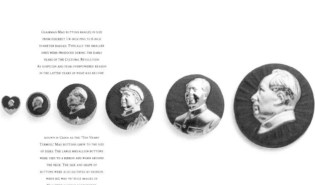

Cultural Revolution. This remarkable gift led to a challenge to Linda Hinrichs' brother, Dr. Larry Davis, to seek out more Mao buttons on his 1988 medical sabbatical to Shanghai. At first, Larry and his two teenage children found none, but as they became more adventurous, they discovered numerous button sources, eventually amassing an incredible collection of their own. Pentagram staffers Shirley Yee and Albert Tong further augmented this collection on their visits to China with their parents. Astonishingly, out of the dozens of Mao buttons collected, only one was a duplicate. Current politics aside, this amazing set of icons represents a curious and special part of twentieth-century history."

Pentagram

San Francisco

Country
Japan

Design Director/Designer
Neil Shakery

Photographer
Douglas Kirkland

Takasagoden

Takasagoden owns a franchised chain of facilities that stage and produce weddings in Nagoya. It is commonplace for couples to be married this way in Japan. Our task was to upgrade the promotion without violating the sensitivity of the culture for which it was intended. The equivalent would be a Japanese designer producing Thanksgiving or Christmas promotions for the United States. Previous promotions for Takasagoden were very catalog-like, portraying the wide variety of services offered in a matter-of-fact way. We felt that potential customers could be approached most effectively by a promotion showing the romance and emotional appeal of the occasion so we decided that the brochure should tell the story of a couple from engagement to honeymoon. Prior to developing the concept we spent a week in Nagoya at the company's main facility, and we were able to sit in on weddings to get a sense of what was involved. The ceremonies and attendant celebrations were extremely complex, taking several hours and involving many changes of costume. When we went back to Nagoya to do the photography, Takasagoden staged a full wedding, complete with 60 of their employees posing as guests.

Money matters must be handled very delicately in Japan and negotiations can be neither rushed nor pinned down too tightly. Our week of research in Nagoya was

すがしい木の香が、心をつつみます。

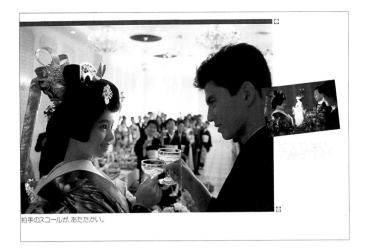
拍手のスコールが、あたたかい。

衣ずれの音が、とてもまぶしくて。

父が、黙々と箸をすすめています。

薬指に、あなたがきます。

Takasagoden promotion brochure
OPPOSITE PAGE *Inside spread
and cover*
ABOVE *Inside spreads*

punctuated with lengthy daily meetings with the client, where our credentials were discussed and examined at great length. However, it was not until one hour before I had to take the train back to Tokyo that I was invited to raise the question of our fee for the job. Similarly, during discussions with a young Japanese graphic designer, whom I was enlisting to help with typesetting, questions about his hourly rate produced an almost embarrassed and totally evasive response.

My proposal called for us to follow the job through the production process. The design and photography were enthusiastically approved, color layouts were shipped for separation, and I awaited delivery of press and type proofs. Nothing arrived. On inquiring, I was told that there were difficulties with copywriting. After months of delay a package appeared on my desk and in it I found the printed brochures, along with a note from Takasagoden telling me how pleased they were with my work. Unfortunately, I was less pleased. The printing was mediocre, embossing and varnishes had been deleted, colors changed, captions dropped, and my young Japanese designer obviously decided to make improvements on my type selection and layout. Although my client seemed receptive to the contribution that a Western designer could make to his company, there seemed to be real limits to how much control he was willing to give up in the final analysis.

157

Michael Peters
England

Country
Korea

Design Director
Glenn Tutssel

Designer
Maddy Bennet

Johnson & Johnson Lite
RIGHT *Baby oil package design*

Johnson & Johnson

The project was to create a package design that would show the purest of baby oils. Our solution involved a feather printed on the back label so that it is magnified by the product itself. We learned that symbolism transcends language barriers; the combination of the feather and the clarity represents the lightness of the product.

Dan Reisinger

Israel

Israel, with its two official languages and English, is a country in which cross-culturization is epitomized, and presents enough challenge to any designer. This fledgling state was created by a diverse combination of Jewish people from all corners of the earth, united by their collective search for a haven.

Unlike most religions, Judaism is not a visually oriented faith; it is rather a cerebral and spiritual voyage. Artists are therefore compelled to seek their imagery within their own personal experience and environment.

The early stages of my education were influenced by the Hungarian-Fascist and Soviet-Communist regimes that dominated my native country. I survived the Holocaust and its aftermath and emigrated to Israel. I have also spent a few years in Brussels and London, and I travel internationally whenever possible.

The act of visualization is my own private culture.

Atelje 212

In this identity for an experimental theatre in Belgrade, the cyrillic letter Љ, slightly turned, doubles for the number 2. The multi-direction of the logo points to changing artistic aspirations in the post-Tito period.

Country
Israel

Design Director
Dan Reisinger

Atelje 212 identity
R I G H T *Logo and graphic house style*

Personal work

Personal statement in support of the liberation of Russian Jewry. A well-known symbol is planted into a different context.

"Let My People Go"
RIGHT *Poster*

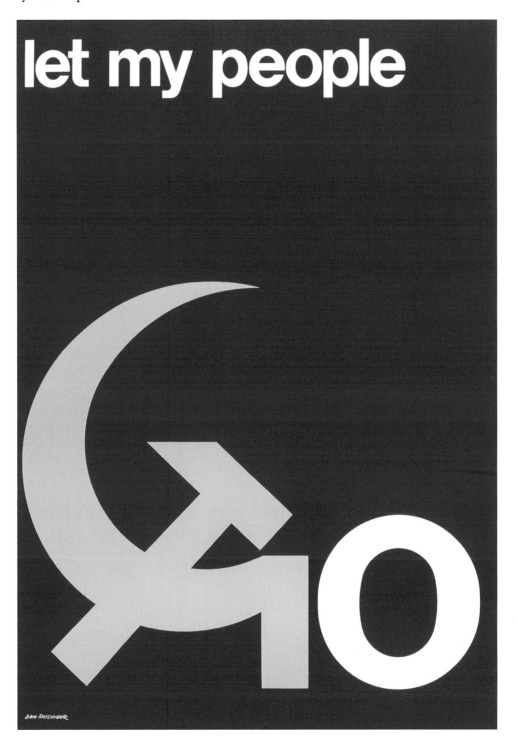

Open Museum/Muzeon Patuah
BELOW *Identity*

Open Museum for Contemporary Art

The logo for the Open Museum, or 'Muzeon Patuah' has four initials contained in two strokes. Both Hebrew and Latin letterforms are identifiable in the image.

Helmut Schmid

Japan

I work in Japan, and for Japan, and I also live in Japan. I am German, yet I have never felt a wall between myself and the Japanese. I do not feel I am a *gaijin*. Instead, I feel completely free in Japan. And I have the feeling that the Japanese accept me just as I am: a person ignorant of their language but enchanted by their concepts of space, form, and sound. Our profession has always been international, or, let's say, broad-minded. The exchange of ideas over borders has always existed.

The brief for projects is always open in my case. I *cannot* design with given design solutions, with a requested typeface or a predetermined color. I can only design when I have the trust of the client. I listen to the client's concepts and requests and try to give the best possible solution. And this best possible solution can only come when *I* am satisfied with the design. Each design must look different within the principles that I set for myself. But working in Japan is not the source of this attitude – I would do the same if I were working in Europe or elsewhere. I hate designers who switch from style to style. There are setbacks, of course, but when a design is not accepted, I can never blame the client. I can only blame myself.

There are two possible ways to work in a foreign country. One is, "When in Rome, do as the Romans." The other is, "Be yourself!" I choose the second way.

My years in Japan have taught me to accept other people's opinions. I hope that there will always remain the particular tastes, smells, and habits of different peoples in different countries. When a German colleague offered his *Das ist falsch!* (this is wrong!) in a recent design discussion, I was astonished and shocked by such behavior. When you ask a Japanese what religion he is, he can never give a straight answer. He is simultaneously Buddhist, he is Shintoist, he is Capitalist, he is. . . . I think this is a good attitude.

Country
Japan

Designer
Helmut Schmid

Design Director
Shunsaku Sugiura

Shiseido

For Shiseido's cosmetic brand "Elixir," the company requested a logo that symbolized newness, "scientific-ness," and the product's effectiveness. It had to be simple and clear. The clean, open lines of the six letters reflect the seriousness of the product. The point of the intersection of the lines in the letter x was left open to symbolize the fountain of life (the Elixir). The design somehow exists in the word.

Elixir logotype
RIGHT *Logo*
BELOW *Package design*

Country
Japan

Design Director
Helmut Schmid

Illustrator
Nicole Schmid

Translator
Sumi Schmid

Robundo

Hats for Jizo (in Japanese *Kasako Jizo* or *Kaza Jizo*) is one of the most popular folk stories in Japan. Jizo is a guardian god of children, with the power to grant wishes. On country paths and street corners, stone statues dedicated to the deity, with their round, gentle, child-like faces, can still be seen. In its various regional forms, *Hats for Jizo* tells the story of how a poor but happy old couple, trying to make enough money to buy rice cakes for the New Year, are granted their wishes in reward for their tenderness toward six unsheltered statues.

Our daughter Nicole encountered the story in her second-grade textbook and made a paper-cut print of her favorite scene. Nicole wanted to tell the tale of this kindly old couple to her grandparents in Germany, and created drawings of other scenes to accompany a translation of the text. By chance, really by chance, Robundo's president saw our work and decided to publish it. To complement the expressive and honest lines of the child's paper-cut prints, the story's letters had to be in a large size and bold weight. The contrast of black and white symbolizes the simplicity of the parable, the winter scenes, and the pureness of the characters.

Hats for Jizo book
ABOVE *Cover*
RIGHT *Inside spread*

Country
Japan

Design Director
Helmut Schmid

Illustrator
Kan Tai-Keung

Calligraphy
Wucius Wong

Takeo

Each year, a different designer is asked to design the desk diary of the paper company Takeo. When Mr. Kido of Takeo asked me, he had the idea of combining two cultures. He suggested that the paintings of Hong Kong artist Kan Tai-Keung would make a good contrast to my style of European grid typography.

Art in the diary should enrich the dry figures of the calendar and information tables. To the delicate paintings, with their Asian flair, I set the titles of the paintings in large, powerful brush strokes as a kind of counterpoint. For the cover I used the three Chinese characters of the diary's title, *Pine, Mountain, Cloud,* printed in deep blue on a cloudlike high-quality paper. They stand for timeless Asian beauty and concept. The actual diary is designed in a clear typography with much attention to the typographic details. It is great fun to work with different people, who have different ideas, in different countries. East needs West, West needs East.

Country
Japan

Design Director/Designer
Helmut Schmid

Pocari Sweat ion supply drink
RIGHT *Package designs*

Otsuka Pharmaceutical

Taking advantage of the health and sports boom, Otsuka Pharmaceutical developed an ion supply drink that met the demand for a mild taste. A design was requested that had to be fresh, informative, and reliable; a design that would bring the company one step ahead of the competition. To make an immediate association with the color of the sea, a deep blue was chosen. The waves, originally intended to be information graphs, became a graphic shorthand. The product name in English was divided in two lines to make it impressive and spaced differently – to get a graphic effect. The can is designed in a kinetic flow with no front or back side. In the first year, the Japanese side of the can was used as the advertising side – since then, the English side is the "A" side. The brand is pronounced "Pokari Suetto" in Japanese. The word *sweat* has no offensive image; in Japan we all love to work!

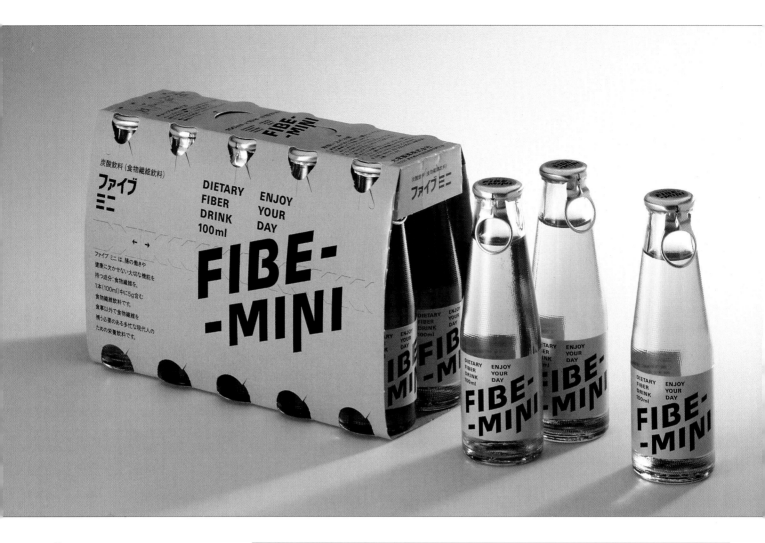

炭酸飲料（食物繊維飲料）

ファイブ
ミニ

DIETARY
FIBER
DRINK
100ml

ENJOY
YOUR
DAY

FIBE-
-MINI

ファイブ ミニは、腸の働きや
健康に欠かせない大切な機能を
持つ成分：食物繊維を、
1本（100ml）中に5g含む
食物繊維飲料です。
食事以外で食物繊維を
摂る必要のある多忙な現代人の
ための栄養飲料です。

Country
Japan

Design Director/Designer
Helmut Schmid

Fibe-Mini fiber drink
ABOVE *Package and label design*

Otsuka Pharmaceutical

Otsuka Pharmaceutical developed a fiber drink, which was to sell in small handy 100 ml bottles. The brand name, Fibe-Mini, is derived from "fiber," and mini has been added to describe its convenient size. The liquid's color is a delicious salmon pink. To enhance the appetizing drink, I selected a color for the small label that matched the contents. As a counterpoint to the feminine color, a dynamic logotype, divided in two lines, became the solution. The catch phrase "enjoy your day" can be interpreted as "do not let any problem bother you." All Japanese information was banned from the face-side, and this gave the product its international look. I was particularly pleased with the client's approval since a pending trip to Europe required that I finish the project in less than ten days.

Country
Korea

Design Director/Designer
Helmut Schmid

Korean Fibe-Mini fiber drink
RIGHT *Label design*

Otsuka Pharmaceutical
Fibe-Mini, Otsuka's fiber drink, became an immediate hit in Japan, selling
300 million bottles the very first year. Two years later, Fibe-Mini was launched in
Korea with an identical image. The color of the label and the English logo were
left unchanged. The main task was to incorporate the Hangul letters of the Korean
brand name. Both the English and Korean brand names had to go on the small
label. The lesson learned is that formal criteria are universal.

167

Country
Japan

Design Director/Designer
Helmut Schmid

Creative Director
Masaki Matsubara

Shiseido

For its men's hair care line, Shiseido wanted to have both a strong brand identity and a clear differentiation among the products. The high-grade initials (HG) create a stylish impression and form a common identification. The cluster-like typography of the English alphabet and Japanese letters make a strong characteristic.

Erik Spiekermann

Germany

Country
The Netherlands

Design Director
Erik Spiekermann

Dutch PTT

The story behind the first stamps designed for the Dutch PTT (and, I believe, the first ones designed for them by any foreigner) reads like the typical client – designer adventure.

Paul Hefting, the project coordinator from PTT's design department (where they don't do any design, they commission it) came to see me in Berlin on January 21, 1991, asking me to design four stamps to be printed on one little card. The theme was sports, occasioned by the 1992 Olympic Games in Barcelona. There was just one small catch – I had to display five different sports – rowing, gymnastics, volleyball, field hockey, and speed skating. There were two choices of format – four stamps could either be next to each other in a landscape format or they could be arranged in a square. I had to incorporate the Olympic rings and the EMS logo (one of those concoctions representing a pan-European express service). The values had not been decided, but all technical details were spelled out clearly in the contract Paul left with me.

Stamps for Olympiad
RIGHT *First issue*

169

Paul Hefting and his colleagues at the design department liked my first presentation, but they said that some people might like things a little more colorful. Before I could get into those details, however, Paul wrote to me saying that there had been a mistake and I needed to make all the stamps vertical, not horizontal. Could I do it? Of course I could, but there were problems with the length of some words, so I changed the order of the sports. Luckily, "*hardrijden schaats*" (ice skating) was eventually changed to just "*schaatsen*," making things much easier and allowing for fairly large type. The typeface I used, by the way, was Meta, which I had just finished designing and which has old-style figures and narrow caps, perfect for the purpose (if a little self-indulgent).

In the meantime, a few other things had turned up. The EMS logo was no longer required, but instead the stamps had to have two sets of blue, white, and red stripes, which apparently is the logo for the Dutch Olympic team. All the values became 80 cents. Then came the official presentation in The Hague. Ootje Oxenaar (head of the design department and the man who designed most of the famous Dutch

banknotes), Paul Hefting, and I went to see Mr. Scheepbouwer, managing director of the Dutch Post Office, who told us that as the stamps needed to be sold, my design proposals were a little bit on the cool side, well, "Teutonic." People would not be excited by looking at gray and white graphics and certainly they would not understand what the stamps were all about. Could I put in some pictures please!

Of course I could, albeit with regrets. The previous day I had bought a book about Piet Zwart in a book shop in Amsterdam, and inside I found a picture of a collage of people doing various sports. Back in Berlin, we got some pictures too, copied them onto a card, cut them out, and pasted them onto a background. Then we had a picture taken with dramatic shadows coming from the cardboard people. This homage to Piet Zwart we pasted onto the grey and white stamps, leaving the system of five into four unchanged.

The new proposals went down well, and we were asked to provide mechanicals. For a while we heard nothing, until one day in August a lawyer called from the PTT expressing concern that the use of our pictures, which we had copied from books and retouched, might cause copyright problems. They also looked too German. He had a point, so our Dutch colleagues went about finding Dutch pictures that the PTT would be able to use without paying millions in license fees and that would look like Dutch sportspeople. We made a new collage and new artwork. When we got the proofs back in September, everything was fine, except that the printers had forgotten to include the figure "1992," which we had provided on the artwork.

After only three redesigns everybody finally seemed happy. It is not so easy, after all, to communicate between The Hague and Berlin, but when it works, it's worth it.

The stamps were presented on the occasion of the opening of the 1992 Winter Games in Albertville. The Dutch Olympic Committee was there, along

Stamps for Olympiad
BELOW LEFT *Collage for the stamps, made with pictures cut out from books and magazines*
BELOW RIGHT *Laser prints of the designs for the first-day cancellation*

171

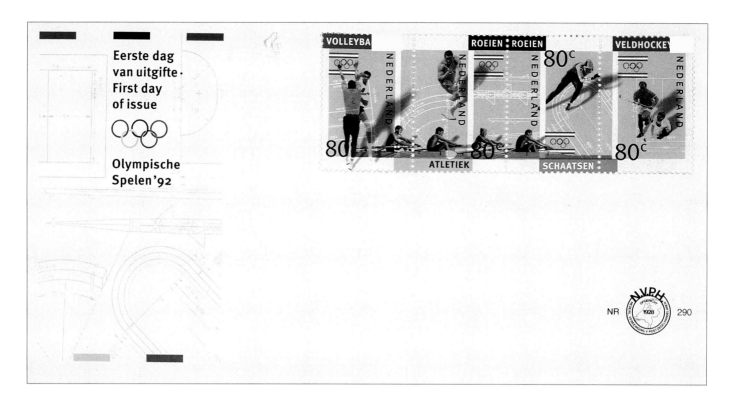

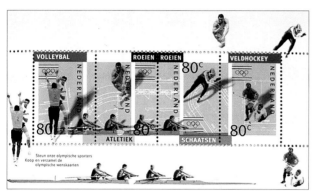

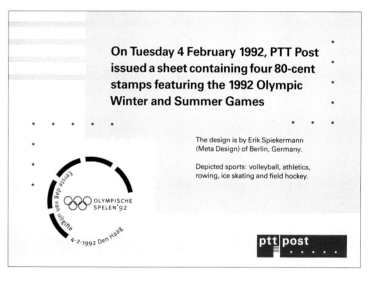

On Tuesday 4 February 1992, PTT Post issued a sheet containing four 80-cent stamps featuring the 1992 Olympic Winter and Summer Games

The design is by Erik Spiekermann (Meta Design) of Berlin, Germany.

Depicted sports: volleyball, athletics, rowing, ice skating and field hockey.

CLOCKWISE *First-day cover without first-day rubber stamp. Presentation folder for the 1992 Olympic Games in Albertville. Set of stamps.*

with representatives of the Dutch Post Office and Mr. Samaranch, head of the International Olympic Committee, himself a keen philatelist. And they had invited me, the little designer from Germany, making this a truly international event.

The stamps, I hear, are selling extremely well, so perhaps I will get to design some more of them. I have never heard from the German Post Office, by the way, although they only commission German designers (unlike the Dutch PTT, who are going to have more foreigners design for them in the future).

Alexander Stitt

Australia

Country
Australia/International

Art Director/Designer
Alexander Stitt

Photographer
John Pollard

Silent Reach
BELOW *Graphic for television mini-series*

Syme International Productions

The producers of the Australian TV mini-series "Silent Reach" needed a promotional graphic to convey the style and theme of the series. This was a modern action-adventure involving, among other things, a group of (rather unlikely!) Aboriginal terrorists. My solution used an automatic rifle, incongruously decorated with the kind of Australian Aboriginal painting usually reserved for their traditional implements; a symbol of two cultures, and of tension and violence. This decorative aboriginal symbolism has since been 'borrowed' by local souvenir manufacturers and applied to everything from tea-towels to T-shirts, and in some cases has become the subject of intellectual property litigation. I'd think twice about doing it again today.

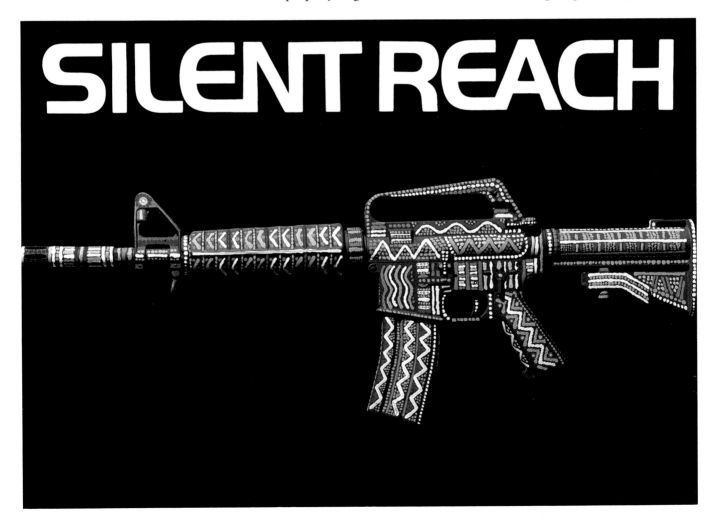

Alan Taylor

United States

Design – whether it be expressed as symbols, trademarks, emblems, logotypes, splashes of color, fabrics and furnishings, or even products – is the only universal language. Properly planned and executed, design can touch and influence people of all ages, of all nations, of all cultures . . . wordlessly.

Perhaps the most contemporary and visible showplace of modern design can be found in the sky: the flying billboards of the world's airlines.

By definition, civil aviation is a people business. However, by regulation and tradition, it is also a fiercely competitive parity business. An objective look at the airline business could lead the observer to conclude it is all about too much of the same equipment flying too many of the same routes at the same time and for the same fares.

But people, not parities, choose carriers. That they do so for reasons that transcend cost and convenience is no surprise. Nor is the fact that many airlines have gained a competitive advantage by identifying and accentuating the image attributes that are desired by passengers, either openly or silently. Most have selected operational attributes, such as on-time performance or efficient baggage handling. Some, however, have tapped an important vein by choosing cultural attributes to communicate and cross-cultural means by which to communicate them.

Four Asian carriers have done so with notable success. Their reasons differed, but the method they used – corporate identity design – was the same. Thai International and Garuda Indonesia used corporate identity design to signal a repositioning based on destination appeal. Their cross-cultural challenge was to preserve and protect host nation values or sensitivities while projecting tourism allure to foreign travelers.

Air India relied on corporate identity design to attract meaningful business travel, both from nationals and from western passengers. To achieve contemporary cross-cultural appeal required a careful (and politically sensitive) design that avoided ethnic overstatement.

As the carrier of an island state with a population of less than three million,

Singapore Airlines can only be classified as an international airline dependent upon foreign patronage. Janus-like, it must therefore project an appropriate cross-cultural image profile to both East and West. Corporate identity design has twice assisted the airline in doing just that.

Before reviewing each airline's particular corporate identity program, it is worthwhile to note that all four airlines supported their programs with public and media relations efforts, with employee incentives or reforms, and with important central government backing. Further, to the extent affordable, all opted for comprehensive programs as opposed to aircraft paint jobs. And all engaged the same design and identity consultant to guide and develop their programs.

Country
Thailand and worldwide

Program Director
Peter MacDonald

Design Director
Rodney McKnew

Designer
Chuck Krausie

Thai Airways International

For many years, Thailand owned and operated separate domestic and international carriers. While this is by no means unusual, conventional wisdom held that Thai nationals flying about within the country would be most at home when the visual presentation of airline imagery reflected their own culture. Conversely, the theory held that foreign passengers would feel safer and more at home with western or cosmopolitan visual images.

The truth was that from top to bottom the Kingdom of Thailand was rapidly being discovered. In 1975, tourism reached the threshold of its current, highly developed level. Inquiries by travel agencies and applications for tourist visas by European, American, and Australian culture seekers were mushrooming. Also, SAS, the airline company of three Scandinavian nations, held a financial interest in Thai Airways and was therefore helping it to build its international operations.

Thai Airways International
RIGHT *Former corporate identity system*

175

Responding to demand, Government acknowledged the important role its international carrier must play on behalf of tourism. First time and repeat visitors to the country, it was recognized, should begin to experience the culture of Thailand when dealing with and travelling on its national airline. This implied expressing Thai culture in the look and "feel" of the airline. It also meant understanding that the expectations created through design should not be at odds with what passengers and visitors would experience after arrival.

Meanwhile, both the international and the domestic carriers were vigorously updating their fleets. Delivery of new equipment offered further inducement to redesign the identity of Thai Airways. The premise was to combine cultural allure with contemporary aircraft superiority.

Executive Director Chatrachai Bunya-Ananta spearheaded the program. He supported the design consultant, who saw the advisability of highly individualized, even exotic, design and a need to approach it with tact and sensitivity. For the Thai people themselves, the new design would need to be faithful to the rich heritage of the country, yet respectful of religious and cultural mores. For western passengers, it would need to invite impressions of mysticism and of gentility, yet also communicate efficiency and competence. These became the identity program's cross-cultural objectives.

The design team's members, who had not been previously involved in an identity program for a Thai company, developed a feeling for the special grace of the Thai peoples and a respect approaching awe for the beauty of the land and the richness and serenity of Thai culture.

It was felt that the airline's complete name, Thai Airways International, was too long and too formal, at least for use on aircraft livery. In the belief that a commercial airliner is not likely to be confused by observers with anything else, use on aircraft of the short, friendly, and culturally associative name "Thai" was recommended. A special roman letter logotype in a style reminiscent of Thai language letterforms was created.

From the beauty and renown of Thai silk were borrowed a color palette rich in violet, pink, and mauve tones and techniques that were used to blend color and texture in an imaginative and exotic combination. Flight attendant uniforms and a new advertising campaign theme, "Smooth as silk," evolved from this creative direction.

Perhaps the most demanding challenge to the designer, however, was to create a symbol for the airline that met all design objectives, coordinated perfectly with the Thai logotype, and promised a high likelihood of memorability. Of the hundreds of sketch form designs explored, approximately ten were refined as finalists. The design selected, described by many as flower-like and by others as phallic, was

very carefully crafted. Consultations with Thai historians and Buddhist scholars helped assure that it was neither culturally offensive nor sacrilegious. Feedback from Western audiences who were shown the designs was positive. Management and employees of the airline responded enthusiastically. There was no question that this symbol and the carrier's new corporate look were unique in the industry.

Subsequent marketing research, an historically significant event, and sales results have confirmed the cross-cultural appeal of Thai Airways' complete corporate identity design, as well as the particular appropriateness of the symbol. An Intramar survey of frequent business and leisure travelers was conducted only two years after the introduction of the new identity. In that study, Thai Airways' livery design was ranked as the third most familiar or best regarded among all carriers serving the Asia-Pacific region. By way of a belated archæological endorsement, a pottery shard found during a 1984 dig in northern Thailand bears a design identical to the symbol created for the airline 600 years later. Lastly and most tellingly, leisure travel to and within Thailand has boomed, and the airline's symbol has been unofficially adopted as the nation's symbol for tourism.

Thai Airways International
ABOVE *New logo*
BELOW *New livery*

Country
Indonesia and worldwide

Program Director
Alan Taylor

Design Director
Mark Landkamer

Designer
Kris Kargo

Garuda Indonesian Airlines

In 1985, world markets for Indonesia's dominant sources of foreign exchange, petroleum and raw materials, were depressed while overseas interest in such cultural treasures as Borobadur, Jogjakarta, and especially Bali was rapidly increasing. The Suharto government quickly made tourism development a national priority and set about improving the infrastructure to accommodate it.

Construction of a new international airport for Jakarta was begun, improvements to the international arrivals and departures facilities at Denpasar were completed, and the construction of new state-owned hotels and the remodeling of existing ones was stepped up. The Ministry of Tourism sponsored or participated in cultural exhibitions in Europe, Japan, and the United States. Reforms to customs and immigration procedures were instituted. And important incentives and training were given to thousands of people employed in the tourism industry, starting with employees of Garuda, the national airline.

Garuda's new managing director, R. A. J. Lamenta, doubled or tripled employee salaries and wages, which were historically among the lowest in the entire airline industry. He reorganized the company to improve efficiency and implemented measures to promote pride in performance. With support from Indonesia's Deputy Director of Tourism, Joop Ave, he also initiated a comprehensive corporate identity design program to improve the airline's image and appearance.

The challenge for the designer was to create an association between the appearance of the airline and the appeal of Indonesia as a tourist attraction. Because western familiarity with Garuda was extremely limited and expectations about the quality of its service were minimal, this was not as formidable a job as might be supposed. Garuda maintained the largest fleet of aircraft in the southern hemisphere but it was not well known abroad or, for that matter, even within Southeast Asia. Those business passengers who did know Garuda's service quality perennially rated it dead last. But leisure passengers, not business passengers, would be the targets of the new identity.

The design team, which listed among its members a woman who had studied and taught in several Asian countries, including Indonesia, realized that Garuda's relative anonymity made their job a little easier, as did the lack of marketing equity in Garuda's existing graphic design elements. So a fresh visual image could be sought without concern over the loss of a look or feel held to be important by Indonesians themselves.

It was soon apparent that the airline's look suggested nothing to the outside world about the diverse culture of this nation of numerous islands and language groups, and that it said nothing positive to Indonesians about their own sense of

identity. The style and fabrics used in flight attendant uniforms, for example, were 1960s European, and their orange color was unflattering to skin tones. Orange, along with some red, was the dominant color motif in aircraft livery and cabin interiors, which seemed more an uninviting reference to equatorial temperatures than a reminder that Indonesia is a lush archipelago.

Even the manner in which the airline's name was used and presented was unprepossessing and non-associative. With unintentional understatement, the Garuda logotype was in the same nondescript lower case typestyle used by the country's tiny domestic carrier, Merpati Nusantara. There was little or no linkage between the names of the airline and the Republic; on aircraft, for instance, "Garuda" appeared on the vertical stabilizer, while "Indonesian Airlines" was on the fuselage forward of the wings. Nor were there any references made in graphics or in promotional communications to the religious significance of Garuda, the bird deity who transports the Hindu god Vishnu by air.

This bird/flight symbolism provided the designer with a logical focus for the new airline identity. The blue and aquamarine waters of the archipelago, as viewed from 30,000 feet, prompted the new identity's color scheme. Appropriate theocratic and topological statements could be thus combined in the new identity. Still, the image strategy created for the airline dictated a more contemporary reference to Indonesia itself and to its culture. This was achieved in two ways.

The literal method was to join the names Garuda and Indonesia. The more subtle method was to draw from an official code of conduct calling for personal endeavor plus collective well-being. This creed helps unify Indonesia's heterogeneous assortment of peoples and their various histories, dialects, and beliefs. The creed,

Garuda Indonesian Airlines
RIGHT *Former corporate identity system*

179

called The Pancilla, contains five principles of social behavior and social obligation. It gave inspiration to the manner in which the bird symbol and the color scheme are used in the new identity.

The Garuda bird symbol is designed with five tail feathers, ascending in graduated color values from pale to deep aquamarine. The upper and lower-case Garuda Indonesia logotype is in royal blue. On aircraft, in signage, and in certain full color print applications the bird symbol is set against a background of the same royal blue. In two-color usage, the bird symbol and/or the symbol and logotype lock-up appear in blue only.

The look of aircraft interiors, ticket offices, VIP lounges, and other customer contact areas repeats the aquamarine color scheme together with a subdued symbol repetition pattern. Fabrics and materials selected for these environments reflect Indonesian textile and woodworking techniques. Female flight attendant uniforms,

which were designed and produced by local artists under the direction of the consultant, also carry through the Garuda color and identity themes. Their graceful, indigenous style and the more military look of the male attendant or cockpit crew uniforms send deliberately cross-cultural Asian/Western messages. One message is to come and experience the romance of Bali; the other is to relax and be secure in the competence of trained Air Force pilots.

From a business standpoint, the identity design program's success is undeniable. First-time foreign visits to Indonesia have increased consistently since 1986, the year President Suharto took the first DC-10 emblazoned with the new identity on a state visit to Europe. Since then, repeat visits and tour group bookings have soared. Load factors and yields on Jakarta and Denpasar flights have improved significantly on Garuda in particular, and on other scheduled carriers in general. Hotel occupancy and tourism have grown commensurately, as have local and foreign private investment in tourism-related ventures.

From a cultural standpoint, the identity design program is equally successful. Indonesian passengers sampled are significantly more satisfied with Garuda's domestic operations than in years past. Airline employees' performance and morale have shown dramatic improvements. Even the proud meaning of the slogan employed and advertised at the identity program's launch, "New Image, New Spirit," survives in concept today.

At times, the design consultants themselves became inseparable from the program unfolding around them. In the process, they learned much from the quiet effectiveness of Lamenta, much about overcoming natural diffidence in the not-so-gentle art of stifling press criticism, and a great deal about the artistry and pride of Indonesian craftspeople.

Country
India and worldwide

Program Director
Alan Taylor

Design Director
Craig Segal

Designer
Kris Kargo

Air India

Although Air India operated several flights to and from Europe each day plus daily service to New York via London, only a small percentage of western passengers booked their outbound travel to or through India on the country's international flag carrier airline. Those who did were primarily bargain seekers or tour group passengers traveling on extremely reduced fares. There was very little inbound business travel and virtually no first-class travel on a full-fare basis.

Outbound from India, Air India had heavy load factors but experienced very low yield, again owing to deep discounting. Indian nationals who had a choice in the selection of their overseas carrier bought price. Those who didn't have a choice, commonly bureaucrats expecting patronage or business passengers observing corporate travel policy, still flew at bargain rates.

By 1988, revenue passenger miles (a statistic upon which many airlines base operating performance) were among the lowest in the civil aviation industry. While top line results were poor, domestic fuel cost increases and surcharges plus chronic disruption by the airline's 11 labor unions were crippling the bottom line. Nearly every time an Air India 747 or A310-300 took off or landed it lost money.

Managing Director Rajan Jetley and Chairman Ratan Tata realized that the way to turn the situation around was to improve yield, and the way to do that was to make Air India the airline of choice for Indian and foreign business travelers. This became the design brief to the identity consultant.

Research showed that the Indian businesspeople who flew Air India were in one of two camps. They either liked the highly ethnic, almost fussy visual image of the airline or they hated it. Most hated it, and no foreign business travelers could prefer it to the look and feel of competitive business class standards. To have business passengers equate Air India with such standards, much less to incline them to choose Air India where it did not enjoy a monopoly, meant presenting the airline in a cleaner, more contemporary style.

This was not so easy. During its 55-year history, Air India had introduced many

Air India
RIGHT AND OPPOSITE
New identity system

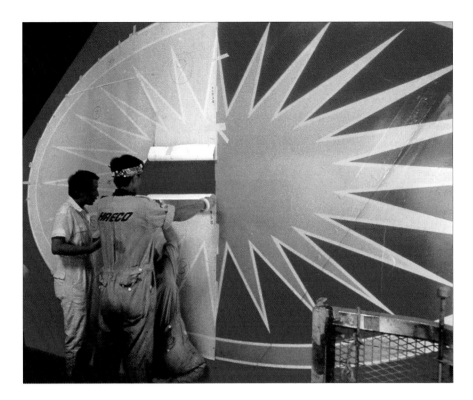

graphic identity elements, symbols, and decor themes.

Chief among them in sentimental value was the centaur symbol selected for the airline in 1948 by its then chairman, J.R.D. Tata. Mr. Tata was one of India's most respected and influential citizens. He chose the centaur, celebrated in Greek mythology and in astronomy as Sagittarius, the archer, because it symbolized speed and because by extension it could be identified with new Constellation aircraft ordered by the airline from Lockheed. However, 40 years later, the celestial archer's significance had dwindled. The centaur's most prominent application was in illuminated signage on the headquarters building in Bombay. On aircraft, traditionally the centerpiece of airline identity, it was used only on 747 engine cowlings.

A Rajasthani arches motif that surrounded all cabin windows was the most culturally expressive element in aircraft fuselage treatment. Many felt that its elimination would trigger regional religious dissension (though ultimately the arches were removed). No one argued about the Devanagari letter forms for the Air India name; they were acknowledged to be politically inviolate. Discontinuing the use of others, like the little Maharajah mascot omnipresent in advertising or the houris and elephants adorning cabin interior side panels, seemed to be a less sensitive matter. Above all, any visual statement that would replace or reuse existing identity elements had to be culturally and politically defensible at home and at the same time impressive and believable overseas.

Understanding politics and India's multicultural sensitivities, Jetley invited a national council responsible for the preservation of Indian culture to participate in the design review process. Further, he and the identity consultant deferred to Prime Minister Rajiv Gandhi for final design approval. Since the redesign was absolute – virtually nothing from the existing identity was retained – this was essential.

Design objectives expanded. Creating a dignified ambassadorial statement for India became a clear priority. So too did expressing enough ethnicity in the visual presentation for the airline to remain Indian rather than becoming generic.

One way the identity design solution accomplished these multiple objectives was by making use of a timeless metaphor for global reach and new beginnings, the sun. The actual sun symbol that was developed was derived from Hindu drawings and texts. It is therefore oblong, rather than round, and it contains twenty-four rays, which makes it both ritualistic and suggestive of round-the-clock service.

A bright red ambassadorial sash provides a field against which the sun symbol, in gold, is positioned. These two elements, together with bilingual logotypes comprise the new graphic identity for the airline.

Because the aircraft exteriors are painted white, the ambassadorial effect of the red graphic elements is accentuated. The dual language logotypes now make far more of an impact than was previously the case because they are large, because they now appear side by side (Devanagari first, English second) instead of on opposite sides of the fuselage, and because they no longer compete with window treatments for attention.

Examples of image transformation inside the aircraft are extensive. Throughout, the fabrics and textures for soft surfaces are authentically Indian, yet in full compliance with international safety standards. Colors in coach class are bright but

Air India
RIGHT *Former corporate identity system*

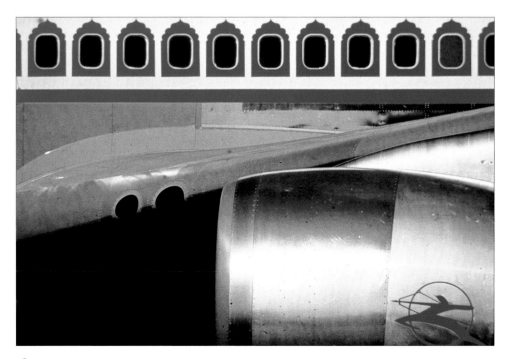

not overpowering against neutral side panel and bulkhead treatments. The intent is harmony and balance, the effect is restful. The new "Sun" business class is modeled after British Airways' Club class, and it is intentionally international in feeling.

Female flight attendant uniforms, which were commissioned and designed locally, retain the sari style, but they are now better coordinated with a cold weather, Western street wardrobe. There is also a relationship between these uniforms and those of the male cabin attendants, stewards, pursers, ground employees, and the uniforms system of Indian Airlines.

Beginning with the city ticket office in Bombay, customer contact areas systemwide are being transformed into an appropriate cross-cultural balance of internationalism, Indian ethnicity, and local country or city styles.

All in all, these developments might have spelled success for the corporate identity design system. That has not been the case. The new corporate identity design was ushered in amid such advertising claims as "The grace of the East and the pace of the West" or "Now the best of both worlds," and critics claimed that Air India's identity had been sanitized. Some said that it was overly westernized or sadly depersonalized (despite a supporting role for the popular Maharajah mascot). Some opposed it on a not-invented-here basis.

Passenger response, on the other hand, suggested that both Indians and foreigners liked what they saw and experienced, even though they were paying more for it. In the year ending March 1989, a prior year's loss of Rs434m was converted into a net profit of Rs433m. Per-passenger yield rose 23 percent in that period.

Despite passenger and public approval, however, identity design program chaos now reigns. Jetley unfortunately moved on to new challenges elsewhere, and the executive responsible for administering the new corporate identity program was forced out. No one replaced him or assumed proper responsibility for the program. The result is an incomplete, partially implemented identity system.

Sadly, having the new system exist side by side with the old says much to the world about India's struggles with self-unification, with balancing Eastern and Western profiles, and with concluding commitments that span political administrations or management regimes. Air India celebrated its 60th birthday in 1992 by reviving the centaur. Current management then announced its intention to scrap the new sun identity design altogether, personally distancing themselves from Jetley's legacy. New livery treatment featuring the centaur was expected to replace the foreign-designed scheme. The reality was that Air India was operating with three different paint schemes on its aircraft.

For the design consultants, the opportunity to be of service and the pride taken in a potentially successful cross-cultural effort were rich rewards. Unfortunately, the outcome has made the experience a deep disappointment.

Country
Singapore and worldwide

Program Director
Alan Taylor

Design Director
Rodney McKnew

Interiors Designer
Angelika Preston

Graphics Designer
Chu Dea

Singapore Airlines

There are two chapters in the identity design experience of Singapore Airlines. The first began in 1972 when the airline was spawned from MSA (Malaysian Singapore Airways) which was then dissolved. The challenge then was to create an identity and image for the airline from scratch. The second chapter occurred in 1986, when Singapore Airlines had attained the status of the most preferred and respected airline in the world.

Singapore itself is rich in diversity, and has always figured prominently in both the political and commercial affairs of Southeast Asia and strategically in the defense of the region. Its history of trade and commerce shapes its style, while its tradition as the home of opportunity to a variety of nationalities marks its cultural character.

But trying to capture or represent what Singapore was in 1972, and thus how its airline might be visually presented, was a very difficult proposition. There were no appropriate symbols of the country which could be effectively adopted for use by the airline. However, there was the possibility that image and identity equity might be borrowed from the livery of MSA. The strong blue and yellow color scheme was promptly co-opted which lessened the challenge of creating an identity from scratch.

The designer still had two needs to address. One was to find a way to symbolize flight. The other was to develop a cultural context for Singapore Airlines. Ian Batey, long the advertising and marketing counselor to the airline, provided and perfected the answer to the latter need – the universally acclaimed "Singapore Girl" campaign. The new airline was immediately personalized by the female SIA flight attendant. She has since added Asian grace, charm, and service dedication to the airline's image.

Singapore Airlines
RIGHT AND OPPOSITE
New corporate identity system

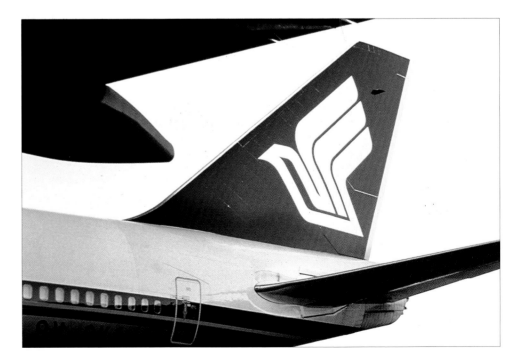

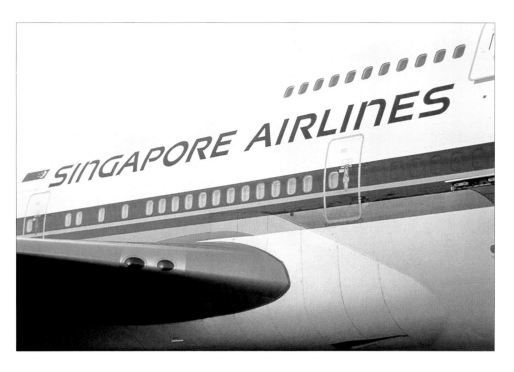

The design consultant then concentrated on the need for flight symbology and developed a bird symbol to represent the airline in lieu of an accompanying logotype. It is an abstract design, in part because there is no widely recognized bird species indigenous to Singapore, and in part because as original commercial art it could be protected by international trademark law. Birds are hardly original symbols for airlines, but this design was created with durability (through ease of reproduction) in mind and with cultural affinity as an objective. The consultant reasoned that the largest segment of the Singapore populace, those of Chinese origin, would always relate enthusiastically to an icon of good fortune. SIA's bird symbol is open-ended, consisting of two lines that never touch or join, that was meant to suggest endless good luck.

Singapore Airlines' subsequent corporate identity design revitalization was a function of management's determination to keep SIA out in front in the airline industry. Deputy chairman Lin Chin Beng recognized that keeping Singapore Airlines number one beyond 1986 meant: 1.) promulgating a cross-cultural positioning statement; and 2.) making certain that all aspects of the airline's visual presentation supported that positioning.

The gist of the positioning was a blending of timeless grace and impeccable service from the East with the latest and best aerospace technology from the West. Still, after 14 years, the look of the airline lagged behind the positioning. On one level this was a housekeeping matter; as the airline expanded, its control over identity presentation had eroded, particularly overseas. On a more fundamental level, the look called for a new richness appropriate to the pre-eminent stature of Singapore Airlines. More chic, more dignity, and more bi-cultural piquancy were needed.

Singapore Airlines
ABOVE *Malaysian Singapore corporate identity system*

The solution for revitalizing graphic elements on aircraft was to exchange pale yellow for gold, to add laser-like orange accent bars to both the trailing edge of the vertical stabilizer and the horizontal striping of the fuselage, and to replace the italicized Singapore Airlines logotype with an enlarged, upright and upper-case one. Identity system maintenance issues were addressed and resolved in technical and graphics standards manuals. Elsewhere, new visual emphasis and cultural statements were chiefly expressed through the upgrading, updating and standardizing of all ground and airborne customer facilities as part of the corporate identity design makeover.

The results appear to justify the undertaking. Design with cross-cultural appeal continues to define Singapore Airlines' pre-eminent position in the industry. And looking the part of the leader aids the airline in charging passengers fully for the privilege of experiencing the best. The carrier was number 22 in the world in revenue volume in 1991, but it was number eight in operating profit. In 1992, Singapore Airlines was once again acclaimed as the best in the world.

Summary

Corporate identity design has played a major role in helping airlines to establish and present a personality to their audiences, to stand out in a parity business, and to capture market share.

Like many other carriers, Thai, Garuda, Air India, and Singapore Airlines have discovered that through the identity design process they could communicate cultural and cross-cultural themes to advantage. They could effectively present a look, a style, and an image representative of and sensitive to their host nation's society and they could win points at home and abroad for doing so. The process also enabled management, employees, and customers to better ascribe personality and preference to each airline.

Yet none of these airline identity programs would have been successful had not the airline's people and the designers worked well as teams – learning from and helping each other in true cross-cultural cooperation. That three out of these four airline identity programs produced lasting impact and economic benefit speaks to the essentiality and professionalism of that cross-cultural cooperation.

ALAN TAYLOR *is an internationally known identity strategist and was formerly chairman of Landor Associates Designers & Consultants, Ltd. In that capacity he led corporate identity design programs developed for Garuda International, Singapore Airlines, and Air India. He commends the designers formerly with Landor who undertook the programs detailed in this essay and thanks Landor Associates for use of the visuals accompanying it.*

Wang Min

United States

Posters

The Yale-China Association wanted a poster to express their mission of helping Chinese students in the US and sending American students to China. The blending of the chopsticks with the fork and knife suggests the combination and contrast of the two different cultures experienced by Chinese students in America.

For an international conference on United States-Korean trade relations I played with colors (red and blue) and symbols (Stars and Yin-Yang) to represent the interaction between the countries. The strokes express dynamism, power and development.

Yale-China Association poster
RIGHT *The Chinese Student in America*

Art Director/Designer
Wang Min

East Rock Institute poster
ABOVE *Dynamics of United States-Korea Trade Relations*

WBMG

United States

Country
Spain

Design Directors
Walter Bernard, Milton Glaser

Designer
Nancy Eising

La Vanguardia

The project was the total redesign of a distinguished 100-year-old Barcelona newspaper requiring new press, new paper, a new size – new everything. The challenge was to expand the audience, particularly of younger readers, without alienating any of the existing older, loyal audience. Using an outside design firm gave the project authority and weight for the in-house staff. An intern from the paper spent a year at our studio during the work and was able to help with implementation, the paper's art director spent time here, and our designer spent some months in Barcelona. We learned that a thorough information campaign, which educates and involves readers on the subject of the redesign, can dramatically reduce the risk of alienation and backlash.

La Vanguardia

THIS PAGE *Variations of redesigned front page format*

OPPOSITE PAGE CLOCKWISE *Front page of weekly "Home" section. Cover design of "Sunday Magazine." Weekly "Highlight" section of Arts & Entertainment. Front page of daily "Magazine" section*

Lire Magazine

ABOVE *Cover before redesign*

RIGHT *Cover after redesign, first issue*

OPPOSITE PAGE *Contents pages, feature spread*

Country
France

Design Directors
Walter Bernard, Milton Glaser

Lire Magazine

The appearance of this magazine about books did not reflect the intelligence and elegance of its editorial content. A redesign that married the visual attitude to the editorial attitude was our solution. A magazine of this sort could not succeed in the United States because of our relative lack of interest in books, but the French audience has very different reading habits. After the redesign, the magazine's circulation swiftly tripled.

LIRE
SOMMAIRE

MAGAZINE

LES LIVRES DU MOIS

Ce numéro comprend deux encarts (p. 35/36 et p. 101/102). Il a été tiré à 159 000 exemplaires. Le prochain numéro paraîtra le 31 mai 1983.

4 5

LE LIVRE

LA PLACE DE LA NATION à Paris, c'est là que naquit, il y a trente-cinq ans, Guy Konopnicki. Ironie du hasard pour cet auteur qui aujourd'hui dénonce l'autre « place de la nation », celle des chants patriotiques. La nation, surtout par temps de crise, occupe sa place, toute la place, avec jalousie. Et quelquefois même avec xénophobie. Serrée frileusement autour du seul Etat, la nation se referme sur elle-même. Alors que de formidables moyens de communication rapprochent les peuples et universalisent les modes, des défenseurs de l'identité culturelle se dressent comme des coqs gaulois. Il faudrait faire barrage à Mickey, au Coca-Cola, au rock et aux feuilletons américains. Mais au nom de quoi ? rétorque Konopnicki. Au nom de Bécassine, du gros rouge, de Dalida ou d'« Au théâtre ce soir » ? L'ex-militant du PCF — à qui le parti n'a pas « rendu les couleurs de la France » ! — tire ses flèches tous azimuts. A droite comme à gauche. Contre le régionalisme et contre l'étatisme. Son pamphlet, aux formules acerbes (mais parfois un peu brouillonnes), dérangera d'autant plus qu'il est optimiste, Konopnicki croyant à la puissance créatrice libérée des frontières nationales. **La place de la Nation** par **Guy Konopnicki,** 240 p., Olivier Orban.

Guy Konopnicki

La place de la Nation

Le coq gaulois contre l'"impérialisme culturel" américain ?
Un combat absurde où la France a tout à perdre sauf le ridicule.

L'EXTRAIT

Les nationalistes de France et les tiers-mondistes ont abouti à une définition étriquée du mot culture, au nom de laquelle ils établissent les lignes de défense nationale face à la subversion culturelle « américaine ». On ne saurait trop préciser le lieu d'où l'on parle, les conditions de sa production, comme l'on disait au temps des sixties françaises : j'écris après avoir posé sur ma platine japonaise l'enregistrement américain (CBS) d'un opéra italien (Don Giovanni) composé par un musicien germanique (Mozart) qui s'était inspiré d'un auteur dramatique français (Molière) qui lui-même avait puisé ses sources chez un auteur baroque espagnol d'origine marrane (Tirso de Molina). Il faudrait aussi définir les nationalités de Lorin Maazel, de Ruggero Raimondi, de Kirite Kanawa et de tous les autres interprètes ainsi que celles des musiciens de l'orchestre, des luthiers qui ont fabriqué leurs instruments et, pour finir, la nationalité de celui qui a réuni cette merveilleuse distribution, Joseph Losey. Je me demande, en écoutant cela, ce que signifie le mot identité placé à côté de l'adjectif culturel. O mes pauvres oreilles, êtes-vous à ce point dépourvues de racines, pour tirer plaisir de ce melting pot (le mot lui-même est anglo-américain mais, Pot pour Pot, je préfère melting à Pol) !

Et dire qu'il y a des gens qui ont la chance de posséder une identité culturelle, qui écoutent des concerts de biniou et de cornemuse, pendant que moi, pauvre déraciné, j'écoute ce bœuf-là de Mozart ! Et pour tout aggraver, j'assimile ça à l'idée du beau — idée parfaitement subjective — et à celle, perverse, du plaisir, que je considère comme l'un des objectifs les plus élevés de l'humanité. Et que l'on ne vienne pas me dire que ce cosmopoli-

DESSIN ORIGINAL DE JEAN-PIERRE CLIQUET

74 75

Country
France

Design Directors
Walter Bernard, Milton Glaser

Alma Magazine

We were commissioned to design and develop a multifaceted service magazine for modern Frenchwomen with families. Three main sections were suggested by the French editor: news, domestic concerns, and culture. We were able to use the experience in service journalism that we gained at *New York Magazine*, which taught us to provide a lot of specific information, and to be strongly on the side of the reader, enhanced by the generosity and luxuriousness of the large format. Good service journalism is internationally applicable, so differences in culture were entirely mitigated by the universal appeal of the approach.

Alma Magazine
ABOVE *"Le Journal" opening page
of News section*
RIGHT *Magazine cover, first issue*
OPPOSITE CLOCKWISE
*"Alma Plus" opening page of Feature section,
"Ram Dam" opening page of Culture, Arts &
Entertainment section, inside spread*

PLUS

A TABLE

Chez vous
Comment est-ce ?

Table ronde
Huit enfants parlent
la bouche pleine

Les repas français
Une seule fois par jour
mais on les aime toujours

La vaisselle
Elle passe de la cuisine
à la salle à manger

Santé et plaisir
Vous pouvez les
conjuguer sans crainte

Les réfrigérateurs
De 55 à 85, ils ont changé

Bon appétit
Pommes de terre plat
unique

RAM-DAM

A TABLE

Chez eux c'est comme ça

ALMA PLUS

ROMAIN 8 ans.

"Aujourd'hui, j'ai mangé un sandwich au jambon. C'est maman qui l'a fait mais des fois c'est moi. Il était avec du pain frais, mais c'est pas souvent comme ça parce que maman n'aime pas gâcher. Un bon repas, c'est surtout quand papa est là, le samedi et le dimanche, parce que maman n'aime pas les bandes dessinées et moi j'aime cela, et papa comprend. Je parle avec lui, je rigole. Avec maman, on parle de l'école, du travail, des questions sérieuses. Quand j'achète le pain seul, il y a un libraire à côté, alors j'en profite pour regarder les bandes dessinées. Quand mon petit frère n'est pas là, j'aide à table, c'est moi qui débarrasse. Maman est plus sévère que papa, elle n'aime pas que je mange la croûte du fromage. Papa, il est savoyard, il la mange."

FABIENNE 9 ans.

"J'achète le pain en passant. Je dîne dans la cuisine avec ma grande sœur et papa et maman dînent après nous. Quand il y a des invités, on doit savoir que je sais bien me tenir à table, mais si personne ne me voyait, j'aimerais manger avec les mains. Un bon repas, c'est un repas en famille, une entrée, de la viande ou du riz, des pâtes, des pommes de terre. J'aime le samedi et le dimanche quand nous dînons tous les quatre devant la télévision. Un repas chez ma grand-mère, c'est bien. Elle habite en Normandie, je reste coucher. Elle fait des frites ! Le boucher passe avec sa camionnette, elle achète de la viande, pas du jambon. À table, c'est gai !"

LOÏC 11 ans.

"Je donne à manger à ma petite sœur quand elle veut manger toute seule mais je préfère aller m'amuser ou lire un livre. Un bon repas, c'est un repas où il y a papa. Le samedi et le dimanche, seulement. Il dit des blagues, il fait des jeux de mots. Il est plus drôle que maman à table. Ma femme, plus tard, sera disponible. Elle s'intéressera à moi, sera là quand je rentrerai pour m'ouvrir la porte. C'est trop triste de sortir sa clé et de rentrer seul dans une maison vide. Si aujourd'hui mamie vient me chercher pour déjeuner, c'est merveilleux. Tout est agréable : le pain est frais, on boit de l'Orangina, on mange des bonbons à la fin du repas. J'aime aussi chez mon cousin. On déjeune entre enfants, dans la cuisine et, comme on termine les premiers, on part jouer dans sa chambre avec l'ordinateur.
Ce qui me dégoûte c'est quand mon petit frère ne veut pas manger. Il jette sa nourriture. C'est insupportable quand on sait qu'au même moment où il la jette il y a cent personnes qui meurent de faim.
Ça me choque !"

VICTOR 11 ans.

"Aujourd'hui j'ai déjeuné seul avec ma sœur. Maman fait un régime et prend des sachets de poudre épaisse dans un verre de lait. Elle ne mange pas en cachette, mais parfois elle se laisse tenter ; hier elle a fait un banana cake, elle en a mangé. Je suis content quand maman mange, j'ai peur qu'elle s'intoxique, on ne sait pas ce qu'il y a dans ces sachets, c'est pas bon pour les enfants, dit-elle ; Je n'ai pas envie qu'elle maigrisse. Elle crie beaucoup parce qu'elle n'a plus de pantalon ou de robe à se mettre. Elle s'est acheté cinq ou six pantalons parce qu'elle n'a plus rien. Mais comme elle change de taille tous les six mois, elle a une garde-robe extraordinaire.
Le dernier repas avec mes parents réunis c'était le dernier Noël, il y a trois ans, et c'était le silence absolu. On avait mis une bougie sur la table, c'est une coutume de ma famille : chez mon père on n'allume pas l'électricité pendant les fêtes. On regardait la bougie, c'était un silence à mourir et autrement on mange moi et Judith sur la table de la cuisine et que maman n'est pas là. Judith est en train de lire à table : elle fait trois choses en même temps ; je sais pas ce qu'elle pense, mais moi je m'embête vraiment.
Je ne finis pas ce qu'il y a dans mon assiette, c'est mon assiette. Ce qu'il y a dedans est à moi. Si j'ai envie de jeter, je jette.
Moi je suis plutôt sentimental et la viande je l'aime bien quand elle est bien cuite pour pas voir le sang de l'animal qui coule. J'aime bien penser que c'est un aliment, que ça n'a pas été vivant.
Privé de dessert ? Ça m'arrive une fois par an, quand je mens à maman et que papa s'en aperçoit. Je vais dans ma chambre sans dîner. Il m'apporte du pain et de l'eau, mais le pain n'est pas sec et l'eau n'est pas chaude.
Ma femme sera sportive, danseuse, des métiers semblables, athlète, mais pas dans un bureau, pas une intellectuelle. J'aurai treize enfants, j'inviterai tous leurs amis, ou presque !"

Country
France

Design Directors
Walter Bernard, Milton Glaser

Jardin des Modes redesign
RIGHT CLOCKWISE *Magazine cover*
anniversary issue, inside pages

Jardin des Modes

This large-format French fashion magazine was designed by Milton Glaser in 1979, updated in 1986, and produced monthly by revolving art directors. The challenge was to allow maximum creativity to the art directors without sacrificing the overall identity of the magazine. The most important guideline for the staff was the attitude toward the visual material, which allowed freedom within a format. The possibility of change within some broad rules of format can keep a magazine fresh, lively, even cutting-edge, while making the best possible use of discontinuity in staffing.

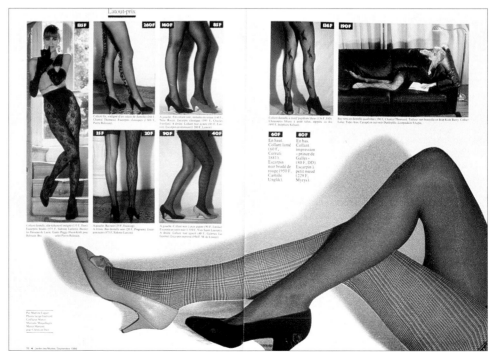

Business Tokyo Magazine
ABOVE Cover before redesign
RIGHT New cover design

Country
United States/Japan

Design Directors
Walter Bernard, Milton Glaser

Designer
Colleen McCudden

Business Tokyo

The task was to produce an original design for a magazine produced in Tokyo by an international staff, owned by a Japanese businessman, addressed primarily to North Americans doing business in or with Japan. The design had to incorporate both the visual vernacular of American readers and the characteristic precision and exquisiteness of Japanese design traditions. We persuaded the owner to relocate the main editorial office to New York to ensure the general editorial tilt and savvy that would resonate for English-speaking readers. The purposeful use of American design expertise by a foreign client targeting American audiences can help overcome any potential for visual miscues.

Henry Wolf

United States

Country
United States

Design Director
Henry Wolf

Esquire Magazine

At *Esquire* in the fifties I had very few problems in getting my ideas on covers. I did about 70 of them in the years I was art director there, and I can remember only one that was not realized. The red wine cover was my answer to a lead article about the "Americanization of Paris." I had lived in France for a few years and I picked red wine as the quintessential French artifact. At that time fast food was just beginning to appear on the shelves here so I put the two together. The only discussion was whether the public spoke enough French to know what *vin rouge* meant and if we should make it 'red wine' instead. I won the argument.

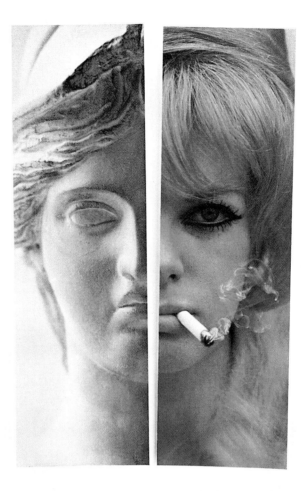

SHOW

THE
MAGAZINE
OF
THE
ARTS

75 CENTS
MAY 1962

The two faces of Europe (and what's behind them)

Country
United States/Europe

Design Director
Henry Wolf

Show Magazine

This was another point – counterpoint solution. The girl is not really Bardot but a look-alike model. The photographer Hiro took the pictures, and then we made two prints and rephotographed them together like pieces of a puzzle to symbolize the old and the new Europe. Again there were no problems. The editors liked it. Hiro, who is of Japanese descent, lent his usual cool and beautiful way of seeing things and brought yet another element of cross-culture to the picture.

Wei Yew
Canada

Country
Canada

Design Director
Wei Yew

Studio 3 Graphics Ltd.

The idea for our Chinese New Year promotional items came about during the first Christmas season of our firm. I found out that many clients were not able to attend our open house because there were so many other parties going on at the same time. So I decided to postpone our celebration until the Chinese New Year – an ideal time because there's nothing else to look forward to in the depths of winter. Hence, the origin of our invitations. An interesting note: thereafter, every year around January and February we receive many phone calls from regular clients to find out the dates for the Chinese New Year since they don't know on which dates it falls – neither do I!! They are also curious about what ideas we will come out with.

Each year we try to think of some element, icon, or symbol familiar to Canadians that will represent or tie in with the Chinese Zodiac animal in the invitation and/or the stationery. For example:

PIG: The three little pigs in the popular nursery rhyme
DOG: Doggie bag, dog bone
OX: Black tie and tails
RABBIT: Top hat, magic
TIGER: Tiger in the tank, or is it the box?
RAT: Cheese
SNAKE: Snakes and ladders and so on, and so on. . . .

Each of these exercises costs us a lot , and yet we have to keep up with this tradition as our clients almost expect to be invited to the event. Perhaps a Christmas party with a Chinese theme may also not be a bad idea.

Chinese New Year promotional items
and stationery
OPPOSITE *Year of the Dog*
THIS PAGE CLOCKWISE *Year of the
Rabbit, Tiger, Monkey, Pig, Chicken*

Studio 3 Graphics Ltd.
102, 10160 115 Street
Edmonton, Alberta
T5K 1T6 Canada

Wei Yew

Helen Wong

Debra Bachman

Shirley Phillips

Suzanne Oel

Sandra Retzer

Wei Yew
Studio 3 Graphics Ltd.
102, 10160 - 115 Street
Edmonton, Alberta.
Canada T5K 1T6
Tel: (403) 482-3333
Fax: (403) 488-3966

Chinese New Year promotional items
THIS PAGE CLOCKWISE *Year of
the Rat, Horse, Tiger*

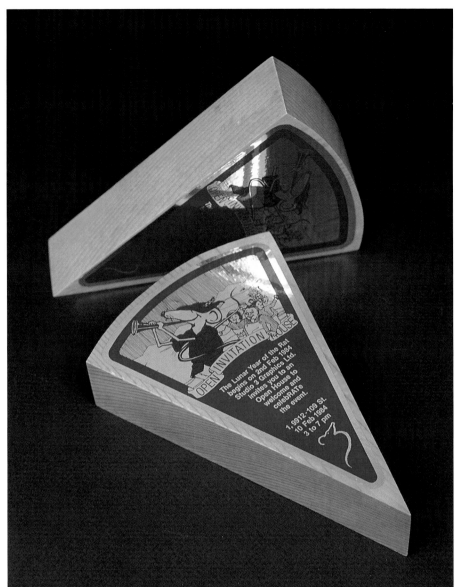

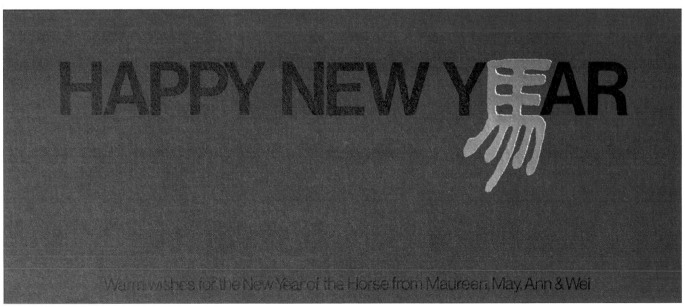

Country
Canada

Design Director
Wei Yew

The Canadian College of Traditional Chinese Medicine

This was the first college in Canada to offer degree courses in traditional Chinese medicine. The solution seemed so obvious right from the beginning – the character for Chinese, "Chung," and the snake of the Aesculapius, led to the combination "Chung Yi," meaning "Chinese Medicine." We went through many different forms of "Chung" and many different versions of snakes to arrive at this present combination.

Country
Taiwan

Design Director
Wei Yew

Keaton International School

Our client was setting up an international school in Taiwan and planning other schools in Japan and Korea. He requested a brochure to introduce the international schools concept in Taiwan. The Keaton logotype has the element of a flame (light), representing the traditional symbol for knowledge. Expanding on that theme of light, we used the source of all light, the sun, for the cover of the brochure. Hence, the sun graphically represents both the Asian and the Western metaphor.

203

Maxim Zhukov

United Nations

What makes designing for the United Nations special? The major difference is that design, like every other activity of the organization, is subject to the same basic principles that present a conceptual foundation of the United Nations. The concept that has a paramount influence on design is the *equality* of peoples and nations of the Earth.

.　　.　　.

Our job is essentially *message design.* Therefore, we at the United Nations have to make this message (be it pictorial or written) clear to every individual or group concerned.

This is why the issue of *language* (again, pictorial and/or written) is critical in all our activities. The concept of "fair and equal treatment of languages" in all communications is a rule within the United Nations, an implication of a Resolution passed at the 42nd Session of the General Assembly.

We can draw an easy parallel with what seems to be one of the focal problems with translating the U.N. texts into six official languages. The linguists know that in order to ensure a reliable translation into whatever language, the master copy has to be written simply, with no parochial or slang expressions (however colorful or vivid they could be).

This requirement that all U.N. documents must be easily convertible into every official language has begotten such a phenomenon as a language ONU*sien,* a kind of special stylistic inflection that makes any given national language slightly different from its original domestic version.

Likewise, when looking for an appropriate visual solution we have to rule out those media, tools, and means that might lead to ambiguity or controversy. We must be highly selective in using any visual device. This exactingness affects all constituents and elements of design – for example, the overall layout, the relationship of the "louder" and "softer" parts, the imagery, the color palette, the choice of typefaces, and the typographical arrangement.

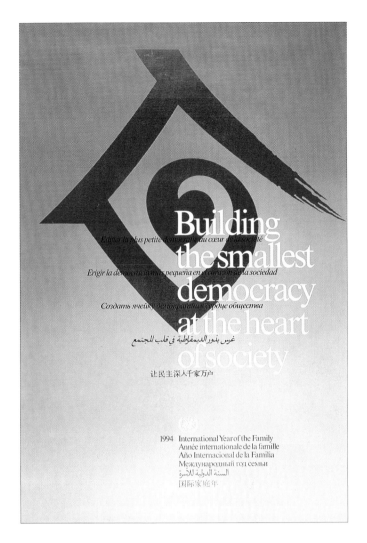

The interaction of the numerous criteria, limitations, and restrictions creates a unique opportunity for acquiring specific and valuable experiences and skills in devising visual structures to meet an unusually large number of requirements. In other words, the United Nations is a great school.

. . .

Design is purposeful by its nature. That is, a product of design has to *serve* a specific need, to comply with specific requirements. With the United Nations the number of requirements that must be satisfied and restrictions that must be taken into account is sometimes so great that a designer's choices are severely limited thus presenting an ultimate challenge to creativity.

Of course, working under pressure and complying with limitations are routine with the design trade. We all know that requirements and limitations, conventions and restrictions are stimulating to a creative mind, boosting the imagination and challenging the professional skills of a designer.

Limitations narrow down a circle of search for solutions; they help to zero in on the focal problems, a process that is imperative for successful design; they provide for the efficiency of solutions that address substantive issues.

Designers
Mikhail Verkholantsev, Vladimir Yefimov,
Maxim Zhukov

Under these circumstances, it is quite predictable that some of the projects and products we work on are almost "self-designed." The limited number of alternative solutions sometimes confines projects to a "generic" look, to a straightforward, no-nonsense, "no-frills" visual form. To work, our designs cannot quite afford to flash, to look fancy, to look "special." I am convinced though, that they cannot afford to look dull or "square" either.

Mir Publishers, Moscow
RIGHT *Publisher's promotional folder, 1984. Mir is a major international science publisher. Their word logo is treated as a set of engraved pictorial initials; each of them may be regarded as both a self-contained composition, and/or as an element of a triparite entity. Not only do the scripts vary – Latin, Cyrillic, Arabic, Devanagari – but so do the references to the symbols and visual metaphors pertaining to various cultures and mythologies.*

BELOW *Publisher's device, 1984. Times Roman (Monotype) was chosen for the English and Russian versions of the logotype for* Mir. *The Arabic and Hindi versions were drawn to match, with their overall styles – most conventional, a kind of 'Times Arabic' and 'Times Devanagari' – and all visual features (scale, color, contrast, stroke weight, stress, etc.) carefully fine-tuned to provide for the same 'look.'*

МИР
Научно-техническая книга на двадцати языках

مير
كتب علمية وتكنيكية بعشرين لغة

MIR
Science and technical books in twenty languages

मीर
बीस भाषाओं में विज्ञान एवं तकनीक की पुस्तकें

. . .

There is a password to this endless journey through innumerable challenges and pitfalls: *compromise.*

A compromise . . . doesn't sound too appealing, does it? We are accustomed to consider "compromise" rather a bad word when it comes to any creative activity. We all hear that true professionals "don't compromise." That is, however, part of the mythology of art, the tales laypeople tell of "artists."

Any realistic settlement (and a design process can be regarded as such) involving multiple interests and/or requirements is truly a balancing act. It ought to be based on a kind of compromise. Any design, any layout, presupposes choices, stresses, subordination. All this is compromise. And it is professional: the point is that it does not really mean any kind of *giving up* forced upon the original concept by the circumstances. The process of adjusting the original concept, fine-tuning it to life, is natural and healthy, and by no means a detriment to the design.

. . .

I have a longing for an art restricted in visual means, an art complicated by situation and context. . . and also for a medium difficult to work.

V. FAVORSKY 20th-century artist and philosopher,
Rasskazy khudozhnika-gravyora, [*Tales of an Engraver*]

. . .

It is clear to all of us that the message, to be universally readable and acceptable, must be shaped as objectively as possible. That logically leads to the restraining of the subjective, personal factor, of such particulars as ethnic traits.

This is why using those media that are potentially ambiguous (at least with some audiences) can prove troublesome and counterproductive. For example, a *go-hua* painting style works fine with a far-eastern viewer, though it will look "exotic" to a European eye. Using a broken script ('black letter') might be conventional for a certificate design with the American public, though it might have quite different connotations for the French and Russians.

. . .

Every visual tool has to be custom-tuned to the purpose and the audience. It is easier, and there is much more choice, when a project is targeted at a single reader/viewer group – for instance, language, cultural, or regional audiences. The more varied the group is, the more thorough the coordination and the cross-adjustments must be.

That is why every time a multitargeted project is being worked on, a common denominator to all versions (or constituent parts) of a project must be found.

For example, if we are looking for a typographic layout for all six official languages, we have to narrow our choice of typefaces down to the range available for typesetting each of them. That affects the typography of the West European languages in the first place, since the font range in Cyrillic, Arabic, and Chinese is much more limited. That makes using certain faces and/or styles (for example, bold italic), which are rare or not available in those scripts, an undesirable choice.

The same applies to the typographic arrangements. For example, both justified and centered arrangements are satisfactory with all six languages, although flush left/ragged right is correct with English, French, Spanish, and Russian; flush right/ragged left works well with Arabic, while flush top/ragged bottom works with Chinese only.

. . .

The principle of anonymity is a natural extension of, and an elaboration on, a concept of the objectivity/impartiality/impersonality that is one of the cornerstones of U.N. policies. Every activity and action of the United Nations is impersonal and anonymous. There is no credit given to any author, translator, editor, designer, or anyone else.

Meanwhile, there are a number of creative people working in the organization who would normally be credited for what they do if they were working outside the United Nations. They include, among others, media professionals: copywriters, photographers, and cinematographers, TV and radio people. Only one person in the United Nations has an official right to be named: this is the Secretary-General. "Designer! Thou shalt swallow thy pride."

However, staying anonymous is all right with us. Again, it is not that unusual for a designer who is, say, working at a large agency, not to sign his or her works. And it also rather faithfully reflects the real pattern of our operation, which is true teamwork, involving several people. Sometimes the cooperation is so intensive that it is really difficult to pinpoint the "author."

Quite predictably again, this anonymity and teamwork do not rule out, but rather encourage, our individual contributions. Twelve people, citizens of eight member nations, work in the Graphic Presentation Unit. This is a typical structure for an element of the U.N. system. We all keep our identities, our national and ethnic backgrounds, our aesthetic preferences, our professional orientations, and our skills and tastes.

. . .

Designers
Olga Ainagas, Jim Eschinger,
Maxim Zhukov

United Nations, New York
*Magazine cover, 1989. Children's drawings
are far less affected by visual stereotypes and
conventions existing within various cultures.
For a cover of an international magazine issued
in six languages - English, French, Spanish,
Russian, Arabic, and Chinese - they serve as a
truly cross-cultural communication medium.*

In communication, convention holds a special place. Its importance for visual design is hard to overestimate. But when we are dealing with the international audience, the role of convention becomes truly vital.

Each time we are thinking over a design, we are reassessing and re-evaluating the established conventions that we usually take for granted, and we are customizing them for the project. There are a great many horror tales about misusing colors. The most potentially troublesome aspect in chromatology for us has to do with national colors, of course; the worst cases result in formal protests from member nations. Besides that, all other pitfalls, involving among other issues, regional, national, religious, and ethnic traditions, conventions, and symbolism, apply as well.

The color problem is one of many. Convention is the word when it comes to

United Nations, New York

*Exhibition title panel, 1989. The direction of
writing (left to right, right to left, top to
bottom) varies with scripts, but normally stays
consistent within one script. (Chinese and
Japanese scripts can be written both left to right
and top to bottom.) In any script, and with any
culture, the random positioning of characters
and/or lines evokes a sense of disorder,
sometimes disturbance, of chaos - which was
the objective and, actually, the message.*

Designers
José Castiñeira, Mai-Khoi Nguyen,
Maxim Zhukov

the imagery: symbols, signs, pictograms, and the like. For example, a lotus does not
say much to a Westerner; while a Christmas tree can have a different meaning for
an Asian.

The important thing is not to keep away from conventional values, but
to explore them, apply them, and exploit them – selectively, consciously, and
purposefully. Of course, playing it safe is a pre-condition to playing it well.

. . .

In the United Nations, controversy is a thing to be avoided like the plague. No
wonder – while compromise is a tool for achieving a settlement, controversy is an
explosive capable of blowing it up.

Keeping things vague and oblique is typical for diplomacy. It is even more
typical of the multilateral processes, the type of diplomacy in which the United
Nations is engaged. Since the United Nations is supposed to look at any problem
from a global angle, to be efficient it cannot afford being specific unless specificity is
truly necessary.

For example, in a photo kit for the International Year of the Homeless we could not
have captioned pictures "New York," "Calcutta," and "Paris." Since the only criterion
in choosing pictures was their visual strength, with no consideration for political,
statistical, or other factors, labelling them could have caused unnecessary trouble.

Another example is cartography. Let's say that a map of geological resources is being prepared for a country that is involved in territorial disputes with its neighbors. Then every effort is made to hide the problem, to conceal the disputed area. It can be covered by an inscription or a legend, it can be trimmed off or disguised in some other way.

. . .

Our work is also affected by factors having to do with the people working in the United Nations, their identities, backgrounds, skills, and tastes. Most of the problems every professional encounters in dealing with a client hold true with the United Nations; however, they are heavily complicated by a huge number of the national, ethnic, cultural, religious and personal characteristics that sometimes seriously affect the process of design.

The number of objective requirements and the complexity of our design problems are so great that they present fertile soil for unfair speculations and distortions, and they are sometimes misinterpreted and abused. For example, United Nations designers sometimes hear that the "flush left/ragged right" arrangement of text is wrong when it comes to disarmament; that painting a pamphlet on the social role of women green (yes, that exact tint of green, PMS 347C) is an absolute must, since it has so much to do with the subject. . . .

. . .

Working for the United Nations – like working for any organization – is not easy. It takes devotion, consciousness, self-oblivion, and even self-abnegation to keep trying to find solutions to the array of problems we face every day.

After all, the U.N. experience *is* highly rewarding. In my opinion, those severe limitations and restrictions that apply to our design activities do provide for a better understanding of design – of its essence, its nature. They also help us to concentrate on those details which, according to George Nelson, "make the product" – those nuances that could be, and sometimes are, disregarded and/or underestimated when there are plenty of choices and alternatives available. Succeeding in creating a good design solution under such special circumstances is twice as gratifying.

This is how Vladimir Mayakovsky, the famous Russian poet, put it back in 1913:

And you, could you have played a nocturne
with just a drainpipe for a flute?

V. MAYAKOVSKY, *What about you?* ['*A vy smogli by?*'] 1913, D. Rottenberg, transl., in *Three Centuries of Russian Poetry*, N. Bannikov, ed., Moscow, 1980, p. 455.

Alan Zie Yongder
Hong Kong

Country
Hong Kong/Asia

Publisher and Design Director
Alan Zie Yongder

Editor
Karen Smith

Artention Magazine

Our challenge lay in creating a magazine cover encapsulating the aims and quality of the magazine itself. Our goal was to be visually dynamic and eye-catching; to make the image of the art magazine approachable, not elitist. To accomplish this, we used classic and recognizable art, transformed by modern interpretation and the human element. We wanted to make the art come alive, to add an element of fun. Putting a familiar face on art gives it greater meaning to a greater number of people. It breaks down the barriers that appear when people feel that a lack of education puts art beyond their reach.

Artention *Magazine*
ABOVE LEFT TO RIGHT *Cover inspired by Gainsborough's* Giovanni Baccelli. *Cover inspired by Warhol's* Art Marilyn Monroe. *Cover inspired by Whistler's* Harmony in Grey and Green: Miss Cicely Alexander RIGHT *Cover inspired by Renoir's* The Opera Box

No. 4 January · February 1989 $40

artention
INTERNATIONAL

Design/Architecture From Our House to Bauhaus

Music World Music Days 1988

Theatre What's in store at the 1989 Hong Kong Arts Festival

Sculpture Dame Elisabeth Frink

Museum The Arthur M Sackler Gallery at the Smithsonian Institution

Dance Patrons pave the way for the Central Ballet of China

Opening Nights Backstage at art shows and gallery happenings

Appendices, Bibliography, Index

When Visiting a Foreign Country

Perceptions of time, life's priorities, physical space, the role of the individual, and a host of other issues vary enormously throughout the world. When I once asked my driver in the Philippines to meet me at 8 A.M., he asked me if this meant "American time" or " Filipino time"?

Hospitality rituals such as having coffee or making small talk are not insignificant gestures, especially in cultures where business hinges on a complex network of personal relationships. Be a good guest and know the proper forms of reciprocation. Refusing coffee from a Cypriot, for example, is nothing less than a rude insult.

Public displays of affection between men and women are frowned upon in many cultures. Similarly, physical contact between men in such areas as the Middle East, Southern Europe, and Latin America is more demonstrative than in the United States.

Most cultures reserve first names for more intimate relationships than do Americans. Know the proper forms of address and use titles correctly. Respect social and business hierarchies even if they seem "undemocratic" to you. Exchanging business cards in most cultures is a more formal transaction than it is in the States. Have plenty of cards with you and exchange them with care and respect. Know when to present them with both hands, for example, and never flip them across the table.

Be polite, be discreet, be respectful. Be sensitive to "face." An unpleasantness that might cause an American bemused embarrassment can be a profound humiliation to individuals abroad. Many Asian cultures consider face among the most valuable possessions a human can have, a common birthright of both the simplest peasant and highest-born aristocrat. Asians place enormous emphasis on the dignity of saving face and allowing it to others. Show respect for your own sense of face. Failing to do so will cause you to lose respect, and create difficulties for your foreign contacts, who will be shamed as well. Moreover, displaying respect and understanding of other cultures does not require you to denigrate your own.

'Yes' is 'no' and 'no' is 'yes' in some cultures. It is rude in Japan or Korea, for example, to say no directly and your hosts there may seem to be acquiescing to a suggestion when they are merely being polite. Similarly, social graces in some countries may force an individual to reject a proposal when it is really quite welcomed.

People may understand less English or your native language than it seems. Use simple words; avoid slang and complex sentences. Speak in a normal volume. Some words that may be neutral or complimentary to you have negative or insulting connotations abroad. For complicated and important discussions, arrange for a translator. Learn a few words of the host's language. Body language may be very meaningful in other cultures. Avoid embarrassing gestures or posture. Showing the soles of your shoes can be extremely rude in the Middle East, passing food with the left hand grossly crude in parts of Asia. Offering a tip in Iceland will only make the recipient uncomfortable.

Make peace with the fact that there are subtleties surrounding foreign cultures that you will never understand and intimacies you will never be able to achieve. S.I. Hayakawa once said that "One can no more truly understand another country than can one a frog or a hummingbird." Recognize that as a professional on the go you will always be struggling to strike a balance between cultural considerations and the urgent requirements of your assignment. Be firm and tactful in evading difficulties such as ceremonies that would irreparably upset your schedule, local foods that might compromise your health, arrangements that might violate your security.

Ken Haas, *The Location Photographer's Handbook*

Anspach Grossman Portugal
711 Third Ave
New York, NY 10017 USA
Tel (212) 692-9000
Fax (212) 682-8376

Backer Spielvogel Bates Ltd
1 Hennessy Road, 2/F Asian House
Wanchai, Hong Kong
Tel (852) 2823-0111
Fax (852) 2527-4086

Saul Bass
Bass/Yager & Associates
7039 Sunset Boulevard
Los Angeles, CA 90028, USA
Tel (213) 466-9701
Fax (213) 466-9700

Cato Design Inc
254 Swan Street, Richmond
Victoria 3121, Australia
Tel (3) 429-6577
Fax (3) 429-8261

Chermayeff & Geismar
15 East 26th Street, 12/F
New York, NY 10010, USA
Tel (212) 532-4499
Fax (212) 889-6515

Seymour Chwast
The Pushpin Group
215 Park Avenue South
New York, NY 10003, USA
Tel (212) 674-8080
Fax (212) 674-8601

Richard Danne
Richard Danne & Associates
126 Fifth Avenue
New York, NY 10011, USA
Tel (212) 645-7400
Fax (212) 645-7707

The Duffy Design Group
701 Fourth Avenue South
Minneapolis, MN 55415, USA
Tel (612) 339-3247
Fax (612) 339-3121

Eurocom Advertising
Gutsrasse 73, Zürich
CH-8055 Switzerland
Tel (01) 461-4041
Fax (01) 461-4568

Lidia Guibert Ferrara
Via Lodovico Settala 1
20124 Milan, Italy
Tel (2) 951-9858

Forward

Forward Publishing Company

45 East 33rd Street

New York, NY 10016, USA

Tel (212) 889-8200 or 1-800-272-7020

Dan Friedman

2 Fifth Avenue, Suite 15U

New York, NY 10011, USA

Tel (212) 777-3091

Fax (212) 228-0221

David Gentleman

25 Gloucester Crescent

London NW1 7DL, England

Tel (071) 485-8824

Fax (071) 485-8824

Milton Glaser

Milton Glaser Inc

207 East 32nd Street

New York, NY 10016, USA

Tel (212) 889-3161

Fax (212) 213-4072

Dr. Greg Guldin

Department of Anthropology

Pacific Lutheran University

Tacoma, WA 98447, USA

Tel (206) 535-7662

Ken Haas

114 Split Rock Drive

Barryville, NY 12719, USA

Tel (914) 557-6664

Fax (914) 557-6069

International Herald Tribune

181 Avenue Charles de Gaulle

92521 Neuilly Cedex, France

Tel (33-1) 4637-9300

Fax (33-1) 4637-2133

Eiko Ishioka

Eiko Design Inc

Mita House #227, 5-2-18 Mita Minato-ku

Tokyo 108 Japan

Tel (3) 3455-5128

Fax (3) 3453-5435

Kyoshi Kanai

Kyoshi Kanai Inc

115 East 30th Street

New York, NY 10016, USA

Tel (212) 679-5542

Fax (212) 545-0834

Ivor Kaplan

c/o Peter Owen Publishers

73 Kenway Road

London SW5 0RE, England

Tel (071) 373-5628

Fax (071) 373-6760

KARO

611 Alexander Street, Vancouver

British Columbia, Canada V6A 1E1

Tel (604) 255-6100

Fax (604) 255-3800

Clarence Lee

Clarence Lee Design & Associates

2333 Kapiolani Boulevard

Honolulu, Hawaii 96826, USA

Tel (808) 941-5021

Fax (808) 949-0481

M&Co
225 Lafayette Street, Suite 904
New York, NY 10012, USA
Tel (212) 343-2408
Fax (212) 343-0980

Magnus Nankervis & Curl Pty Ltd
137 Pyrmont Street
Pyrmont, NSW, 2009 Australia
Tel (612) 566-3000
Fax (612) 566-3022

Fernando Medina
Triom Design
157 Mason Street
Greenwich, CT 06830, USA
Tel (203) 661-2464
Fax (203) 661-2572

James Miho
Art Center College of Design
1700 Lida Street
Pasadena, CA 91109-7197, USA
Tel (818) 396-2200
Fax (818) 405-9104

Clement Mok
Clement Mok Designs
600 Townsend, Penthouse
San Francisco, CA 94103, USA
Tel (415) 703-9900
Fax (415) 703-9901

Bruno Oldani
Bygdøy allé 28B
N.0265 Oslo 2, Norway
Tel (02) 55-01-26
Fax (02) 56-02-01

Pentagram Design Ltd
11 Needham Road
London W11 2RP, England
Tel (071) 229-3477
Fax (071) 727-9932

Pentagram Design
Michael Gericke
212 Fifth Avenue
New York, NY 10010, USA
Tel (212) 683-7000
Fax (212) 532-0181

Pentagram
Linda Hinrichs & Neil Shakery
620 Davis Street
San Francisco, CA 94111, USA
Tel (415) 981-6612
Fax (415) 981-1826

Michael Peters
Identica
1 Olympia Mews Queensway
London, W2 3SA, England
Tel (71) 221-9900
Fax (71) 221-2225

Dan Reisinger
5 Zlocisti Street
Tel Aviv 62994, Israel
Tel (03) 695-1433
Fax (03) 696-6723

Helmut Schmid
Helmut Schmid Design
Tarumi-cho 3-24-14-707
Suita-shi, Osaka-fu 564, Japan
Tel (06) 338-5566
Fax (06) 338-6699

Erik Spiekermann

MetaDesign

Bergmannstrasse 102, D-1000

Berlin 61, Germany

Tel (030) 69-00-62-00

Fax (030) 69-00-62-22

Alexander Stitt

Alexander Stitt & Partner

Shangri-La, 91 Park Street

South Yarra 3141 Melbourne

Australia

Tel (613) 866-2314

Fax (613) 866-8604

Henry Steiner

Steiner & Co.

28c Conduit Road

Hong Kong

Tel (852) 2548-5548

Fax (852) 2858-2576

Alan Taylor

11 Hampshire Circle

Bronxville, NY 10708, USA

Tel (914) 961-8663

Fax (914) 793-6261

Wang Min

Adobe

795 Coastland Drive

Palo Alto, CA 94303, USA

Tel (415) 321-4294

Fax (415) 321-6246

WBMG

Walter Bernard & Milton Glaser

207 East 32nd Street

New York, NY 10016, USA

Tel (212) 689-7122

Fax (212) 481-0286

Henry Wolf

Henry Wolf Productions Inc

167 East 73rd Street

New York, NY 10021, USA

Tel (212) 472-2500

Fax (212) 772-7715

Wei Yew

Studio 3 Graphics

#203, 10107 115 Street

Edmonton, Alberta T5K 1T3

Canada

Tel (403) 428-3333

Fax (403) 428-3966

Maxim Zhukov

A&M/CS/Publishing

United Nations Headquarters

New York, NY 10017, USA

Tel (212) 963-8048

Fax (212) 963-9106

Alan Zie Yongder

Artention Magazine

14/F Aik San Building

14 Westlands Road

Quarry Bay, Hong Kong

Tel (852) 2963-0111

Fax (852) 2565-8217

Bibliography

Aldersey-Williams, Hugh. *World Design: Nationalism and Globalism in Design.*
New York: Rizzoli, 1992. (A thorough look at cultural diversity in design from the
mid-1980s to the present, this book examines national identity as expressed
through the objects and images of 19 countries.)

The American Institute of Graphic Arts. *Signs and Symbols.* New York:
Visual Communications Books, 1990.

Axtell, Roger E., ed. *Do's and Taboos Around the World.* New York:
John Wiley & Sons, 1985. (A delightful anthology of etiquette, customs, gestures,
and idioms from around the world.)

Axtell, Roger E., ed. *Do's and Taboos of Hosting International Visitors.* New York:
John Wiley & Sons, 1990.

Benedict, Ruth. *Patterns of Culture.* Boston: Houghton Mifflin Co., 1989.

Braganti, Nancy L., and Elizabeth Devine. *The Travelers Guide to Asian Customs
and Manners.* New York: St. Martin's Press, 1986.

Braganti, Nancy L., and Elizabeth Devine. *The Travelers Guide to Latin American
Customs and Manners.* New York: St. Martin's Press, 1989.

Braganti, Nancy L., and Elizabeth Devine. *European Customs and Manners.*
New York: Simon & Schuster, 1992.

Campbell, Joseph. *The Mythic Image.* Princeton, NJ: Princeton University Press, 1974.

Chatwin, Bruce. *The Songlines.* New York: Viking Penguin, 1990.

Copeland, Lennie and Lewis Griggs. *Going International: How to Make Friends
and Deal Effectively in the Global Marketplace.* New York: Random House, 1985.
(An excellent guide on doing business internationally, this book discusses
communicating, negotiating, and establishing foreign contacts. It offers advice on
travel and living abroad, with specific suggestions for 30 major countries.)

Fisher, Glen. *International Negotiation.* Yarmouth, ME: Intercultural Press, 1980.

Haas, Ken. *The Location Photographer's Handbook.* New York: Van Nostrand Reinhold, 1990.

Hall, Edward T. *The Hidden Dimension.* New York: Doubleday, 1969.

Hall, Edward T. *The Silent Language.* New York: Doubleday, 1973.

Hall, Edward T. *Beyond Culture.* New York: Doubleday, 1976.

Hall, Edward T. *The Dance of Life.* New York: Doubleday, 1984.
(These four paperbacks are an excellent introduction to cross-cultural sensitivity for the general reader.)

Hughes, Robert. *Culture of Complaint: The Fraying of America.* Oxford University Press, New York & Oxford, 1993.

Ives, Colta Fella. *The Great Wave: The Influence of Japanese Woodcuts on French Prints.* New York: Metropolitan Museum of Art, 1974.

Le Japonisme. Paris: Editions de la Réunion des Museés Nationaux, 1988.

Jung, Carl G. *Man and His Symbols.* New York: Doubleday, 1964.

Kieve, Heinz Edgar. *Civilization on Loan.* Oxford: A.N.I. Ltd., 1973.

Leebart, Derek, ed. *Technology 2001: The Future of Computing and Communications.* Cambridge, MA: MIT Press, 1991.

Lippard, Lucy R. *Mixed Blessings, New Art in a Multicultural America.* Pantheon Books, New York, 1990.

Minsep, Foseco. *The Business Traveler's Handbook: How to Get Along with People in 100 Countries.* Englewood Cliffs, NJ: Prentice-Hall, 1983.

Rubin, William, ed. *"Primitivism" in 20th Century Art.* New York: The Museum of Modern Art, 1984, (2 volumes).

Simony, Maggy, ed. *The Traveler's Reading Guide.* New York: Facts on File, 1987.
(A comprehensive bibliography of fiction and nonfiction works organized by country, which may suggest further reading to inform and inspire the creative process.)

Sullivan, Michael. *The Meeting of Eastern and Western Art: From the Sixteenth Century to the Present Day.* CA: University of California Press, 1989.

Weisberg, Gabriel O. *Japonisme: Japanese Influence on French Art 1854–1910.* Cleveland: The Cleveland Museum of Art, 1975.

Yew Wei, ed. *Pacific Rim Design.* Canada: Quon Editions/ Singapore: Page One - The Bookshop Pte. Ltd., 1991.

Index

227